Night Photography:
From
Snapshots to Great Shots

Night Photography:
From
Snapshots to
Great Shots

Gabriel Biderman

with Tim Cooper

Peachpit Press

Night Photography: From Snapshots to Great Shots
Gabriel Biderman

Peachpit Press
www.peachpit.com

To report errors, please send a note to errata@peachpit.com
Peachpit Press is a division of Pearson Education

Copyright © 2014 Gabriel Biderman

Photography © Gabriel Biderman, Chapters 1, 2, 4, 5
Photography © Tim Cooper, Chapters 3 and 6

Senior Editor: Susan Rimerman
Developmental/Copy Editor: Scout Festa
Production Editor: David Van Ness
Proofreader: Bethany Stough
Indexer: James Minkin
Composition: WolfsonDesign
Interior Design: Mimi Heft
Cover Design: Aren Straiger
Cover Image: Gabriel Biderman

ISBN-13: 978-0-321-94853-3
ISBN-10: 0-321-94853-X

9 8 7 6 5 4 3 2

Printed and bound in the United States of America

About the Authors

Gabriel Biderman is a Brooklyn based fine-art and travel photographer. His work has been featured in photography exhibits in New York, London, and Hawaii. He leads night photography workshops and has contributed articles and blog posts for print and online publications. Gabriel is also the special events and tradeshow point person for B&H Photo. See his work and read his blog at ruinism.com.

Tim Cooper is a Washington, D.C., based photographer who specializes in night photography and nature images. His editorial and commercial work has appeared in *Travel & Leisure*, the *New York Times Magazine, Outdoor Photographer, Fly Rod & Reel,* and *DC Magazine*. Tim leads popular workshops and is an instructor at the Rocky Mountain School of Photography. See his work and read his blog at timcooperphotography.com.

Dedication

To Nancy, my muse and love in the day and night. —GB

Acknowledgments

Writing this book has been a crazy journey of late nights, test shots, phoning friends, and locking myself up in a garret and waiting for the words to flow.

It could not have been possible without the help of my good friend Tim Cooper, who didn't know what he was getting into when he volunteered to write two chapters in this book. You are a life and marriage saver. I'm so happy to share this book with you.

To the incredibly professional Peachpit team: Susan Rimerman, for keeping me on target-ish; Scout Festa, for translating Gabe to English; David Van Ness, for getting me CMYK ready; and the rest of the crew who gave me this wonderful opportunity to share my passion with others.

Jonny and Angus—we've come a long way from the duct-tape darkrooms and rooftop photo shoots! You paved the way, brothers!

David Brommer, General of the B&H Events Space and SOD—you pushed me to be all I could be! Manny and the B&H crew—it has been an honor to work over 12 years at the world's biggest "toy store" with some of the best people in the industry.

Troy and Joe—full moons aren't the same without you; more adventures to come! Lance, Scott, and Tim—thanks for helping so many nocturnes "find their way in the dark."

To the Infinists, Week of Arters, and Reciprocity Failures, especially Michael and Angelier for helping me capture "Gabe" in the gear shots. Matt H., JC, Brandon, Sylvester, Tom P., Thom J., and Andre C.—thanks for always being willing to play in the dark!

To the staff and teachers of RMSP, who believed in me and trusted me from Vegas to Zion—may we always meet somewhere between space and time!

Scott Kelby, Seth, Syl, Moose, the Nat Geo crew and all the other educators I've been so fortunate to learn from.

Adam, Jennifer, and Ruth, who after years of teasing or being teased have shown me so much love and support. David N., you inspire me! To the "other" B&H & S&S—have I told you how lucky I am to have you in my life?

I want to thank my mom and dad, who raised me in creative environments, supported most of my decisions, and always encouraged me. Fannie and Phyllis, my grandmothers, who are responsible for my outgoing personality and who inspired the next wave of artists in our family. I miss you both and wish you were here to share this moment.

Nancy, it has been 16 years since you kissed me under the San Francisco stars. Over 200 moons have waxed and waned since. Thank you for being an inspiration, so incredibly supportive, and a perfect match. I love you.

And to all the rest of my family, my friends, and the photographers who have shared and supported all my late-night antics!

—Gabriel Biderman

Contents

Introduction

Good pictures should leave an impact on the viewer. Most of us capture our memories with a quick click, but with longer exposures comes a slower and more meditative approach. Night photography pushes the boundaries of time and how we seize it.

As a night photographer, time has always been an obsession of mine. I might not be the best at budgeting my time, but I sure know how to play with it!

I was wrapping up Chapter 5 of this book in Miami and was worried because I didn't have any lightning shots to reference. It was 2 a.m. and I was about to crawl into bed when all of a sudden a shock of white light lit up the room. I put my hat on (yes, it does come off), grabbed my bag of gear, and ventured outside. It wasn't raining yet, and I was only a few blocks from the beach. I could see the lightning in the distant storm clouds. I was surprised to find a crowd on the beach. Couples were huddled together, people were swimming, and there was the general revelry of witnessing nature's fireworks. Several people were snapping pictures, but I was the only one with a tripod. I quickly set up and started tracking those bright bolts. I got the shot you'll see later in this book about 30 minutes into the shoot, but I was so energized that I kept shooting and experimenting until 4 a.m.

In this book, I hope to inspire you to move beyond the snapshot and take more control of the time right in front of you. I go over all the tools you will need, and I shine a light on techniques that will make you more proficient in the field and on the computer. The building blocks of creating an image with impact are discussed at length, as well as the scenarios you might find yourself in and how to best capture them once the sun goes down. The goal is to demystify the night and inspire you to creatively express time in a single image.

Good night photography shots have always been elusive yet rewarding. But digital technology allows us to review our work and learn from our mistakes instantaneously. Strange things happen when you play with time. This book is meant to be a resource for you as you capture and create. Dedicate yourself to shooting and putting yourself into as many night scenarios as you can. You will need to experiment to gain experience. Which reminds me: Try to photograph with friends and share your work. When you shoot with someone, it challenges you to up your game, you can bounce ideas off each other, and you can forge collaborations.

The book coverage doesn't end with collapsing the legs of your tripod. We'll also cover processing your night images in Lightroom and Photoshop to complete your photographic vision.

Finally, make sure to share your amazing results with other night owls at the book's Flickr group! Join the group at www.flickr.com/groups/night_fromsnapshotstogreatshots.

Carpe noctem!

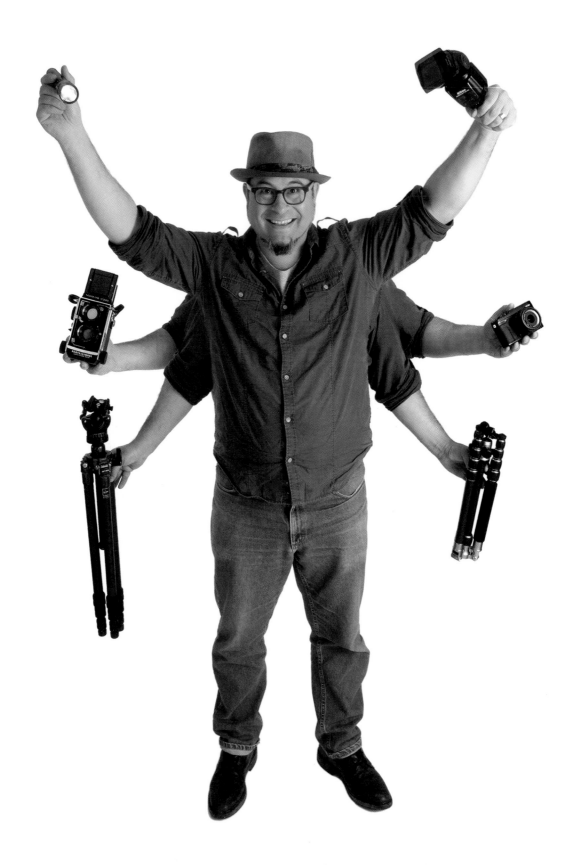

1
Equipment

The Right Tools for the Night Job

Photography is like cooking pasta. In the beginning, we tend to throw a lot of photos (like spaghetti) at the wall and see what sticks. Do you like portraits or landscapes? Are you a wide-angle specialist or an abstract macro artist? Who you are as a person should resonate in your photography. As we get more experienced, our photographic style becomes more focused and our images are cooked to perfection. And as any proper cook knows, having the right tools helps you create real masterpieces.

A lot of the equipment we use to shoot during the day will also be helpful in creating inspirational images at night. But night photography makes different demands—ones that we might not even consider—on the camera, tripod, and lens. When you get a new piece of gear, test it out and understand what it can do before taking it out on a night shoot. Whether you are new to night photography or a seasoned shooter, I also advise shooting with a minimal amount of equipment. Gear is good, but too much can dilute your vision.

So in this chapter, I cover the essential tools that will help you become a lean, mean night-photography machine.

Poring Over the Picture

After sunset, the Rio-Antirio Bridge became a stunning blue beacon in the night. I rolled down the passenger window, set my DSLR to continuous shooting mode, and stuck it out the window. As we approached each pylon I kept my finger on the shutter button, taking a burst of 50 to 60 shots. I experimented with exposure times and asked my friend to drive faster and slower. I had to think fast, know where my controls were, and make quick adjustments.

I adjusted my camera to continuous burst mode so I could get five frames per second and increase the number of successful shots.

I zoomed in to fill the frame with brilliant blues.

A shutter speed of 1/6 of a second created the perfect amount of motion blur.

I was very careful not to overexpose the blue light, or it would turn white.

It was important that part of the image remain sharp, thus heightening the blur of the movement around it.

ISO 800 • 1/6 sec. • f/4.5 • 55mm lens

This image was the result of being at the right place (my brother's 40th birthday party) at the right time (twilight) with the right lens (a Lensbaby). I put the focal point on the clock of the Ferry Building in San Francisco. This threw the bright streetlights out of focus and turned them into beautiful discs of light. This unique image could not have been taken with any other type of lens. Knowing your gear and what it can do is an important part of the photographic process.

The warm light from the clock and streetlamps complements the rich blue sky.

The Lensbaby can turn a normal scene into a dreamlike image.

I used a Lensbaby Composer with a 50mm double-glass optic at 2.8 to create a sweetspot of focus around the clock and tower.

The out-of-focus areas lend a sense of movement to the photo.

The rich blues of twilight complement the yellow and red lights.

ISO 640 • 1/30 sec. • f/2.8 • 50mm lens

Night Equipment

The Camera Bag

I advise using a small and comfortable bag that is still large enough to hold your essential gear. My favorite backpack is the Lowepro Fastpack 350 (**Figure 1.1**). Backpacks are the most comfortable way to carry a lot of equipment, and this bag always goes with me on my longer trips. My cameras, lenses, and flashes fit in the bottom compartment. The top compartment fits my accessories, snacks, and an extra shirt. A medium-sized tripod can also easily attach to the side of either the Fastpack 250 or 350.

Figure 1.1
The Lowepro
Fastpack 350

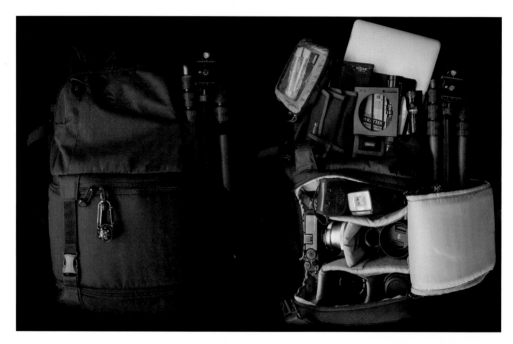

I'm all about using smaller shoulder bags that force you to bring the bare minimum and stay focused on shooting. I'm a big fan of the Tenba Messenger series, which comes in fun colors like burnt orange and plum, as well as, of course, black (**Figure 1.2**). I can fit my mirrorless camera, two or three lenses, a flash, and accessories inside. The Think Tank Retrospective series of bags come in a variety of sizes and are great to travel with because they don't scream "camera bag." I can squeeze a small folding tripod on top of those

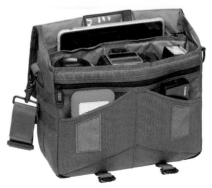

Figure 1.2 **The Tenba Messenger bag**

bags as well. Both of these bags are great when you are scouting locations and don't want to be bogged down with the weight of all your gear.

The Night Camera

The digital age has made night photography a lot easier. Gone are the days of writing copious notes and then weeks later matching them up with the images you got back from the lab. Digital makes you learn faster. You can review the shot instantly, decide what adjustments you need to make, and move on to the next shot. Long exposures eat up the battery life of digital cameras, though, so you'll want to bring one or two extra batteries on a night shoot.

Not every camera can be a great night-capturing machine. Point-and-shoot cameras take great snapshots during the day, but they can be very frustrating at night. Better image quality, longer exposures, and versatility can be found in DSLR (digital single-lens reflex) or mirrorless cameras. These cameras have bigger sensors and better in-camera processors, making for less noise (grain) and a smoother tonal range. They also offer a wide range of interchangeable lenses so that you can shoot with top-quality glass or specific focal lengths. DSLRs slightly outperform mirrorless cameras because their viewfinders are brighter in darker scenarios.

What's in My Travel Bag

- Fujifilm X Pro 1
- Second camera is either a film camera or a Fujifilm X E-1
- Zeiss 12mm 2.8 lens
- Fujifilm 14mm 2.8 lens
- Fujifilm 18mm 2.0 lens
- Zeiss 32mm 1.8 lens
- Fujifilm 55–200mm 3.5–4.8 zoom lens
- Metabones Speedbooster adapter for Nikon and Contarex lenses
- 16GB or 32GB Lexar high-speed SD cards

- Think Tank Cable Management 20 and 30 bags filled with extra batteries, cable releases, flashlights, quick release plates, and other accessories
- Nikon SB 910 with gels
- One or two tripods
- ND filters
- Black card
- Sensor-cleaning brushes and swabs
- Portable hard drive
- Mac laptop
- Microfiber cloth

My favorite night cameras are the Fujifilm X Pro 1 and X-E1 (**Figure 1.3**). The image quality is outstanding, and unlike any other camera on the market, they can capture hour-long exposures without the need for stacking or long exposure noise reduction (more on that later). The X Pro has a hybrid optical/electronic viewfinder, which makes for easier viewing in dim light. The X-E1 is electronic only but adds a mini-connection that allows you to create time-lapse images.

Figure 1.3
Two of my favorite night cameras: the Mamiya C220 (left), which takes 12 large square exposures on a roll of 120 film, and the Fuji XE-1 (right), which is breaking new ground in the world of digital long exposures. Either will put you into a different mindset and inspire you to be more creative.

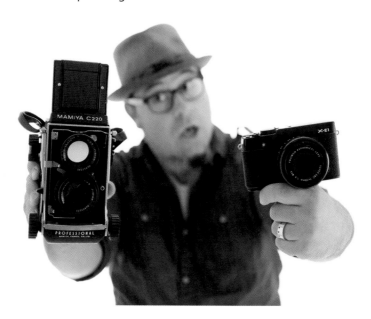

The megapixels (MP) race isn't as fierce as it used to be. Most manufactures have focused on bigger sensors and better processors to help cleanly move all the information from capture to card. Most cameras since 2012 have at least 16 MP. The more pixels a sensor has, the more detail it can capture. The more detail you have, the bigger your print can be.

Digital cameras come in a variety of sensor sizes (**Figure 1.4**). Full-frame is the equivalent of 35mm film size; the APS-C, Micro 4/3, and 1-inch sensors are smaller. Typically, a full-frame sensor will outperform a smaller sensor, allowing for cleaner, higher ISOs and a better tonal range. But the difference in performance isn't as great now, because camera processors keep getting better. The only sensors I would shy away from are those that are 1 inch or smaller, as their image quality caps out at ISO 800.

If you have a DSLR camera from the last two or three years or a mirrorless camera from the last one or two years, chances are you're in good shape to get snapping.

Figure 1.4 **This graph shows the difference between digital camera sensor sizes. Clean ISOs of up to 3200 can be achieved with the larger sensors.**

Medium format 6 x 6 Film 56mm x 56mm

35mm/full-frame 36mm x 24mm

APS-C Nikon, Sony, Fujifilm 23.6mm x 15.7mm

APS-C Canon 22.2mm x14.8mm

Four-thirds system 17.3mm x 13mm

1" Nikon CX/Sony RX 13.2mm x 8.8mm

1.23" point-and-shoot 6.17mm x 4.55mm

The most important features in a "night" camera are the following:

- The ability to shoot RAW files

- Manual exposure mode

- Bulb (B) setting for long exposures

- The ability to use a remote shutter release

Film Cameras

Film is still a valid format for night photography. Although film doesn't offer the instant feedback that digital does, it also doesn't suffer from digital noise in longer exposures. Dramatic circular star trails are very easy to achieve with a single 1-hour exposure on a film camera (**Figure 1.5**). To get the same effect with a digital camera, you'll need to take multiple shots and stack them in post (something we will go over in a later chapter).

The used market is a great place to find incredible deals on film cameras. Look for one that doesn't use batteries, or one in which the battery is used to power only the meter (not the shutter). Medium-format cameras are preferred because you get 12 to 16 very large negatives per roll of film. My medium-format film cameras of choice are the Mamiya C220 (no batteries) and the Mamiya 7 II (battery dependent, but it is long lasting). Hasselblads are excellent night cameras and much more affordable now than they were 10 years ago. The budget-friendly Holga or Diana plastic toy cameras are surprisingly fun night cameras. They have their quirks, but offer a soft and ethereal look for under $50.

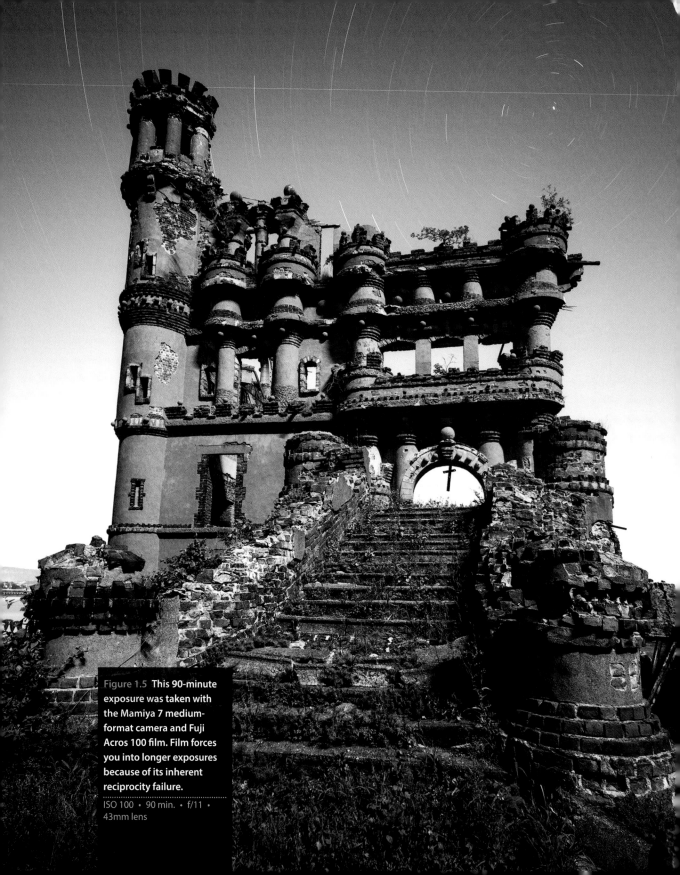

Figure 1.5 This 90-minute exposure was taken with the Mamiya 7 medium-format camera and Fuji Acros 100 film. Film forces you into longer exposures because of its inherent reciprocity failure.

ISO 100 • 90 min. • f/11 • 43mm lens

Because night photography is more slowly paced, I prefer to shoot with two setups to stay productive. I assess the scene with my digital camera and then shoot with both film and digital. The digital captures tend to be from 6 seconds to 6 minutes, whereas the film captures are from 6 minutes to 2 hours. That way, when I come home from a shoot, I have a more varied selection of images to work on.

As for the film I use, I love the black and white Fujifilm Acros 100. The grain is incredibly smooth, and the image quality is outstanding. Color films tend to have drastic color shifts at longer exposures, but a tungsten film like Fujifilm 64T offers a cool blue color cast under the moonlight. The Fujifilm Provia series is more readily available than the 64T and has a warmer color balance.

Film and Reciprocity Failure

A digital sensor's ISO can be adjusted from 50 to 25,600, but the ISO of film is less pliable. Film is optimized for the ISO it is rated for and can suffer from reciprocity failure if the exposure is too long. The longer the exposure, the less sensitive the film's silver halide grain becomes to light. This breakdown can start as soon as 1 second and accelerates as the exposure gets longer. No two films are the same. Fuji Acros does not suffer from reciprocity failure until 2 minutes, whereas on Kodak Tri-X 400 you would need to push a 2-minute exposure to 16 minutes to compensate for the lack of sensitivity (**Figure 1.6**). If you have a favorite film, search for the technical data sheet on the film company's website. It will be listed under "reciprocity characteristics" or "exposure adjustments for long exposures."

Reciprocity Failure Compensation Chart		
Suggested Exposure	**Fuji Acros 100 film**	**Kodak TriX film**
1 sec	1 sec	1.5 sec
2 sec	2 sec	4 sec
4 sec	4 sec	10 sec
8 sec	8 sec	30 sec
15 sec	15 sec	1 min 30 sec
30 sec	30 sec	4 min
1 min	1 min	8 min
2 min	2 min	16 min
4 min	6 min	35 min
8 min	12 min	1 hour 30 min
15 min	30 min	3hr 30 min
30 min	1 hour 30 sec	not recommended

Figure 1.6
A comparison of reciprocity compensation for two of my favorite films, Fuji Acros 100 and Kodak Tri-X 400. The Fuji is a fine-grained film that allows short exposures in dimly lit scenes but lets you extend exposures in dark, moonlit scenes.

You will also need to adjust how you develop your film. If you have consistently compensated for reciprocity failure, underdevelop the roll by at least 10 percent when you process it. Because we are "overexposing" the film to get the correctly adjusted long exposure, the underdeveloping will help prevent the highlights from blowing out. Take a lot of notes when you're shooting film so you can fine-tune these reciprocity recipes.

The bright side to reciprocity failure is that it forces you to take longer exposures. Film is still regarded as an excellent way to capture continuous star trail shots—sometimes the exposure is only limited by the sun starting to rise!

Lenses

Your lens is your eye on the world—do you see it in grand vistas, or are you more detail-oriented? Most of us own a zoom lens. Are you happy with it? If you are always backing up, you need a wider focal length (**Figure 1.7**). If you feel like you are never close enough to the action, then a telephoto lens would be a good investment. Zoom lenses have a variable, not fixed, focal length. An 18mm–135mm lens can zoom from a wide 18mm to a telephoto 135mm. Pay attention to what focal length you frequently shoot. For example, if you find that you often shoot at 50mm, get a 50mm fixed focal length lens. An easy way to figure out your favorite focal lengths is to look at your photos' metadata in a program like Adobe Photoshop Lightroom (**Figure 1.8**). Also, consider renting lenses before investing in them, to see if they match your vision.

Figure 1.7
Invest in good glass. I use the word invest because quality lenses will last you for more than ten years. High-end lenses are often called "fast" because they let in a lot of light in low-light situations. Their minimum apertures are from f/.095 to f/2.8.

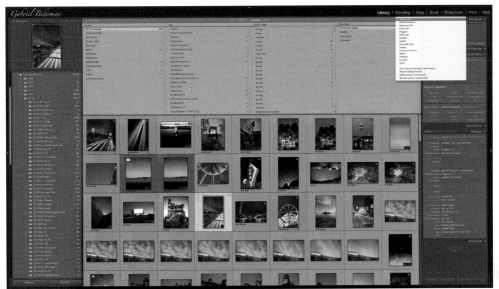

Figure 1.8
Finding your metadata in Lightroom is simple. In Library Grid mode, you can filter through your Exposure Info. This will show your focal length, ISO, aperture, and shutter speed for each selected image.

Make sure your lens has a lens shade; not all lenses come with one. The lens shade attaches to the front of your lens and helps block out extraneous light. Each lens will have a dedicated shade, so pack accordingly. People often forget to bring their lens shades for shooting at night, but remember that streetlights and the moon are big culprits for causing flare in your images.

A lot of lenses come with some sort of stabilization mode (**Figure 1.9**). When it is turned on, it searches for camera shake and reduces it with counteractive vibrations. This is very helpful when you're handholding your camera, but you should turn this stabilization off if your camera is mounted on a tripod. If you don't, you risk the chance of burning out the motor because the lens will continue to "search for vibration" when there is none.

Figure 1.9
If a lens has a stabilization mode, it will have a dial that you can switch from On to Off.

I tend to shoot wide to super-wide at night—it makes it easier to include more sky and adds drama to the image (**Figure 1.10**). My preferred focal lengths are 18mm, 21mm, and 24mm. I also bring a 50mm for detail shots, but I rarely go more telephoto than that.

Figure 1.10
The same shot at focal lengths from 18mm–300mm. Wider lenses are great for showing the whole scene, and telephotos are useful for zooming in for detail shots.

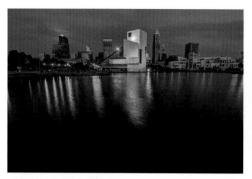

18mm

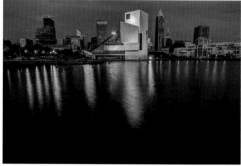

21mm

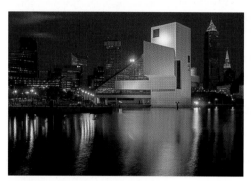

35mm

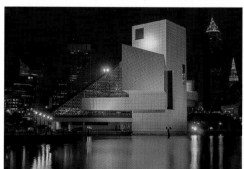

50mm

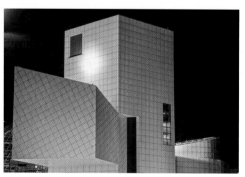

105mm

300mm

Tripods

The foundation for creating a steady shot is a tripod (**Figure 1.11**). A solid tripod will take your night photography to the next level, and as with good lenses, you get what you pay for. There are two types of tripods on the market: aluminum and carbon fiber. Manfrotto's aluminum tripods are rock steady but weigh in at 4.6 pounds. Gitzo's carbon fiber tripods are silky smooth and will last through many years of heavy use, but they can be pricey.

Over the last few years there's been an influx of "traveler," or folding tripods (**Figure 1.12**). I'm a big fan of these tripods because they are lightweight and fold down to 12 to 16 inches yet get as high as 57 inches without the center column extended.

When you're using a tripod, always extend the legs first and use the center column only if you have to. A tripod's weakest point is the center column, so I extend it only in extreme situations.

These are the key factors when you're buying a tripod:

- **Cost.** Can you afford it?
- **Load capacity.** Will it hold your camera and lens?
- **Weight.** Is it light enough to lug around?
- **Maximum height with and without column extended.** Will you need to bend over? Or will it be too tall?
- **Minimum height.** How low can you go?
- **Folded length.** Will it fit in your suitcase or bag?

Figure 1.11 **Both of these tripods are carbon fiber; aluminum tripods can be too heavy to lug around at night. The Gitzo 2540 leveling tripod (left) makes it easy to operate on uneven surfaces. The MeFOTO RoadTrip tripod (right) is my compact yet sturdy traveling companion.**

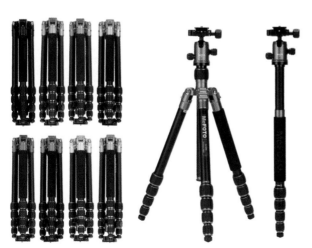

Figure 1.12 **MeFOTO has taken the industry by storm with their inexpensive and colorful travel tripods. They come in aluminum or carbon fiber and several sizes.**

Tripod Heads

Ballheads are the most popular way to connect your camera to your tripod. They are lightweight and give you unlimited angles so you can get the right shot. My all-time favorite ballhead is the smooth and durable Acratech GP-s (**Figure 1.13**), which weighs less than a pound but holds up to 25 pounds. I usually dismiss panheads because of their bulk, but Induro's PHQ1 (**Figure 1.14**) is a very precise five-way panhead.

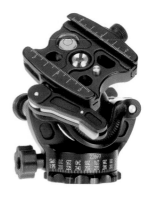

Figure 1.13 The Acratech GP-s ballhead has been a game changer for my night work.

The camera connects to your tripod's head with either a quick-release plate or an L bracket (**Figure 1.15**). I always pack an extra quick-release plate because they're easy to lose. Double-check that your quick release plate fits snugly into the tripod socket at the bottom of your camera. There should be no wiggle room. Quick releases tend to loosen over time, and the last thing you want is to have your camera fall off your tripod! A more secure way to connect your camera is with an L bracket, which is a form-fitting bracket that wraps around the bottom and side of your camera. It needs to connect to a head that is Arca-Swiss compatible, so check what type of plate your head takes before investing in an L bracket. An L bracket also helps keep your axis consistent when you switch between horizontal and vertical shots.

Keep these things in mind when you're buying a tripod head:

- **Cost.**

- **Load capacity.** The average DSLR with a 24–70mm 2.8 lens weighs four pounds.

- **Weight.** Will it weigh you down?

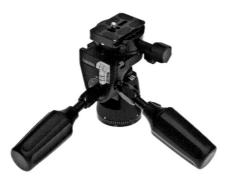

Figure 1.14 The Induro PHQ1 provides precision positioning for the ultimate in control and flexibility

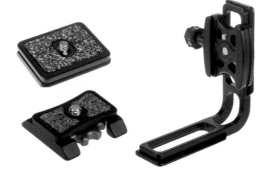

Figure 1.15 Quick-release plates (left) are less expensive, but an L bracket (right) offers the best connection between your camera and tripod.

Cable Releases

With your camera now rock-steady on the tripod, you don't want to accidentally jar the camera by pressing the shutter button. Instead, plug in a wired remote to trigger the shutter, thus eliminating any camera shake (**Figure 1.16**).

Vello makes wired remotes to fit almost every major camera. My main remote is the Vello ShutterBoss, which allows me to program interval shooting and long exposures. This type of remote is a must if you want to create time lapses and star-stacking shots. My backup is the simple Vello wired remote, which does not use batteries and is typically under $10. I'm not a fan of wireless remotes, since they go through batteries very quickly.

Flashes and Flashlights

Flashes and flashlights are essential tools for the night photographer. They will add a new dimension to your light-painting or reveal important detail in dark areas. Flashes, strobes, and LED lights (**Figure 1.17**) add light that freezes action or fills a scene with light. Invest (there's that word again) in a powerful flash that can recycle quickly. The Vivitar 285HV has been a workhorse for many night photographers. However, you will get faster recycle times with a flash that can also take a dedicated battery pack, such as the Bolt Compact Battery Pack. The Bolt will double the number of flashes you can pop off in a single long exposure.

Figure 1.16 From left to right, a simple manual screw-in cable release, the Vello ShutterBoss, and the Vello Wired Remote. Check what type of connection your camera has, and buy the appropriate remote.

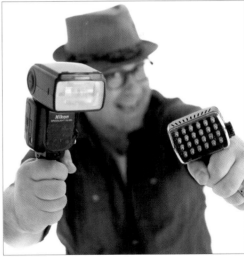

Figure 1.17 Flashes and continuous lights like LEDs will add pop to your night shots.

I've become addicted to flashlights! They come in different shapes and sizes and offer many different ranges of power (**Figure 1.18**). I typically roll with three on a shoot: a low-power light to help me find things in my bag, a 40-lumen incandescent as my main light, and a 100-lumen LED to paint things from over 50 yards away (**Figure 1.19**). The low-power flashlight is red, so it doesn't blow out my "night vision."

Figure 1.18 **Flashlights are the light-painting brush of the night photographer.**

Flashlight considerations:

- **Lumens.** The power, or brightness, of the light beam. The higher the number, the farther you can throw the beam of light.

- **Color temperature.** You'll find different types of bulbs in flashlights. The most common are LED and incandescent. I prefer the warmer light of incandescents to the typically blue light that most LEDs emit. More expensive LEDs will be daylight balanced or pure white, which makes it easy to add colored gels to them. If you're unsure what "color" your flashlight is, shine it on a white wall.

- **Focus.** Better flashlights let you twist the head to focus the beam. This can be a valuable feature when you're trying to do specific or elaborate light painting.

Light Modifiers

There are a ton of light modifiers in the market right now. The most important ones I use are snoots, grids, and gels. A snoot goes over your light source to create a tunnel of light. The longer the snoot, the tighter the beam of light will be when it comes out the other end. I like the large Rogue FlashBender (**Figure 1.20**) because it folds flat and can also be used as a bounce light. Grids will help you get an even tighter beam of light than a snoot. Imagine a night portrait of someone's head surrounded by darkness. How do you get the light to fall on the head and not the rest of the scene? Use a grid!

Gels (**Figure 1.21**) can introduce a new color, or blend similar colors into a scene. I always have about 20 gels in my bag. I like the Honl or Rogue gel packs because they offer a wide variety of colors, allowing me to handle almost any sort of scene.

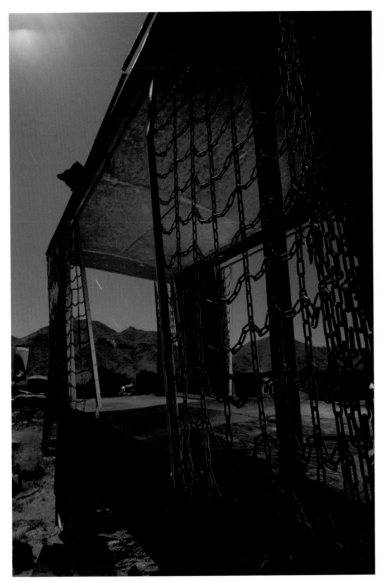

Figure 1.19 This light painting took several test shots to figure out. There were seven pops of a red-gelled full-power flash inside the chained vehicle. I used a snooted 40-lumen flashlight to open up the black tire and shadows underneath it.

ISO 200 • 8 min. • f/8 • 20mm lens

Figure 1.20 The Rogue FlashBender (left) can be used to create a tight beam of light for your flash or flashlight. The Rogue Grid (right) makes an even tighter beam, so you can really focus the light in your scene

Figure 1.21 Use a gel over a flash or flashlight to add a decisive mood or atmosphere to your image.

Snoots can be used on flashlights as well as flashes. For the image called "Auto-moonscape" (**Figure 1.22**), I put a red-gelled flashlight inside an 8-inch snoot so the light would only fall on the small circle.

Figure 1.22
I used a snoot around my flashlight to prevent the red light from spilling onto the moonscape.

ISO 200 · 8 min. · f/11 · 20mm lens

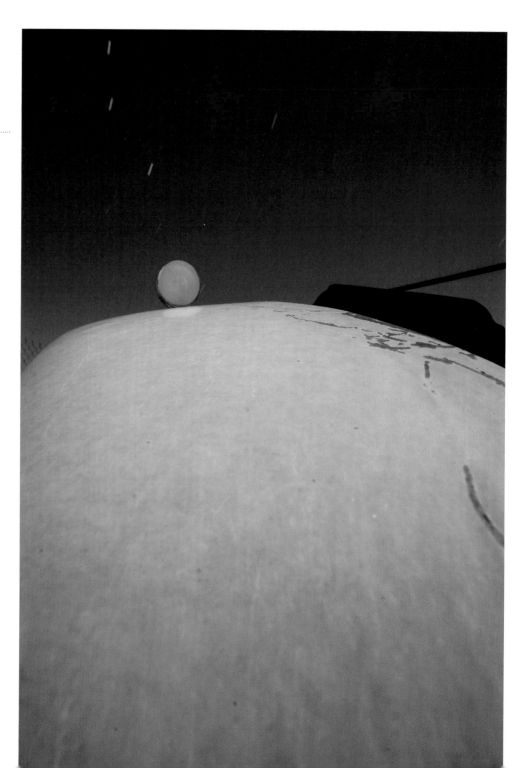

Nocturnal Accessories

I have a Think Tank Cable Management bag that keeps my batteries, quick releases, and knick-knacks organized. A couple of key accessories that I grab out of the bag are bubble levels (**Figure 1.23**) and variable ND filters (**Figure 1.24**).

Figure 1.23 **A bubble level is an inexpensive tool that fits into the hot shoe of the camera. It will help you precisely align your camera so the horizon line is not off kilter.**

Figure 1.24 **Variable ND filters can extend your exposure by two to eight stops. As you rotate the filter, it becomes darker or lighter. The darker it is, the longer your exposure will be.**

Bubble levels help you align your camera, which is especially helpful when you're setting up on uneven ground. You can always align and crop in post, but that could mean cropping out valuable information. A lot of cameras have a built-in level that's easy to see on your screen, but I've found that they're not as accurate as a physical bubble level.

Variable ND filters are popular for landscapes and daylight long exposures. I'd never thought of using one at night until one of my students used one to capture trails of cars streaming down the Las Vegas strip. The rest of us were averaging 6- to 15-second exposures, while he was getting amazing 1- to 4-minute shots (**Figure 1.25**).

Figure 1.25
I put a 10-stop ND filter over my lens, which turned a 1/30 of a second exposure into a 30-second exposure. This helped create much longer trails.

ISO 200 · 30 sec. · f/11 · 28mm lens

As a glasses wearer, I'm never without a lens cloth. They can be invaluable when shooting in dusty or wet conditions. Lenses tend to fog up in humid conditions, and you'll want to keep them clean so you can keep on clicking.

In almost all my bags, I have a thick 8x10-inch black and white card. They can be found at any arts and crafts store. I use the black side to block flare from hitting the lens, and the white side makes a perfect soft fill light when I shine a flashlight on it.

Night photographers used to take a lot of notes when shooting film. In this digital age, a lot of the shooting data is written onto the image, so the smartphone is the new notebook. Not only can we jot down notes about how we created the image, but there are plenty of apps that can tell us when the sun will set, when the moon will rise, and where the stars will be (**Figure 1.26**). Plus, you can keep

Figure 1.26 The accessory that almost everyone has! Apps can help you do everything from calculate exposures to figure out where the moon and stars will be. Here are a few of my faves.

up with your Facebook pals once you've committed to that hour-long exposure! I recommend that you set your phone's brightness lower than normal so your eyes can easily adjust between the phone and the darkness.

Systems and Styles

I bought a lot of gear before I finally found a camera "system" that I'm excited to use and that is an extension of my eye. There is a fine line between being a gear addict and being someone who purchases the right tools to get the job done.

When you get a new piece of gear, live with it for a month and ask yourself whether it fits in your toolbox. You should be very familiar with everything that is in your bag—the more comfortable you are with your equipment during the day, the less you'll fumble around at night.

The day before a photo shoot, I charge all my batteries, check all my equipment off my list as I pack it up, and ensure that it is clean and in tip-top shape. Nothing is more frustrating than going on a shoot and finding that something essential is missing or not working.

The night inspires many different styles of photography. Do you know yours, or are you still exploring? Even if you are comfortable with your photography, it's important to challenge it with new tools or a different experience. Let's take a look at several styles and systems that might inspire you to take better shots between dusk and dawn.

The Scout

The scout needs to be stealthy and not look like a photographer. A point-and-shoot or small mirrorless camera is perfect for helping you either blend in or not look so suspicious. Scouting is essential to any style of photography. The better you know your subject, the more successfully you will capture it. Nothing beats physically assessing a location. For example, you could research whether a location is actually open after sunset. Safety and security are key factors to the night experience. Bring a friend along if you are scouting a suspect location.

If you bring a tripod, it should be a compact one that does not draw attention to you. Without a tripod on a scouting mission, you're freer to move about and practice different compositions. Remember that the goal is to assess the scene and see if it is safe and, of course, photogenic. The scout searches for compelling compositions and judges where troublesome light or shadows might fall. Shoot with a zoom lens to figure out the scene's ideal focal length and know which gear to pack for the real shoot (**Figure 1.27**).

Figure 1.27 I scouted this location with a friend before taking this shot. Because we didn't know the legality of shooting there (I didn't see a No Trespassing sign), we wanted to be quick. The light was bright, constant, and easy to meter, so we were able to bang it out in 15 minutes.

ISO 160 · 1/15 sec. · f/5.6 · 80mm lens

The Urban Explorer

The urban explorer is a scout with more powerful equipment. Their light-painting skills are usually a grade or two above the common night photographer. Urban explorers commonly find themselves in very cool and very illegal buildings or places. They honed their ninja skills by navigating around old floors, rebar, and general danger. They wear black clothing, boots, and gloves, and they carry flashlights and camping/survival supplies. Nondescript backpacks are the bag of choice—something comfortable to climb and run with. A durable dustproof or water-resistant DSLR is best, but the Olympus OM-D series of mirrorless cameras are tough and would also fit the bill. The tripod is the pride of the urban explorer's kit, like a knight's sword. Gitzo and Really Right Stuff tripods and heads are the most common gear being whispered about in the shadows of desolate locations. So if this excites you and you find that the night heightens your fascination with abandoned buildings and places, it might be time to do a little exploring! But please be safe. If you're new to this, team up with an experienced urban explorer (**Figure 1.28**). Try to find a contact of the location before you cross the line. The issue of trespassing can sometimes be rectified if you establish a relationship with the property owner and get permission. There are also plenty of night photography workshops at cool locations like junkyards, ghost towns, graveyards, and historic places.

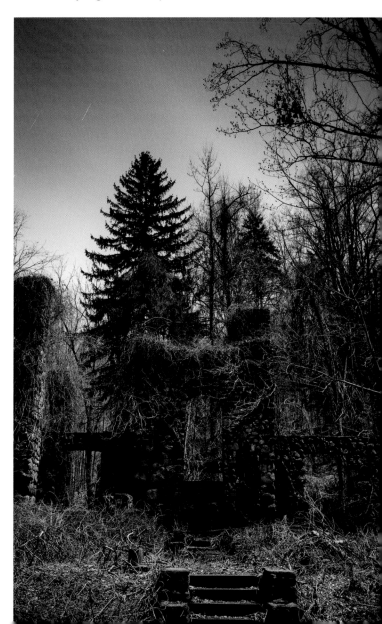

Figure 1.28
NothGate is a popular area for hikes during the day, but under a full moon it becomes a surreal-scape.

ISO 200 · 20 min. · f/16 · 35mm lens

The Traveler

Everyone wants to come home with that one shot that epitomizes their vacation. The traveler outsmarts the tourists by bringing higher-end gear and key accessories. Not everyone wants to bring a tripod on vacation, but a folding tripod will easily fit in your suitcase or tote bag. Leave the point-and-shoot cameras at home and pack your DSLR or mirrorless camera, which will

give you better image quality. An 18–200mm or 28–300mm lens is a perfect companion to your camera and will ensure that you get a variety of shots. But that shouldn't be the only lens you bring. A super-wide for grand vistas and a fast prime (like a 50mm 1.4) won't weigh you down, and they'll make sure that you keep shooting when the sun goes down. The experienced traveler makes sure that a variable ND or 10-stop ND filter is always in the go bag, ensuring that you get creative long exposures during the day and longer car trails at night. Be a smart traveler and search online for images of the place you'll be visiting. When you land, check out postcard racks to get an idea of the popular sights and angles. Travelers sniff out each new location like a detective searches for clues, and they don't leave a stone unturned until they find *the* shot. The traveler doesn't sleep much; they scout and shoot during the day and then settle in on the best locations at night. The night is perfect for the traveler because most of the tourists pack up their bags at sunset, and the traveler keeps on clicking (**Figure 1.29**).

The Stargazer

The wow factor of capturing long star trails or the Milky Way gets almost everyone excited about night photography. The stargazer is a patient and committed shooter. They will often spend an hour creating a single shot. They know their system inside and out and are comfortable with all the buttons and dials. The stargazer's system is rock solid, from the spikes on the tripod to the L bracket around the camera. Their dream setup would include at least one fast and wide Zeiss manual focus lens, like the 15mm or 21mm, as well as a versatile, customizable tripod, like one from Gitzo's Systematic series. They will have a couple of cable releases, flashlights, and plenty of extra batteries in their bag. Stargazers plan their shoots months ahead of time and pay close attention to where the moon and stars will be (**Figure 1.30**). They avoid the city lights and take road trips to rural locations with like-minded star catchers. When was the last time you just sat under the stars and thought? It can be a Zen-like experience, and I recommend that everyone try it at least once.

Final Thoughts

There are many different styles of night photography; don't pigeonhole yourself into just one. Experiment and have fun. Even if you don't plan to become a night photographer, understanding what you can do with time will make you a more versatile photographer. Team up with a friend and explore the beauty that can be found in exposures that take seconds, minutes, or even hours.

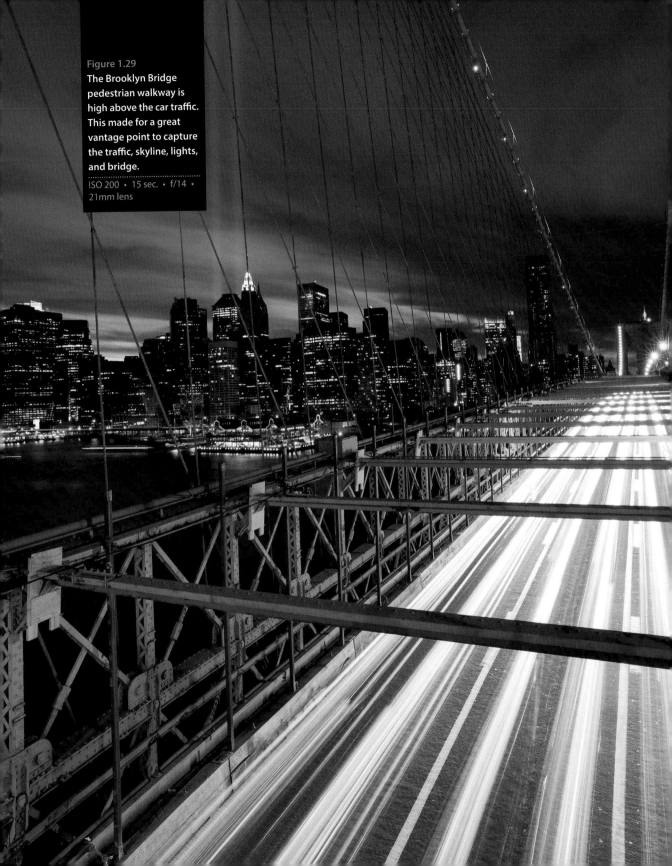

Figure 1.29
The Brooklyn Bridge pedestrian walkway is high above the car traffic. This made for a great vantage point to capture the traffic, skyline, lights, and bridge.

ISO 200 • 15 sec. • f/14 • 21mm lens

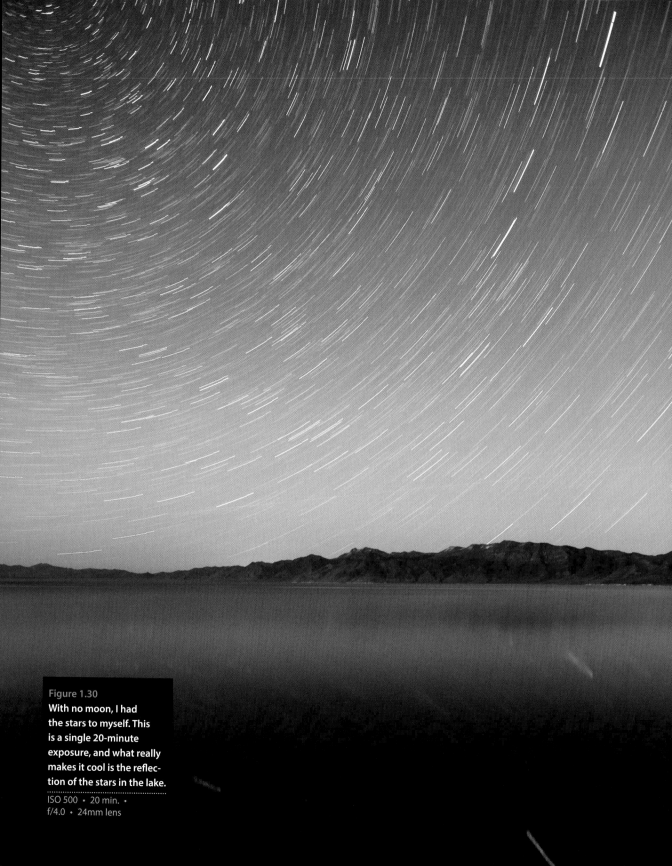

Figure 1.30
With no moon, I had the stars to myself. This is a single 20-minute exposure, and what really makes it cool is the reflection of the stars in the lake.

ISO 500 · 20 min. · f/4.0 · 24mm lens

Chapter 1 Assignments

Create a checklist

Lists help us organize. Create one for the gear you own, and include serial numbers for insurance purposes. Have a checklist for what you pack for a photo shoot; that way, you won't leave essential gear behind. Most importantly, use a notebook or a smartphone to store a list of photographic ideas, places you want to photograph, or images that inspire you.

Assess and test your gear

Does your camera have Bulb (B) mode? Do you have a sturdy tripod and head? Do you own extra batteries and a cable release? Keep your gear clean and organized, and be familiar with it before you take it out for a night shoot.

Find your focal length

Image editing software like Lightroom can look at all your pictures and organize them by focal length. Pay attention to this information, and get a prime lens for your most commonly used focal length.

Share your results with the book's Flickr group!
Join the group here: www.flickr.com/groups/night_fromsnapshotstogreatshots

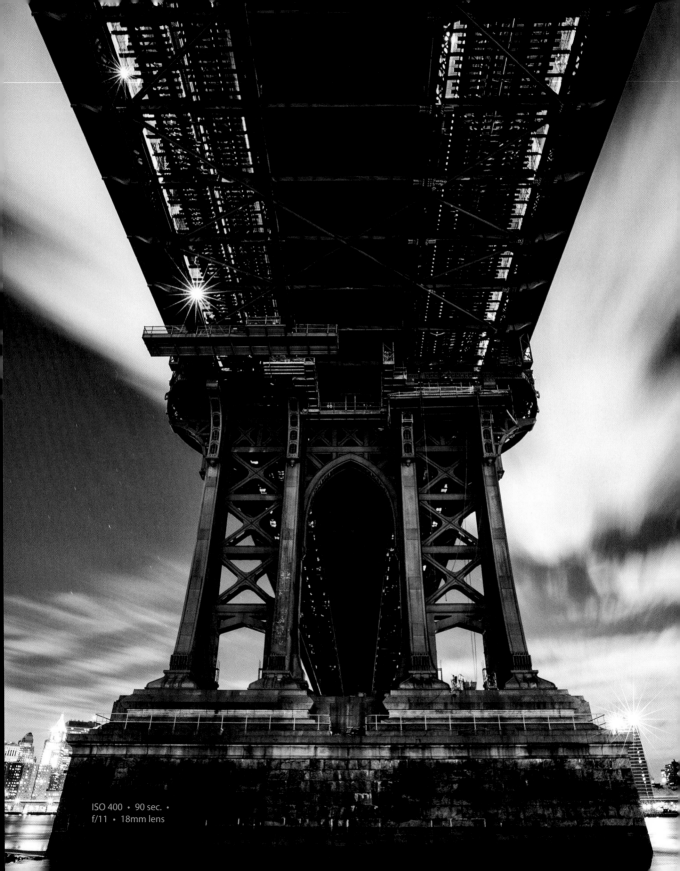

ISO 400 • 90 sec. •
f/11 • 18mm lens

2
Exposure

Understanding the Night Light

Photography is all about light, and cameras are our light-capturing machines. When a camera clicks, its sensor is exposed to light. Sometimes the image can be too light, sometimes too dark. Determining the proper exposure is the key to becoming a good photographer.

In this chapter we will take an in-depth look at the three governing factors of exposure: ISO, aperture, and shutter speed. I'll also go over Manual mode, and I'll share some tips on how to quickly and easily figure out the best exposure for night photography.

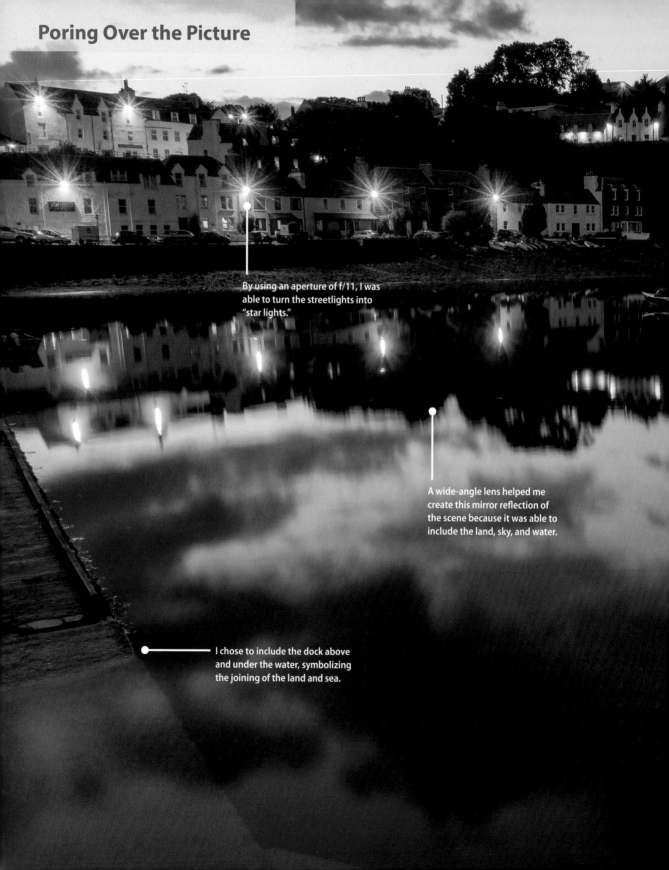

Poring Over the Picture

By using an aperture of f/11, I was able to turn the streetlights into "star lights."

A wide-angle lens helped me create this mirror reflection of the scene because it was able to include the land, sky, and water.

I chose to include the dock above and under the water, symbolizing the joining of the land and sea.

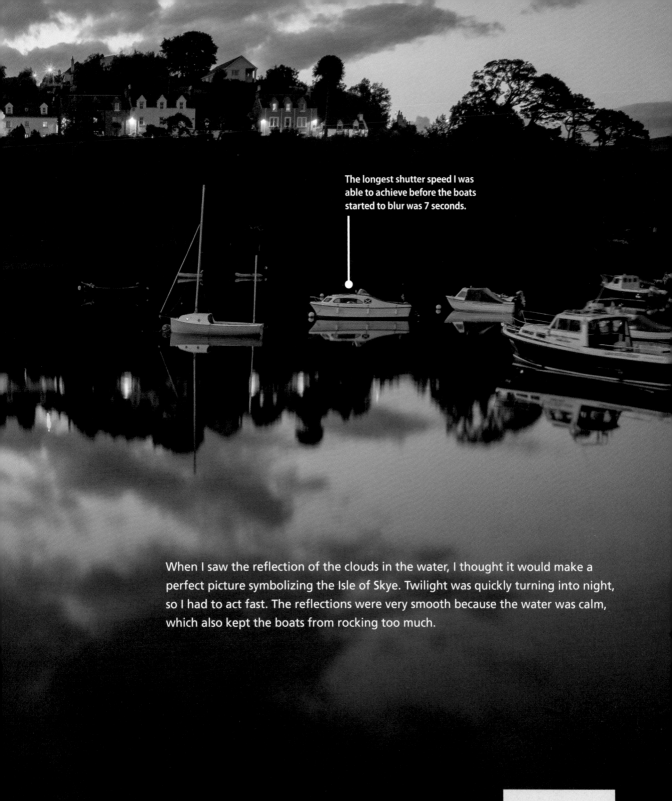

The longest shutter speed I was able to achieve before the boats started to blur was 7 seconds.

When I saw the reflection of the clouds in the water, I thought it would make a perfect picture symbolizing the Isle of Skye. Twilight was quickly turning into night, so I had to act fast. The reflections were very smooth because the water was calm, which also kept the boats from rocking too much.

ISO 200 · 7 sec. · f/11 · 28mm lens

Understanding Exposure

Capturing light with a camera is as simple as filling a cup with water. Too much water in the cup and it spills (overexposed); too little water and I'm still thirsty (underexposed).

Most of the world snaps pictures in one of the automatic modes. But you're committed to taking better night photographs, so pick up your camera and set it to Manual (M) mode. In Manual mode, you, not the camera, make the decisions.

The camera's meter is the computer that assesses the three factors that go into exposure: ISO, aperture, and shutter speed. Let's look at each one.

ISO

ISO is a measure of the camera sensor's sensitivity to light. Think of the sensor as the base, like a piece of paper that we are painting light onto. Do you want a thick piece of water-color paper that requires a lot of paint to absorb, or a simple sheet of sketching paper that requires just a little bit of paint?

The lower the ISO, the less sensitive the sensor is to light; the higher the ISO, the more sensitive the sensor is to light. The lower ISOs typically yield a richer color that has very little grain, or *noise*. Though higher ISOs tend to be noisier, they allow us to take pictures in places where there is little or no light.

Figure 2.1 is a series of shots I took as an ISO test. None of the images have had noise reduction applied. Look at how smooth the tonal range is at ISO 200, 400, and 800. The image starts to get a little noisy at 1600 and 3200, but that can easily be smoothed out in a post-production program like Lightroom. 6400 is really the breaking point for most pro cameras these days.

Grainy photographs have a certain aesthetic. Back in the days of film, it was common to use 3200 or 6400 ISO film to get a gritty look when shooting in bars and clubs. If you shoot at an ISO over 3200 and want your photos to look clean, you will need to be aggressive in post, which generally softens the image.

Newer cameras can achieve cleaner and higher ISOs, but every camera is different. Test your camera to figure out how high your ISO can get without sacrificing image quality.

For optimal image quality I use the lowest ISO number—not the Low ISO setting.

ISO 200

ISO 400

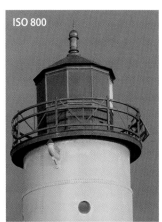
ISO 800

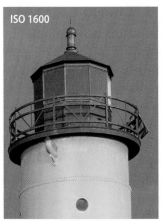
ISO 1600

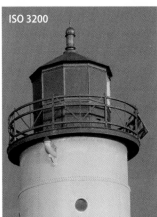
ISO 3200

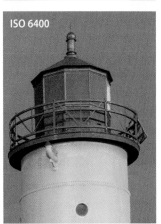
ISO 6400

Figure 2.1
This test was taken with the Fujifilm X-Pro 1, which has one of the cleanest sensors on the market.

Aperture

The aperture is the opening in the lens that lets light pass through to the sensor. Aperture controls the depth, or lack thereof, in your image. If you have ever seen a James Bond film, you know exactly what an aperture looks like—it is that circle that Bond steps into at the beginning of each film before firing his gun at the audience.

The aperture numbers, or *f-stops*, look weird because they are fractions, but just remember that the smaller the number, the bigger the aperture—and the less depth of field you will have (**Figure 2.2**).

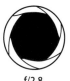
f/2.8

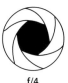
f/4

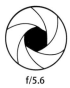
f/5.6

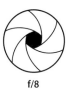
f/8

f/11

f/16

Figure 2.2
A typical aperture range.

Why is depth of field important? Because it's one of the main tools you can use to direct how people look at your image. Do you want to show them everything, or just a small slice of the scene? A good storyteller chooses what to reveal or hide in an image.

In **Figure 2.3**, I "opened up" my aperture as wide as it would go: f/1.4. This created a sliver of focus, isolating the broken pier from the background. The bridge and city are out of focus, but in a very pleasing and dreamlike way. You get a sense of the city, but not the details.

In **Figure 2.4**, I "closed down" to a smaller aperture of f/11. This gave me depth throughout the image, but I feel it reveals too much information. With everything in focus, the pier competes with the bridge and background for attention.

Figure 2.3 (left)
Using a large aperture, like f/1.4, creates very little depth of field past the broken pier.

ISO 200 • 1 sec. • f/1.4 • 50mm lens

Figure 2.4 (right)
Using a smaller aperture, like f/11, creates much more depth of field, and everything in the scene is in focus.

ISO 200 • 30 sec. • f/11 • 50mm lens

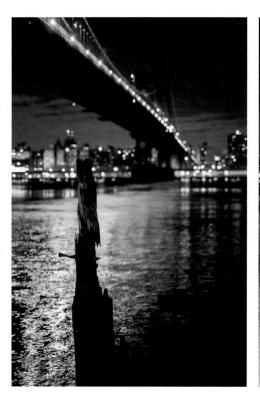 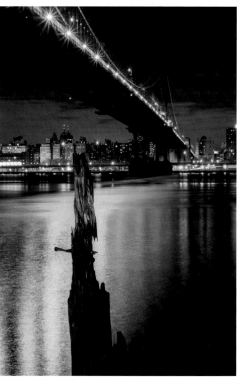

Lenses and Focal Length

Wide-angle lenses inherently have more depth of field than telephoto lenses, which significantly compress depth. So an aperture of f/4 looks much different on a 24mm lens than it does on a 70–200mm lens. Test the apertures on each lens so you can better understand the characteristics of each focal length.

Shutter Speed

Shutter speed is the length of time that light is allowed to come through the aperture and paint a picture onto the sensor. If there is a lot of light falling on the scene, you would typically use a fast shutter speed. If the scene is dark, you would use a slower shutter speed to allow as much light as possible onto the sensor.

Shutter speeds are measured in fractions of a second. Fast shutter speeds start at 1/250 of a second and go as high as 1/8000 of a second. Fast shutter speeds freeze moving objects such as people running or cars driving. The slowest shutter speed at which we can typically hand-hold a camera is 1/60 of a second. Once we go below 1/60, we need to stabilize the camera on a tripod and use a remote release to trigger the shutter.

Night photographers live in the shutter speeds below 1/60, and that is where the fun starts! Look at the two shots of the fountain (**Figures 2.5** and **2.6**). When I set my camera to an automatic mode, it froze the motion of the water with a higher shutter speed. But if there is motion in the scene, I often accentuate it with a slower shutter speed, as in Figure 2.6.

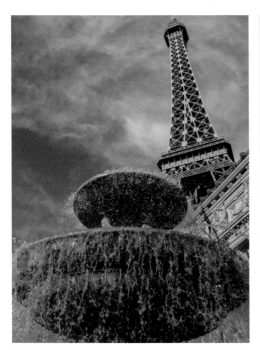
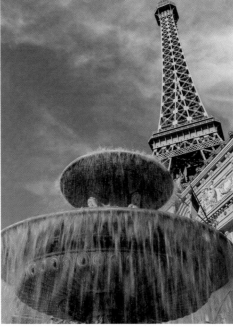

Figure 2.5 (left)
I let the camera do the thinking on this bright sunny day, and it gave me an exposure that froze the action.

ISO 80 · 1/200 sec. · f/5.6 · 28mm lens

Figure 2.6 (right)
I switched to Manual mode and dropped my shutter down to 1/15 of a second. The slower shutter speed emphasizes the movement of the water in a striking way.

ISO 80 · 1/15 sec. · f/22 · 28mm lens

Best Shutter Speed for Scene

Don't always go for the longest possible shutter speed. Assess the scene to see what exposure best suits the image.

Mastering Manual Mode

Cameras are computers, and they do a very good job of measuring the data that is given to them. But a camera can't *see* the scene like you can. If you want to take your photography to the next level, then you need to be in charge of the camera rather than let it be in charge of you. Automated modes such as Night Scene, which are available in many cameras, let the camera choose the right exposure for you. Night Scene mode usually raises the ISO, opens the aperture as wide as possible, and adjusts the shutter speed accordingly. This gives you a decent exposure, but it often sacrifices image quality.

The M setting in your camera stands for Manual mode, but I like to call it Master mode. Once you master Manual mode, you will be creating images, not taking them.

Shoot in Raw

The first step in mastering Manual mode is to shoot in Raw. JPEGs might be fine for snapshots, but if you are committed to getting the best quality out of your night photograph, you need to shoot Raw.

A Raw file is an unprocessed file that is significantly larger than a JPEG file. Night photographers tend to do a lot with their files in post—adjusting white balance, blending exposures, and so on. Having these larger files means you will have more control over detail and color, and your images will have a wider dynamic range. Yes, you will need to process each file, but you will be able to take control and master the shot rather than allowing your camera to make the decisions for you.

Monitor the Meter

In Manual mode, you need to pay close attention to your in-camera meter, which measures the exposure in the scene. The aperture, shutter speed, and ISO give information to the meter, which then tells us if the photo is underexposed, overexposed, or just right. Generally, the hash mark (**Figure 2.7**) should be right around the 0 mark. If it is below the 0, then the picture is underexposed; if it's above the 0, it is overexposed. By raising or lowering the aperture, shutter speed, or ISO, we adjust our overall exposure and get the hash mark closer to the 0.

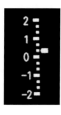

Figure 2.7 **This is what a typical meter looks like in Manual mode. You will find it in your viewfinder or LCD screen. Note that the hash mark is one click above 0. I like to keep it at 0 or one click above or below.**

Stop

You will often hear people say "Open up your aperture by half a stop" or "stop down your ISO by a full stop." This is an easy way to communicate that we want to let more or less light onto the sensor. Apertures, ISOs, and shutter speeds are all measured in numerical values. **Figure 2.8** lists the common full-stop increments for each. The math for full-stop adjustments is easy: you either double (add a full stop) or halve (subtract a full stop) the number.

Full Stops		
ISO	**Aperture**	**Shutter Speed**
Low = Less Grain/Sensitive	Large/Wide = Less Depth of Field	Slower/Longer = Motion Blurred
–	–	1 sec.
–	–	1/2 sec.
–	f/1.0	1/4 sec.
50	f/1.4	1/8 sec.
100	f/2.0	1/15 sec.
200	f/2.8	1/30 sec.
400	f/4.0	1/60 sec.
800	f/5.6	1/125 sec.
1600	f/8	1/250 sec.
3200	f/11	1/500 sec.
6400	f/16	1/1000 sec.
12,800	f/22	1/2000 sec.
–	f/32	1/4000 sec.
–	–	1/8000 sec.
High = More Grain/Sensitivity	Small = More Depth of Field	Faster/Shorter = Motion Frozen

Figure 2.8
If you double your ISO from 200 to 400, you have added one stop of light. If you stop down your shutter speed from 1/500 to 1/125, you have taken away two stops of light.

Most cameras are set by default to go in 1/3-stop increments—so three clicks equals a one-stop adjustment. I'm a big fan of full-stop adjustments. In night photography, you rarely need to make adjustments of 1/3 of a stop. You can easily set your camera to full-stop increments in the custom functions of your camera menu.

The Exposure Triangle

Various combinations of apertures, shutter speeds, and ISOs can yield the same exposure. Just because your meter tells you that 1/500 of a sec. at f/4 and ISO 400 is the correct exposure doesn't mean you have to accept it. What if you want less depth of field? You could open up your aperture one stop to f/2.8. You are now one stop overexposed, but to fix that you can close down your shutter speed by one stop, giving you a *reciprocal exposure* of 1/1000 of a sec. at f/2.8 and ISO 400. The exposures in **Figure 2.9** are reciprocal, or equivalent. Note that as we make the aperture smaller, the shutter speed becomes longer.

Figure 2.9
Reciprocal exposures: Each of these combinations of aperture and shutter speed will give you the same exposure. As the aperture decreases by one stop, we add one stop to the shutter speed.

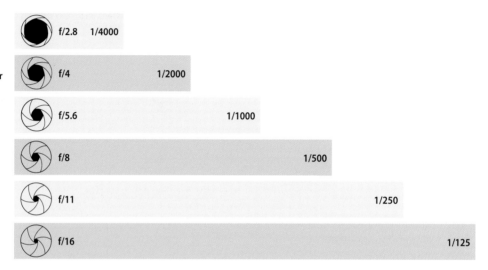

f/2.8 1/4000

f/4 1/2000

f/5.6 1/1000

f/8 1/500

f/11 1/250

f/16 1/125

The relationship between aperture, shutter speed, and ISO forms the exposure triangle (**Figure 2.10**). Once the baseline exposure is assessed, we can take creative control and make adjustments to movement, depth, or grain in the image. But remember that if you take away light with one value, you need to add light to one of the others.

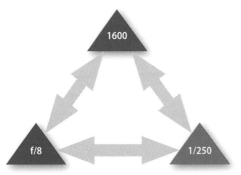

We take away two stops of light by adjusting the ISO to 400.

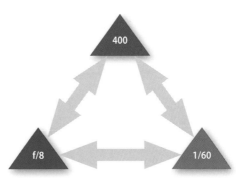

We add light by making the shutter speed longer, so our final exposure is ISO 400 at f/8 and 1/60.

Figure 2.10
Your base exposure is ISO 1600 at f/8 and 1/250, but you want to decrease your ISO by two stops so there will be less grain.

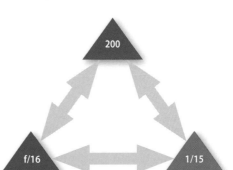

There will be times when we need to adjust all three settings. At ISO 400 and f/11, the meter tells us that the shutter speed must be 1/60 of a sec. But you want to heighten the sense of motion by dropping your shutter speed by two stops.

Because we adjusted the shutter speed to 1/15 of a sec., we have to decrease the ISO or aperture by two stops. But my ISO only goes down to 200. Let's apply one stop to each, so our new exposure is ISO 200 at f/16 and 1/15 of a sec.

Bulb Mode

Every camera has a finite number of apertures and ISOs. Shutter speeds go up to 30 seconds. To get beyond 30 seconds, you will need to switch to Bulb (B) mode (**Figure 2.11** and **2.12**). This is usually achieved by going one click past 30 seconds or switching a dial to the B setting. Use a cable release to take full advantage of Bulb mode. You can lock the cable release down for as long as you want or until your camera battery drains!

Slow shutter speeds are the most creative factor in night photography. Bulb mode allows you to explore the images that are created when you expose for seconds, minutes, or even hours.

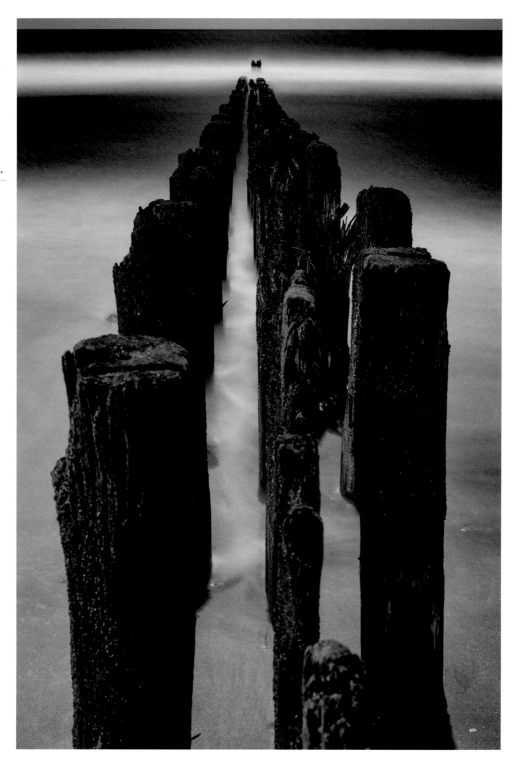

Figure 2.11
Moving water is one of the most popular subjects to capture with long shutter speeds. Exposures over 8 seconds turn the water silky smooth and create a wonderful ethereal look.

ISO 200 · 4 min. · f/8 · 50mm lens

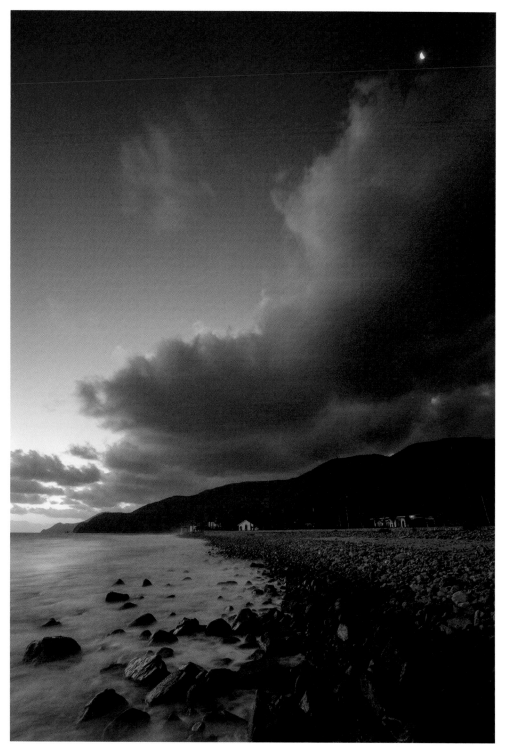

Figure 2.12
I chose a shorter exposure to capture this photo of the moon giving way to the sunrise. Note that the water has an airy look and is not as smooth.

ISO 200 • 4 sec. • f/11 • 18mm lens

Now Do It in the Dark

When you are away from the bright lights of the big city, the night brings a whole new set of challenges. Get familiar with your camera and all of its buttons so you are not fumbling around in the dark. I often use a low-power red flashlight to see my black camera and gear inside my black bag in the black of night.

Histograms Help

We've discussed figuring out a base exposure (by making sure the hash mark in the camera's meter is close to 0) and then making adjustments to it. But a more accurate way to determine exposure information is to look at the image's histogram on your camera's LCD screen (**Figure 2.13**). A histogram is a graph that depicts the number of dark and light pixels that make up an exposure. The darker pixels are on the left, and the lighter pixels are on the right.

When you're reviewing an image on the back of your camera, press the Info button to bring up the histogram view. This view shows a smaller version of the image, so I usually toggle between the full image view and the histogram view. That way, I can fully assess my composition and exposure.

Figure 2.13 **A histogram shows you the tonal range of your image from black to white. (The graph above the histogram would not appear on your camera.)**

While there is no perfect histogram, you should generally try to avoid having the graph bunch up all the way to the left or right. Spikes that touch the top at either end tell us that the image has blacks without detail or whites without detail.

The histogram is a huge help for night photographers, because we need to make sure we are retaining detail in the shadows. **Figure 2.14** shows two photos of a typical night scene. Note that the left image's histogram is bunched up on the left side, telling us that there is a lot of dark information in the image. It looked good on my LCD screen, but it was at least two stops underexposed. I adjusted my exposure and took the image on the right; notice that its histogram is spread out more into the midtones.

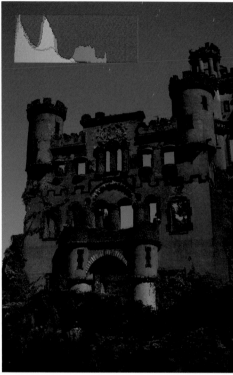

Figure 2.14

(left) The histogram tells us that the image on the left is underexposed.

ISO 3200 • 7.5 sec. • f/5.6 • 35mm lens

(right) I added one stop to the exposure and took the image on the right, which has more information and detail.

ISO 200 • 2 min. • f/5.6 • 35mm lens

Histogram Defiance

Sometimes the most compelling images are the ones that are not perfectly exposed. They challenge the viewer. **Figure 2.15** is all about black versus blue. The shape of the mountains is more impressive and abstract in the darkness. It would be a totally different image if the detail in the mountains were revealed.

If the concept of exposure is new to you, then play it safe for now and use the histogram as a guide to get you to the right zone. If you are an experienced photographer who has a good understanding of exposure, try something more dramatic.

Figure 2.15
I purposely stopped down my exposure when I saw that I was getting too much detail in the mountains.
ISO 6400 · 25 sec. · f/11 · 35mm lens

Blinkies

Another way to check the exposure of your image is to turn on your highlight/shadow warning. They are fondly called "blinkies" because your image's overexposed highlights or underexposed shadows blink white or red on the LCD screen (**Figure 2.16**).

Remember that some highlights, like streetlights, will never have detail in them. They will blink, and I am fine with that. In a later chapter, I'll share my trick for preventing streetlights from looking like overexposed blobs of light.

Figure 2.16
The image on the left is not a psychedelic experiment—the reds represent overexposed highlights and underexposed shadows. These blink on your screen, warning you that your image is missing information. The image on the right is the view after adjustments.

ISO 200 • 2.5 sec. • f/8 • 28mm lens

Long Exposure Noise Reduction

Noise in an image is caused by one of two factors: a high ISO or a long exposure. Almost every camera has menu settings called Long Exposure NR (Noise Reduction) and High ISO NR, and they are usually turned on by default. I'm fine with leaving High ISO NR on, but I recommend turning Long Exposure NR (LENR) off. When LENR is on for any exposure over 1 second, the camera's processer applies a black mask on top of the image that subtracts the brightness of the noise.

Less noise is good, but LENR takes time. For most cameras, it doubles the time of your exposure. So if you take a 30-second exposure, it will apply 30 seconds of LENR. During that time, you will not be able to see through your viewfinder or take another picture, because your camera is busy getting rid of the noise. You can see how this could become a problem if you are taking a 30-minute exposure—you won't be able to use your camera for an hour! Some higher-end cameras have bigger buffers; you might be able to squeeze out one or two more shots before your camera gets too busy processing.

LENR also tends to soften the overall image. Remember that LENR stacks a dark frame over your image, and this subtractive process takes a bite out of your photograph's sharpness. You can compensate for this by being more aggressive with your sharpening in post.

I recommend that you test your camera's long exposures to see when noise starts to creep in. I've found that most DSLRs can cleanly capture a six- to eight-minute exposure at an average temperature of 68 degrees Fahrenheit. Yes, the temperature makes a big difference. The hotter it is, the quicker our sensors heat up and produce noise. A Canon EOS 5D Mark III can typically get up to six minutes without noise appearing. But in the summertime, when temperatures are in the 80s at night, that camera can barely get a 2-minute exposure without LENR.

The High ISO Test

Digital camera meters do an excellent job of measuring the light, even in low-light situations. But sometimes a scene is too dark and the camera will fail to get an accurate reading. A quick solution is to raise the ISO—perhaps to something we normally wouldn't use, like 6400 or 12,800—and take a test shot. This will make the sensor more sensitive and get a better reading of the dimly lit area. Sure, the image might have a lot of noise in it, but it's just a test shot so you can work out your composition, focus, and exposure. It might take me two or three test shots to get a read on the scene. Once I've figured it out, I then drop the ISO to something more optimal.

Figure 2.17 shows my full-stop reciprocity chart for long exposures. Just as with the exposure triangle, we are playing our ISOs, apertures, and shutter speeds off each other to get the perfect shot.

Full Stops Long Exposure Chart		
ISO	**Aperture**	**Shutter Speed**
Low = Less Grain/Sensitive	Large/Wide = Less Depth of Field	Slower/Longer Exposures
–	–	1 sec.
–	–	2 sec.
–	f/1.0	4 sec.
50	f/1.4	8 sec.
100	f/2.0	15 sec.
200	f/2.8	30 sec.
400	f/4.0	60 sec.
800	f/5.6	2 min.
1600	f/8	4 min.
3200	f/11	8 min.
6400	f/16	15 min.
12,800	f/22	30 min.
–	f/32	1 hour
–	–	2 hours
High = More Grain/Sensitivity	Small = More Depth of Field	Even Longer Exposures

Figure 2.17
Let's say my base exposure is ISO 800 at f/8 and 30 sec., and I want to stop down my ISO to 200. That is two stops of light I am taking away. If we add those two stops to the shutter speed, it would be two minutes.

On the following page is an excellent example of how I used the long exposure chart to figure out an image (**Figure 2.18**). The only lights in this scene were the streetlight behind the tree and the moon. Because it was so dark, I couldn't see well through the viewfinder. I raised my ISO to 1600 and lowered my aperture to f/2.8 to let as much light in as possible. The meter reading was 8 seconds at ISO 1600 and f/2.8.

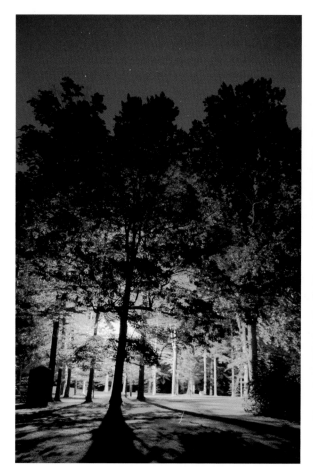
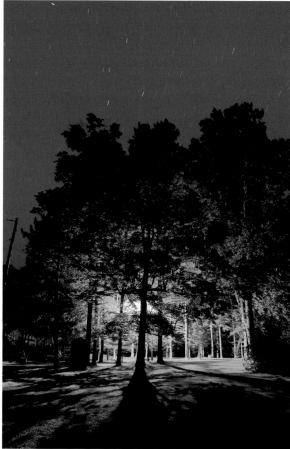

Figure 2.18
The test shot is on the left.

ISO 1600 • 8 sec. • f/2.8 • 24–70mm at 32mm

The final image is on the right.

ISO 200 • 4 min. • f/8 • 24–70mm at 26mm

The test shot told me two things: that I wanted to adjust my composition to add drama to the shadows and put the tree in the center of the frame, and that the image was over-exposed by one stop. The light behind the tree was very hot, so I decided to take away one stop of light. My adjusted baseline exposure was 8 seconds at ISO 800 and f/2.8.

But this was just a test shot. I wanted a longer exposure that would create star trails, and I wanted to shoot at my optimal ISO and aperture: ISO 200 and f/8. Dropping my ISO from 800 to 200 equals –2 stops, and closing down my aperture from f/2.8 to f/8 equals –3 stops, so I needed to add five stops of light to my shutter speed of 8 seconds. Looking at the chart in Figure 2.17, you can see that the additional five stops gave me a shutter speed of four minutes.

The Six-Stop Rule

For those of you who are intimidated by f-stops and math, I have the golden ticket for you. It is called the "six-stop rule," and it will help you figure out exposures in darker scenes. First, check that your camera has at least a six-stop ISO range; for example, 100 to 6400 is six stops, and so is 200 to 12,800. If it does, then doing the math on an ISO of either 6400 or 12,800 couldn't be easier:

- 1 second at ISO 6400 equals 1 minute at ISO 100.

- 10 seconds at ISO 12,800 equals 10 minutes at ISO 200.

As long as your test-shot shutter speed is in the seconds, when you drop the ISO by six stops the number of seconds at the higher ISO will equal the number of minutes at the lower ISO. Leave your aperture constant. Note that some cameras use a name (such as High 1) rather than a number above ISO 6400.

The six-stop rule is a valuable tool for night photographers who are shooting in rural locations under the moon or in very dark scenes. It helps us speed up our test shots and be more efficient at night. This rule doesn't work when you're shooting bright night scenes, like in Times Square. Those scenes can be judged more easily with your in-camera meter and don't go beyond 30 seconds. Medium-bright scenes, such as a park with streetlamps, also may not fit the six-stop rule—your test shot might only be two or three stops away from your final shot.

Chapter 2 Assignments

Test Your ISOs

Figure out how high you can push your ISOs before you start to sacrifice image quality. Put your camera on a tripod, and shoot in dim light. Keep your aperture constant at either f/5.6 or f/8, and just cycle through all your full-stop ISOs, starting with the lowest. Adjust your shutter speed accordingly to make up for adding one stop of light to each exposure. This will get you used to making full-stop adjustments.

Review the images on a computer rather than on your camera's LCD screen. View them at 100 percent, and pay close attention to the shadows. When do you start to see speckles of noise? A few little dots are easy to remove, but excessive noise all over the image means you've reached your limit.

LENR Test

Test how long a shutter speed your camera can handle before noise comes into the picture. Set your camera to manual focus, turn off LENR, and shoot in a completely dark room. Adjusting your ISO and aperture accordingly, shoot with shutter speeds of 1 minute, 2 minutes, 4 minutes, 6 minutes, 8 minutes, 10 minutes, and 15 minutes.

Review the images on a computer at 100 percent, and pay close attention to shadow areas. When do you start to see noise? If you can't see noise at 15 minutes, then try 30 minutes and 45 minutes.

You can also try this test at various temperatures so you can assess the effect of heat on your sensor.

Aperture Test

This test is a way for you to better understand the depth of field in your favorite lenses. Set up objects at 3 feet, 6 feet, and 9 feet, and have something to reference that is more than 30 feet away from your camera. Put your camera on a tripod, and focus on the closest subject at each aperture.

Notice how the depth of field changes at each aperture. Also note how much more depth wide-angle lenses give than telephoto lenses. Examine your images on a computer at 100 percent, and see if there is any loss of quality at the smaller apertures.

Six-Stop Test

Find a dark scene, and become familiar with the six-stop rule. Remember to keep your aperture constant so you are only playing the ISO against the shutter speed.

Share your results with the book's Flickr group!
Join the group here: www.flickr.com/groups/night_fromsnapshotstogreatshots

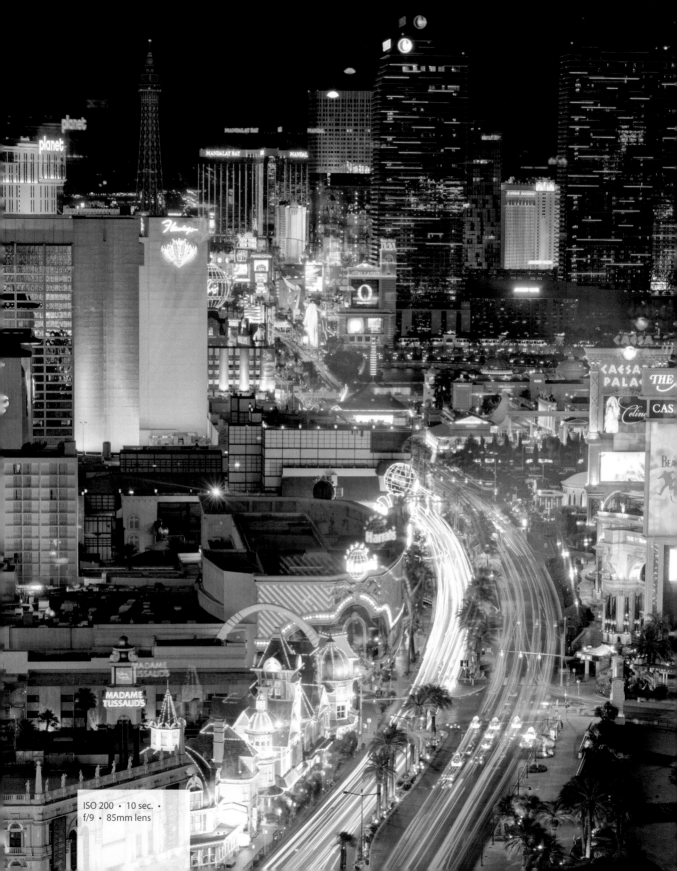

ISO 200 • 10 sec. • f/9 • 85mm lens

3

Composition

Honing Your Night Vision

Photographing at night is very rewarding, but it doesn't come without challenges. Common procedures such as locating camera controls, focusing, and composing are more difficult in the dark. While challenging, shooting at night also offers great benefits. One advantage is the ability to slow down and take your time. Some types of photography, like sports or wedding photography, can be stressful due to timing or schedules—if you miss the moment, you miss the shot. Night photography allows us to be more contemplative. In this chapter, I address the advantages and difficulties associated with shooting at night, and I go over rules and techniques that will make your time in the field easier and your images more meaningful and expressive.

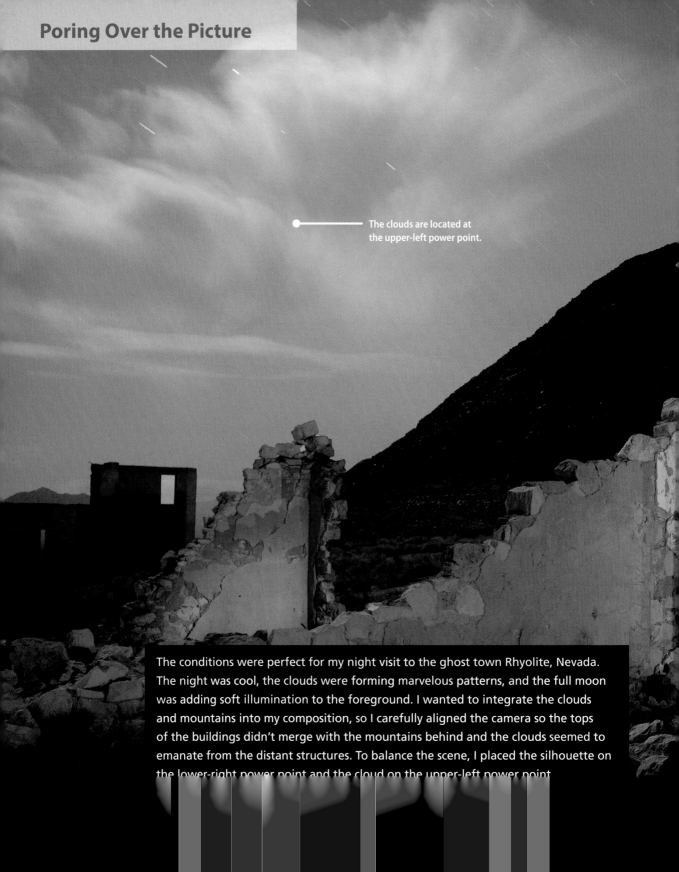

Poring Over the Picture

The clouds are located at the upper-left power point.

The conditions were perfect for my night visit to the ghost town Rhyolite, Nevada. The night was cool, the clouds were forming marvelous patterns, and the full moon was adding soft illumination to the foreground. I wanted to integrate the clouds and mountains into my composition, so I carefully aligned the camera so the tops of the buildings didn't merge with the mountains behind and the clouds seemed to emanate from the distant structures. To balance the scene, I placed the silhouette on the lower-right power point and the cloud on the upper-left power point.

A 3-minute exposure allowed me time to light-paint, and it rendered the stars as small trails.

The moonlight provides soft illumination on the foreground and mountain.

I positioned the camera so the building and mountain do not merge.

The silhouette is located at the lower-right power point.

ISO 640 · 3 min. · f/8 · 35mm lens

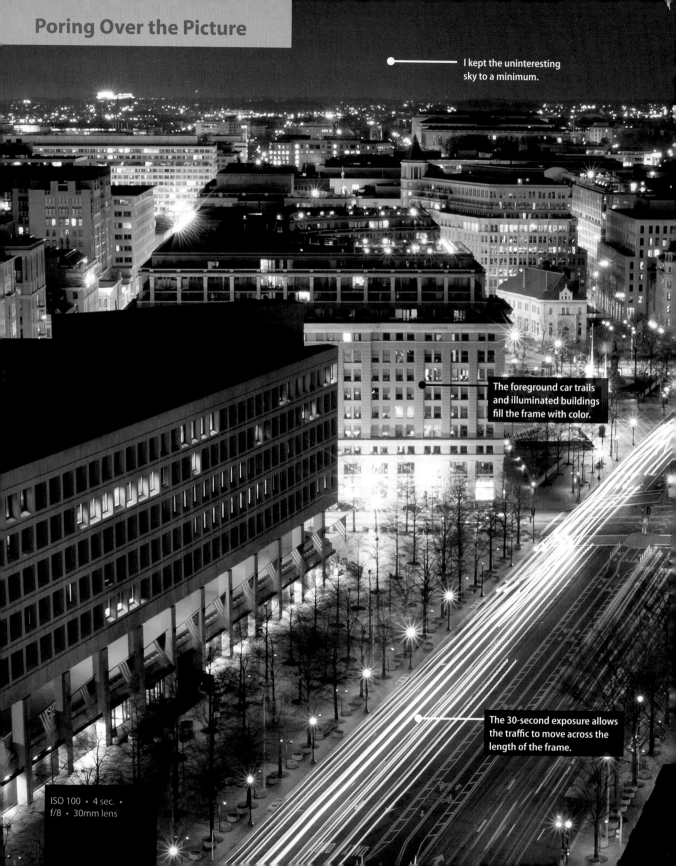

Poring Over the Picture

I kept the uninteresting sky to a minimum.

The foreground car trails and illuminated buildings fill the frame with color.

The 30-second exposure allows the traffic to move across the length of the frame.

ISO 100 · 4 sec. · f/8 · 30mm lens

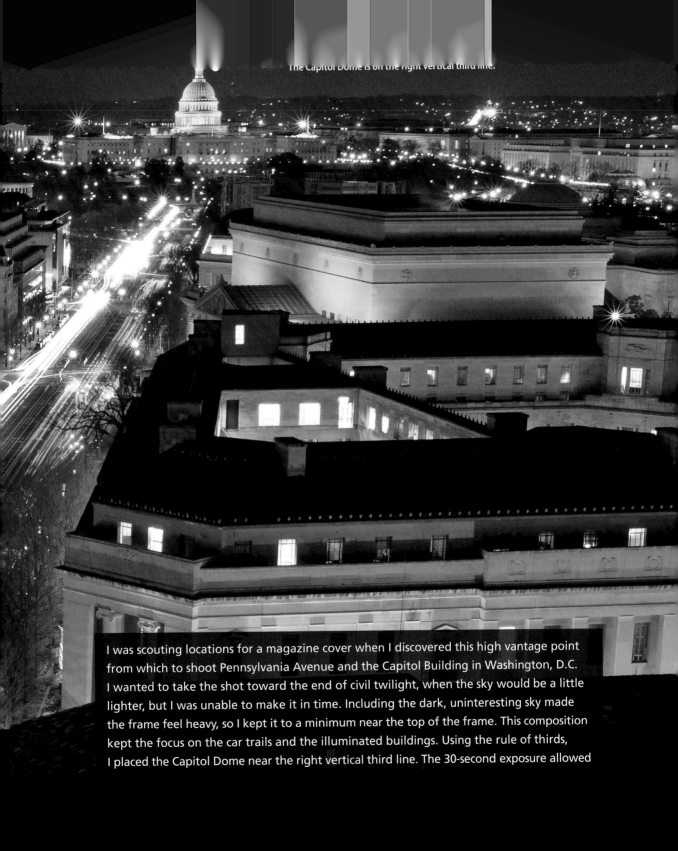

The Capitol Dome is on the right vertical third line.

I was scouting locations for a magazine cover when I discovered this high vantage point from which to shoot Pennsylvania Avenue and the Capitol Building in Washington, D.C. I wanted to take the shot toward the end of civil twilight, when the sky would be a little lighter, but I was unable to make it in time. Including the dark, uninteresting sky made the frame feel heavy, so I kept it to a minimum near the top of the frame. This composition kept the focus on the car trails and the illuminated buildings. Using the rule of thirds, I placed the Capitol Dome near the right vertical third line. The 30-second exposure allowed

Night Vision

Our eyes are fabulous instruments. Their ability to adjust to a wide range of light is astonishing. Stand outside on a bright sunny day and you're able to take in all the information about your surroundings. Enter a dark room and, after a time, your eyes adjust to the low level of luminance, allowing you to make out shapes and details. As you stand on a street illuminated with city lights, you look at the bright buildings and discern every detail in the highlights; as you look into the shadows, your eyes adjust to pick up detail there as well.

Adjusting to extreme darkness takes time, though. As your surroundings get darker, your pupils dilate to allow more light to enter, just like opening your aperture from f/8 to f/2.8. This is called "night-adjusted vision." Introduce a bright light source, and you feel blinded because your pupils are so wide open.

Once your eyes become adjusted to the darkness, it's important to keep them that way. The introduction of bright light can be painful and ruins this adjusted vision. In an effort to keep my night-adjusted vision, I use a low-power flashlight with a red filter over the lens to find the camera controls or search for things in my camera bag. Some flashlights are designed for this purpose. Some have different brightness settings, and others have a red light as an option.

Another way to keep your night-adjusted vision is to turn down the brightness on your camera's rear LCD. When the image appears onscreen it can be blinding when you've been standing in the dark for 15 minutes! The overly bright image may also lead to underexposure because it appears bright enough to your wide-open pupils. Turning it down better approximates the actual exposure.

The brightness of your phone can also cause problems. I sometimes refer to an app or use the timer on my phone during night shooting. Keeping it at a low setting makes viewing it much more comfortable.

Focusing in the Dark

Getting sharp focus in the dark is nearly impossible if you rely solely on your autofocus system. Autofocus needs a certain amount of light to gain focus. In dim situations, it simply hunts back and forth trying to bring the scene into focus. And if the camera is not in focus, you usually cannot trigger the shutter to get the shot. This is generally not a problem in cityscapes, where there is plenty of light, but out in the country you may experience some problems. Here are a few tips to help you gain focus.

Autofocusing

1. Find the part of the scene you would like to focus on.

2. Manually move your autofocus point over that area in your viewfinder.

3. Use a high-power flashlight to illuminate that area of the scene while you focus the camera.

4. Once you've gained focus, turn off autofocus (on the lens barrel or camera body) to stop the camera from trying to focus when you shoot. This is important—if you forget to turn it off, pressing the shutter button to take the shot will start the auto-focus procedure over again and you'll have to pull out the flashlight and start over.

My go-to flashlight for painting scenes at night is a 65-lumen Xenon Surefire, but when I'm trying to autofocus in the dark, I opt for a 100- or 200-lumen light. This brighter light allows you to stand at your camera and illuminate the subject you would like to focus on. Using fixed focal-length lenses also makes this process easier. Fixed lenses are faster, which means their maximum aperture is wider, letting in more light.

Manual Focusing

Fixed lenses also come with another advantage: They have a focusing scale, located on the top of the lens barrel (**Figure 3.1**), that helps you manually focus your lens. The line in the center is called the focus indicator. The numbers in the background are distances in feet (top row) and meters (bottom row). The yellow *5* above the focus indica-

Figure 3.1 **The focusing scale on a fixed 35mm lens.**

tor tells you that the lens is focused at 5 feet. The numbers to the sides of the focus indicator are f/stops. In Figure 3.1, you can see f/11, f/16 and f/22 on each side. Here's how to use the focus scale:

1. Turn off the autofocus on the lens or camera body.

2. Estimate the distance to your main subject.

3. Rotate the lens's focus ring until that distance appears over the focus indicator.

4. Press the shutter release button. Your lens stays at the manual setting rather than autofocusing.

5. For your next shot, remember to check your focusing distance or return to autofocus.

This procedure is especially handy when you're shooting star trails. Stars and other distant objects are seen by the camera as being at a distance of infinity, which is designated by the ∞ mark on your lens. For this type of scene, simply spin the focus ring until the ∞ mark is over the focus indicator. The center of the mark should be directly over the indicator, as seen in **Figure 3.2**. Many lenses focus past infinity, so be sure to cut the infinity mark in half with the focus indicator.

Figure 3.2 **The focusing scale on a lens focused to infinity.**

Hyperfocal Focusing

The focus indicator also tells you what will be in focus at any aperture. For example, on a 24mm lens focused to 4 feet at an aperture of f/16, everything from about 2 feet to infinity will be in focus (**Figure 3.3**). Rotating the focus ring so that infinity is centered over the f/22 gives you even deeper depth of field. Setting the lens in this manner

Figure 3.3 **The lens set to provide maximum depth of field at f/16.**

is called hyperfocal focusing. It means you are getting the most depth of field out of any given aperture.

I highly recommend getting a couple of fixed lenses (wide and normal) for your nighttime work. They are inexpensive, sharp, and easy to work with. You can calculate the hyperfocal distance for zoom or fixed lenses by using a smartphone app. Each app is slightly different, but here's the general procedure:

1. Input the type of camera you're using. This tells the application the size of your sensor.

2. Input the focal length of your lens. If you are using a zoom lens, look to the focal length indicator on the zoom barrel (**Figure 3.4**).

Figure 3.4 **The focal length indicator on this zoom lens is set to 24mm.**

3. Input your desired f/stop. I typically don't like to go higher than f/16. The closer to the center of the range (f/8 or f/11), the higher the quality of the resulting image.

4. Press a button on the app to calculate the hyperfocal distance. (Some apps calculate automatically when you enter the f/stop.)

5. Manually focus your lens until the hyperfocal distance is centered over the focus indicator.

 In the example of a 24mm lens at f/16, the hyperfocal distance is 4 feet. Setting the lens as seen in Figure 3.3 ensures sharp focus from 2 feet to infinity.

Figure 3.5 shows the DOFMaster app on an iPhone. You input the format, lens, and f/stop, and then you press the HD button to calculate the hyperfocal distance. In this example, it tells you to manually focus your lens to 4.02 feet.

Rules and When to Break Them

Typically, the first thing we do when composing is place our main subject in the frame. This is a critical first step to creating
a strong photograph. Poor subject placement can make or break a photo. Even if an image is technically perfect, poor composition will make it far less interesting. Fortunately for us, the great artists who have come before us codified some simple guidelines that help us place subjects in our frame. Although photographic composition is a lifelong study, it's easy to get the basics down. Here are a few things to keep in mind as you set up your shots.

Figure 3.6
The larger, brighter Crystals building attracts the eye.
ISO 200 · 1 sec. ·
f/11 · 35mm lens

Main Subject vs. Secondary Subject

At the heart of composition lies the concept of having a main subject and a secondary subject. The main subject should be easily identified and not hidden within the picture. The job of the secondary subject is to support the idea of the main subject without distracting from it.

A strong main subject may be brighter, more colorful, more contrasty, or larger than the secondary subject. In **Figure 3.6**, the main subject is both brighter and larger than the secondary subject, the sky. Notice the line of contrast where the Crystals building meets the darker building behind. These lines of contrast are very attractive to the viewer's eye.

In **Figure 3.7**, the main subject is the New York, New York hotel in Las Vegas. Its sheer size identifies it as the main subject, but it is also more colorful and brighter than the other subjects within the frame. The moving traffic at the bottom acts as a supporting secondary subject without overwhelming.

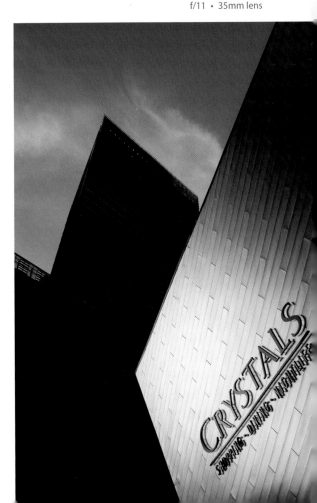

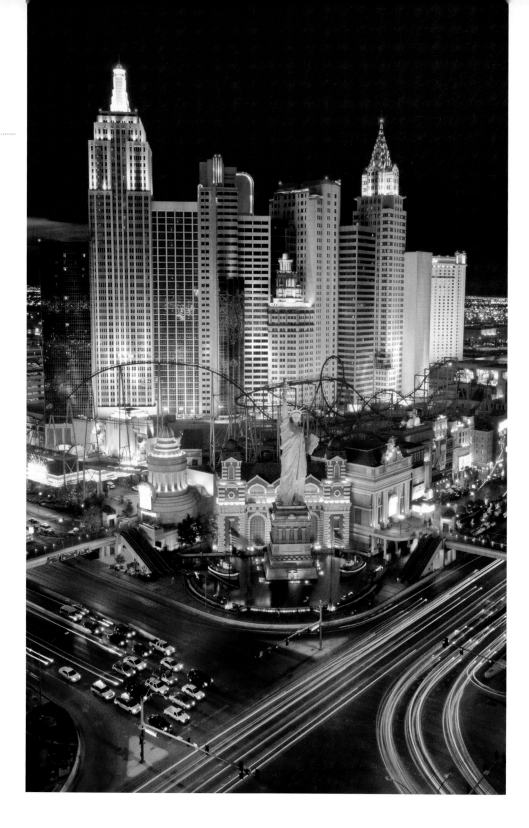

Figure 3.7
The New York,
New York hotel is
the main subject
in this image.

ISO 100 • 25 sec. •
f/22 • 35mm lens

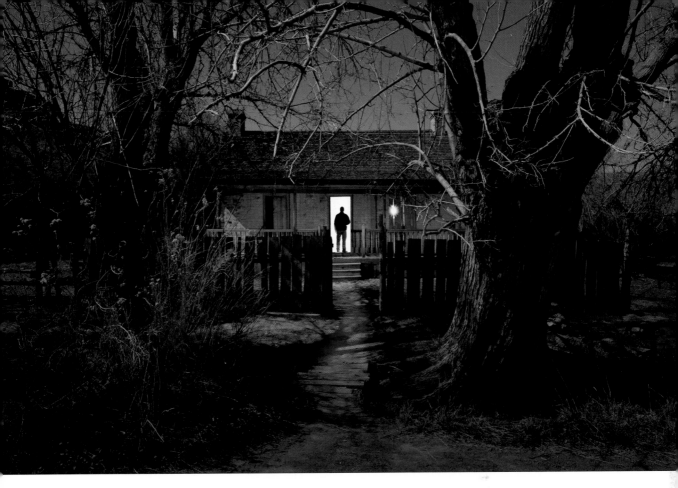

For an image of an old homestead in Utah, I wanted to create an eerie, spooky feeling (**Figure 3.8**). That spooky feeling is actually the main subject. I wanted the viewer to feel drawn up the path to the house. To strengthen the mood, I painted the house by using a blue gel over my flashlight and stood in the doorway while I painted the interior room white. This makes the house and doorway the brightest, most colorful, and most contrasty part of the image. The bare trees and fence act as secondary subjects. Although they are larger than the house, they are darker and less colorful. Their forbidding nature supports the supernatural feeling of the scene.

Figure 3.8
The darker trees are the secondary subjects supporting the brighter and more colorful house.

ISO 200 • 1 min. • f/9 • 24mm lens

Stay Out of the Center

A good composition should have plenty of energy. This energy is either created by the viewer's eye movements as they scan the image, or implied by the subject matter itself. Placing the subject in the dead center of the frame usually produces an image with very little energy. **Figure 3.9** is an example of an image with very little energy. Notice that the footbridge is dead center. This means it's centered from top to bottom as well as from left to right. Placing a subject in the dead center reduces the energy in the frame, which results in a static and boring photograph.

In **Figure 3.10**, you can see that by moving the main subject off center, I've produced a more interesting image. The secondary subject—the lights—becomes stronger, and the length of the walkway is expanded, inviting you to walk up the stairs.

Figure 3.9
Putting your main subject dead center produces a boring photograph.

ISO 200 • 2 min. • f/8 • 35mm lens

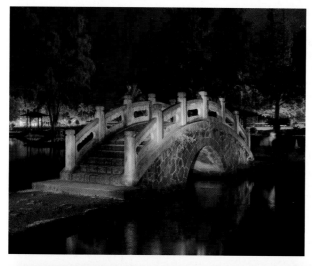

Figure 3.10
Moving the main subject off center creates a better composition.

ISO 200 • 2 min. • f/8 • 35mm lens

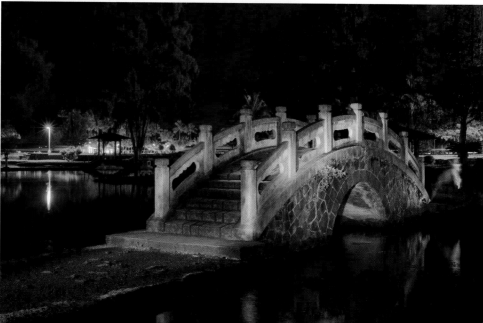

Remember that centering an object means it's the same distance from left to right and top to bottom. You can see in **Figure 3.11** that centering a subject on only one of these axes works well. Here, the truck is centered left to right but not top to bottom. In this case, the image doesn't exhibit that static feeling.

Figure 3.11
The truck is centered right to left but not top to bottom.

ISO 100 · 4 min. · f/9 · 35mm lens

Although placing a subject dead center typically creates boredom, a subject that is *near* the center can be quite powerful. In **Figure 3.12**, I placed the young men just to the right of center. This positioning makes for a strong composition without compromising the energy. Simply moving your main subject just a little off center can do wonders for the overall feel of your photograph.

Figure 3.12 **Even if the main subject is just a little off center, it adds energy to the frame.**

ISO 200 • 1/20 sec. • f/4 • 17mm lens

Rule of Thirds

The rule of thirds template is a time-tested method for placing subjects or horizon lines within your photo. As **Figure 3.13** shows, the template is created by dividing your frame into three rows and three columns. By placing your horizon along one of the lines, you're automatically keeping it away from the center. **Figure 3.14** is an example of putting the horizon on the upper third line. By making the sky only one third of the picture and the foreground two thirds, I am indicating that the foreground is the main subject. The sky acts as a supporting secondary subject.

Figure 3.14 **The horizon is on the upper third line.**
ISO 200 · 10 sec. · f/11 · 35mm lens

Figure 3.13 **The red lines indicate the rule of thirds.**

Horizon lines can be implied as well as real. In **Figure 3.15**, I've put the top of the sandstone formation on the lower third. While this is not the actual horizon line, it visually takes that role. In this photo, the night sky is the dominant portion of the scene, and the tree and sandstone are complementary supporting subjects.

Vertical lines in our images behave in much the same way as horizon lines. They divide the frame, indicating to the viewer the most important part of the picture. **Figure 3.16** demonstrates this division. In this image, the old building in the foreground is vertically divided from the new city in the background.

Figure 3.15
The implied horizon is on the lower third.

ISO 3200 · 30 sec. ·
f/4 · 24mm lens

Figure 3.16
Using the vertical third lines to divide the frame.

ISO 100 · 15 sec. ·
f/6.7 · 32mm lens

Breaking the Rules

Another time-honored tradition in photography is breaking the rules. Your rule-of-thirds placement doesn't have to be exact. The lines are meant to be guides not absolutes. If you always place your subjects and horizons precisely along these lines, your photography will become predictable and monotonous. Mix it up a little. Let your composition guide you. In many cases, a secondary subject deserves no more than a quarter or an eighth of the frame.

In night photography, the need to keep the secondary subject small often happens when the foreground is nothing more than a silhouette against the night sky. **Figure 3.17** shows how a large mass of pure black distracts from the sky. Fill your frame with color. Allow the main subject to dominate the frame. A better choice in this scenario would be to minimize the black and maximize the sky. **Figure 3.18** is not built around the rule of thirds, but it does use the concept of size. Here, the sky fills the majority of the frame and the silhouette takes up far less space. This is not to say you shouldn't include foreground in your night photos. **Figure 3.19** demonstrates that when a foreground is sufficiently illuminated, it can be a strong supporting subject. Here, the mountains are illuminated by the rising moon. They take up approximately a third of the frame, allowing the sky to remain the central focus of the image.

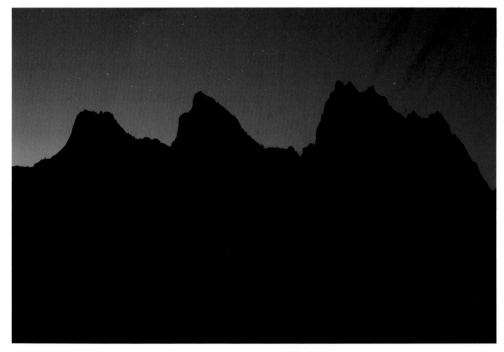

Figure 3.17
Too much black in the frame over-whelms the main subject.
ISO 800 · 30 sec. · f/6.3 · 24mm lens

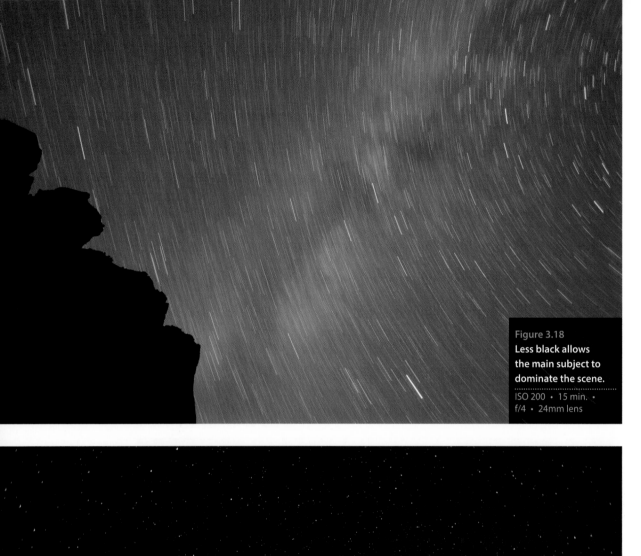

Figure 3.18
Less black allows the main subject to dominate the scene.

ISO 200 · 15 min. · f/4 · 24mm lens

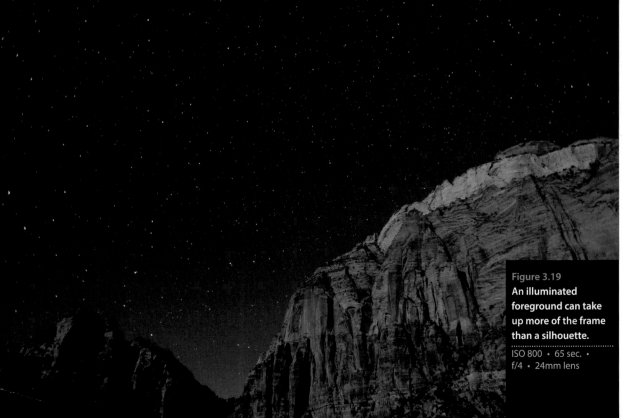

Figure 3.19
An illuminated foreground can take up more of the frame than a silhouette.

ISO 800 · 65 sec. · f/4 · 24mm lens

A similar situation arises when shooting cityscapes. Once nautical twilight passes, the sky becomes increasingly black. Too much black sky overwhelms the image and decreases the interest in the primary subject, the city lights (**Figure 3.20**). In this image, the bridge takes up only a small portion of the frame. In **Figure 3.21**, I moved closer to the bridge and used a longer lens to fill the frame with color and minimize the black.

Figure 3.20
Too much black sky overwhelms the scene.
ISO 100 · 8 sec. · f/6.7 · 35mm lens

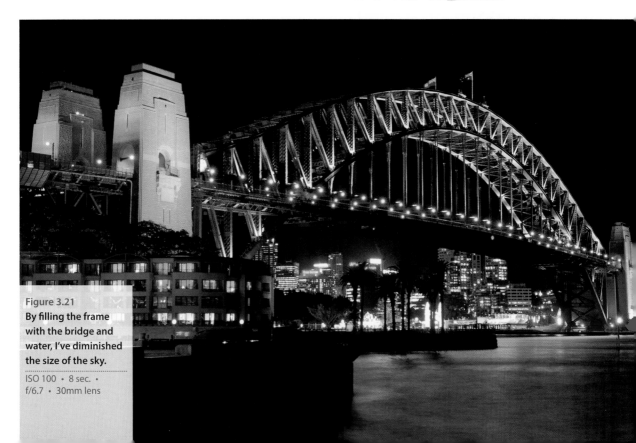

Figure 3.21
By filling the frame with the bridge and water, I've diminished the size of the sky.
ISO 100 · 8 sec. · f/6.7 · 30mm lens

Power Points

Power points are the areas where the third lines intersect (**Figure 3.22**). These points are strong locations in which to place the main subject. I photographed **Figure 3.23** under a full moon while I used a flashlight to paint the interior and exterior of the homestead. By making the building and windows brighter and placing them on the lower left power point, I have indicated to the viewer that this is the primary subject. But just as with the rule of thirds, you don't want to be a slave to the power points. Consider them areas rather than strict points.

Figure 3.22 **The intersections of the third lines are power points.**

Figure 3.23
The window is on the lower left power point.

ISO 200 • 3 min. • f/8 • 35mm lens

Even putting your subject in the general vicinity of a power point will greatly increase its power. **Figure 3.24** is a perfect example of this. The tower is located just off the right third and its power point. In this case, the lit door in the lower left balances the bright tower, allowing it to be located farther to the right. Let the subject matter be your guide.

Figure 3.24
I placed the tower just off the upper right power point.

ISO 100 • 8 sec. • f/5.6 • 50mm lens

Always consider the shape and size of your subject. **Figure 3.25** shows the long, narrow shape of the Golden Gate Bridge. The bridge itself is the main subject, but the left tower meeting the silhouette of the hillside is an attractive area because of its high contrast, rich color, and brightness. Notice that it's not directly on the power point. Doing so would push the image to the right, cutting off the other end of the bridge. You could also use a wider lens to shrink the size of the bridge, but that would diminish the power of this mighty structure. It's better to locate the subject within the frame as needed rather than force an area over a power point.

Many cameras provide an in-camera rule of thirds grid. This grid appears over your image when you're using Live View, and sometimes in your viewfinder as well. This option is a great way to familiarize yourself with the rule of thirds concept. Check your camera's menu system for display preferences to discover if this is an option on your model.

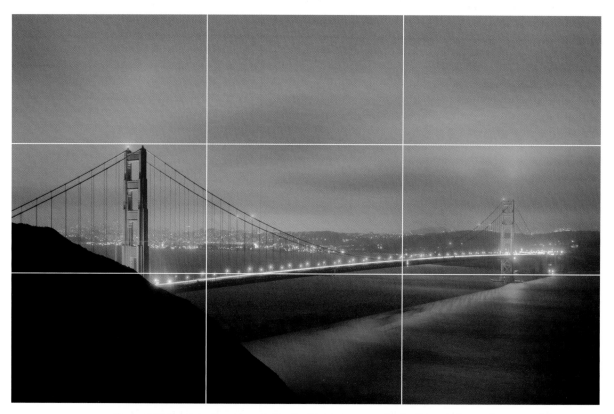

Figure 3.25 **Subjects do not have to be directly on a power point for the technique to be successful.**

ISO 200 · 20 sec. · f/9.5 · 35mm lens

The in-camera level is another handy feature on many cameras. It allows you to perfectly level your camera without the addition of a spirit level in the hot shoe. **Figure 3.26** shows the level display of a camera that is horizontally level. **Figure 3.27** shows a camera that is tilted to the left. Again, check your menu system for access to this tool.

Figure 3.26
In-camera level indicating a level camera.

Figure 3.27
In-camera level indicating a camera that is tilted to the left.

Playing with Time

Unlike many photographic variables, exposure times are more flexible at night. The same overall exposure can be achieved with multiple combinations of f/stops and shutter speeds. Changing your shutter speed from 1 minute to 2 minutes is only a one-stop change in exposure, but it makes an enormous difference in subject movement or time available to paint with light. While you're composing, you should always consider the way a subject's motion is recorded over time. Is the length of time too long? Too short? Will the motion be complementary to the scene? How much time is necessary to achieve the desired results? Remember that longer exposures are not necessarily always better.

Figure 3.28 shows an image I made while driving through a tunnel in Washington, D.C., with my camera mounted on a tripod in the backseat. As I was planning this shot, I imagined the tunnel walls being a blur of color, and the interior and the other vehicle remaining sharp. After a few trips through the tunnel experimenting with shutter speeds, I realized that the sweet spot for the shutter speed was pretty narrow. One-half and one-quarter of a second were too short, not allowing the walls to blur enough; 2 seconds and 4 seconds were too long, causing the car in front to blur. In this case, the 1-second exposure was the best option.

Sometimes the only motion in the scene is that which you induce. In **Figure 3.29**, I placed my tripod on a moving walkway to let it move me through the tunnel of light. The 2- and 4-second exposures did not provide enough blur; the 15-second exposure required me to travel over too many bumps in the walkway, making the handrails too blurry. I settled on an 8-second exposure to create the final image.

When you first begin shooting at night, it will be difficult to guess the time needed to render movement exactly as you imagine it. Experiment. Try a series of shots using various shutter speeds. One of the greatest advancements in modern digital cameras is their ability to show you an image immediately after it is captured. Take advantage of this by zooming in on your image during playback to carefully examine the effect of motion on your overall composition.

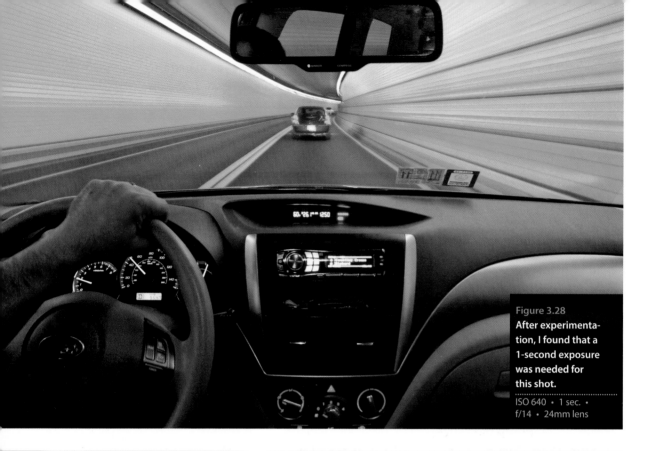

Figure 3.28
After experimentation, I found that a 1-second exposure was needed for this shot.

ISO 640 · 1 sec. · f/14 · 24mm lens

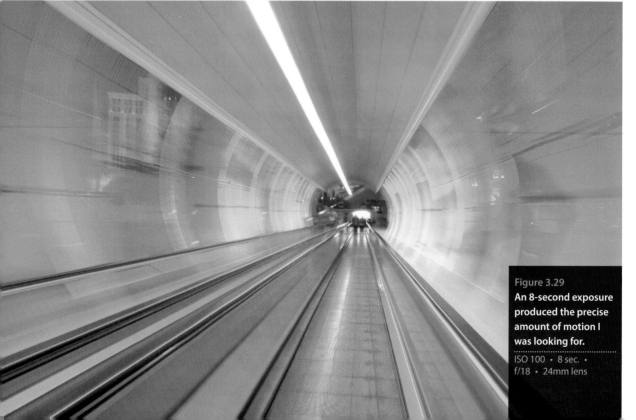

Figure 3.29
An 8-second exposure produced the precise amount of motion I was looking for.

ISO 100 · 8 sec. · f/18 · 24mm lens

Chapter 3 Assignments

Practice the rule of thirds

Try placing your horizon lines along the third lines. Remember to maximize your main subject and minimize your secondary subject.

Use the power points

Experiment with subject placement by locating important areas of the scene at the intersections of the third lines—the power points.

Use infinity

Create a star-trail shot by composing mostly sky with a distant foreground. Ensure sharp stars by setting your camera or lens to manual focus and rotating the focus ring until the infinity mark is split by the focus indicator.

Practice hyperfocal focusing

When you need more depth of field with a fixed focal-length lens, manually set the lens to the hyperfocal setting using your focus scale. If you have zoom lenses, download a depth of field calculator for your smartphone.

Share your results with the book's Flickr group!
Join the group here: www.flickr.com/groups/night_fromsnapshotstogreatshots

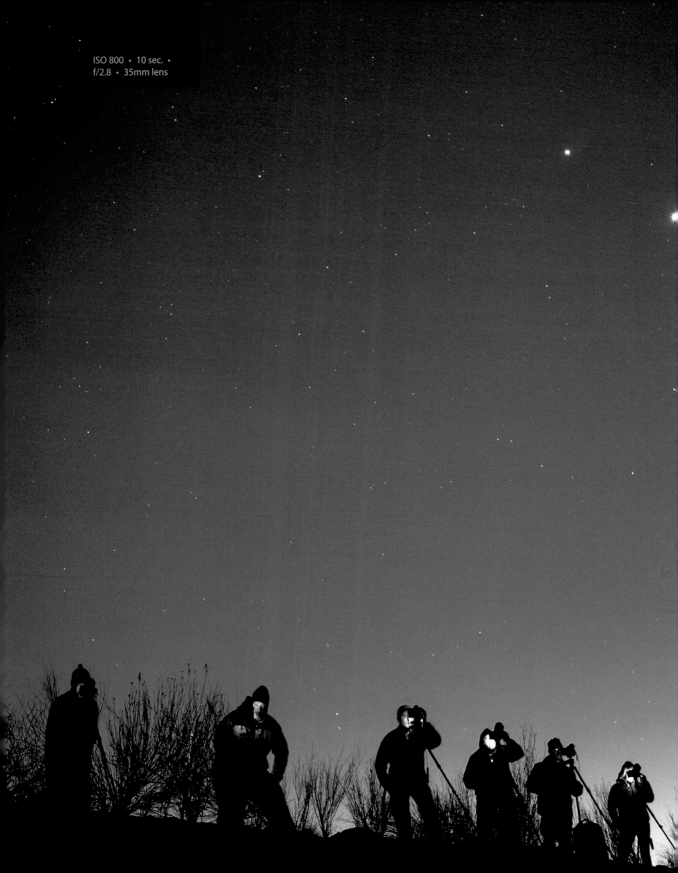

ISO 800 • 10 sec. •
f/2.8 • 35mm lens

4

The Night Light

Capturing and Creating Light

Lights in the night guide us through the darkness. Its sources are as varied as its size and brightness—from golden streetlights and bright white stadium lights to the cool moonlight. Our eyes are capable of adjusting to the contrast and colors of the night, but cameras often struggle to balance the many degrees of brightness. Next time you are out, really look at the diversity of light sources. At night, you will see a much broader spectrum, encompassing a multitude of moods. Understanding how to incorporate a new light source will make you a better photographer. In this chapter, we explore color, light painting, and creative ways to play with light.

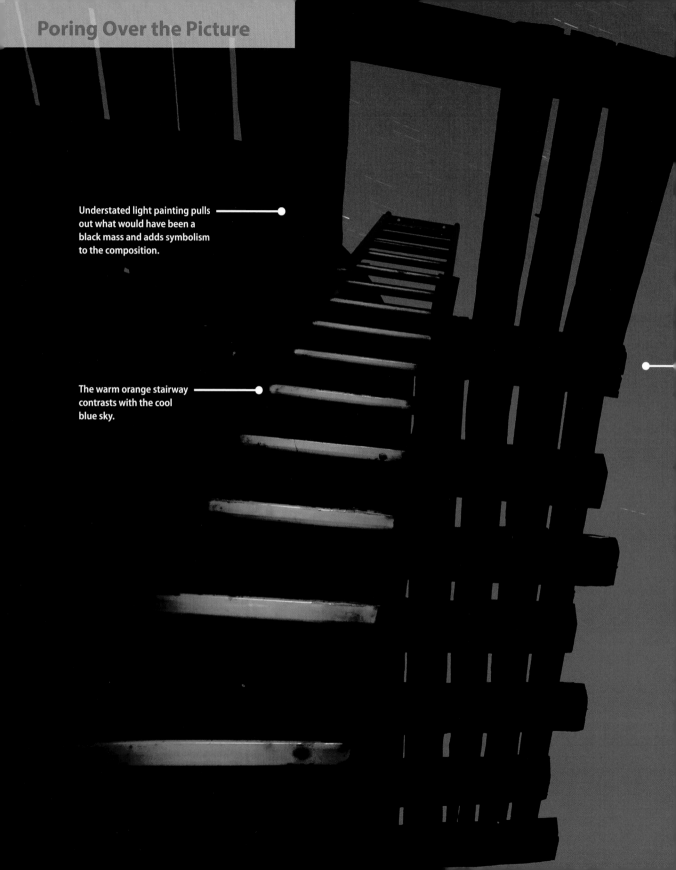

Understated light painting pulls out what would have been a black mass and adds symbolism to the composition.

The warm orange stairway contrasts with the cool blue sky.

The composition has
two distinct sides.

The breaks in the stars were
caused by a thick cloud passing
through the image during the
4-minute exposure.

Our eyes are drawn to vivid colors and bright light, but what we keep in the shadows
can be just as important as what we reveal. I was careful to light only the steps of the
ladder so your eyes are led up each rung, ending in the rich blue sky.

ISO 200 • 4 min. •
f/8 • 21mm lens

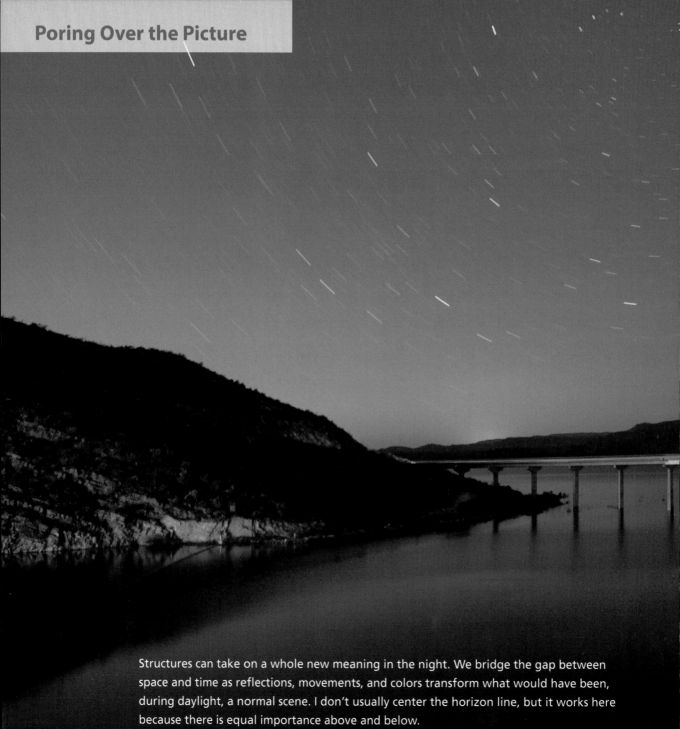

Structures can take on a whole new meaning in the night. We bridge the gap between space and time as reflections, movements, and colors transform what would have been, during daylight, a normal scene. I don't usually center the horizon line, but it works here because there is equal importance above and below.

The circular path of the stars complements the shape of the bridge.

The straight lines and curves keep your eyes moving around the image.

It was a challenge to include and balance the rich red reflection.

ISO 400 · 10 min. · f/8 · 18mm lens

The Many Colors of the Night

Most of us describe the colors of the night as either warm or cool, but it is also important to understand that color evokes emotion. Blue can be calming as well as melancholy. Red may be bold, but is it with love and passion or with frustrated tension? Your interpretation of the light conveys your visual message. Take a look at your favorite photographs—is the color of the light helping evoke the emotions you feel?

Color Primer

The boldest colors with the most impact are the primary colors: red, yellow, and blue. In **Figure 4.1** the red and yellow letters stand out strongly against the blue of the sky. Mixing two primary colors yields the secondary colors: Red plus yellow equals orange. Add red to blue and you get purple. Blending yellow and blue results in green. What's important to recognize is the relationship that colors have with each other. This can easily be viewed on the color wheel (**Figure 4.2**).

Figure 4.1
The red and yellow letters make this a bold and graphic picture.

ISO 160 • 2 min. • f/5.6 • 80mm lens

Figure 4.2 Opposites attract—cool and warm colors live opposite each other on the color wheel. They complement each other when used together in an image.

Complementary colors lie opposite each other and bring out vibrancy and contrast when used together in an image. A common complementary combination at night is the blue of the sky and the yellow/orange ambient light from streetlights. In **Figure 4.3** the red/orange taillights provide a nice warm pop in an image whose main color is the cool blue of the sky.

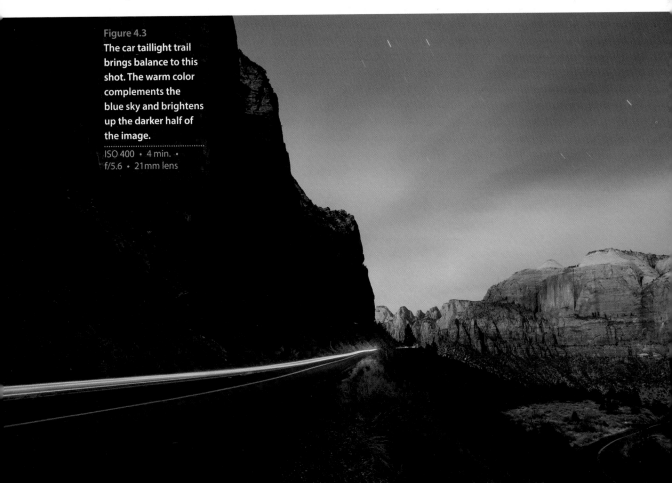

Figure 4.3
The car taillight trail brings balance to this shot. The warm color complements the blue sky and brightens up the darker half of the image.
ISO 400 · 4 min. · f/5.6 · 21mm lens

Analogous, or harmonious, colors are adjacent to each other on the color wheel and produce a softer, subtler look. They can appear monochromatic because their contrast and tonality don't vary that much. The main colors in **Figure 4.4** are orange, yellow, and green. They provide a smooth background for the black and white bike to hang from. The yellow adds the strongest contrast because it is the brightest. Our eyes are always drawn to the brightness and most colorful part of a picture.

Figure 4.4
Using colors that are next to each other on the color wheel gives an image a soft, painterly feel with little contrast.
ISO 3200 · 1/20 sec. · f/3.2 · 50mm lens

Light Sources and Their Color Temperatures

All light has a color temperature (how warm or cool the light source appears). The standard unit of measurement for color temperature is Kelvin (K). The lower the Kelvin number, the warmer the color appears; the higher the number, the cooler it appears. **Figure 4.5** is a standard Kelvin chart that shows the colors as well as their common sources. Learn to recognize color temperatures so you can capture them accurately. We have all seen the wonderful warm light of candles on a cake, but have you captured it successfully or did the flash's white light blow it away?

We are actually approaching a new age in nighttime color: In the United States, the orange glow of sodium vapor streetlights is quickly disappearing as more and more cities replace them with eco-friendly LED lights, which are cooler and have less character. The common incandescent light bulbs that were in every household have been phased out in favor of CFLs (compact fluorescent lights). At least CFLs come in three flavors: soft white, bright white, and daylight. Have you ever shot an office building and noticed a green or magenta color cast coming out the windows? That is the light of low-cost fluorescent bulbs. In rare instances you might see the greenish blue light of the metal halide or mercury vapor in light sources in parks, streetlights, parking lots, and industrial sites. **Figure 4.6** shows a high-pressure sodium vapor light and a metal halide light on the same post.

Figure 4.5 **Light sources and their color temperatures.**

Type of Light Source	Kelvin Rating
Candlelight	1500K
High Pressure Sodium Vapor	2000K
Soft White CFL	2500–3000K
Bright Whitel CFL	3500–4100K
Moonlight	4100K
LED Streetlights	4000–5000K
Daylight at Noon/ Flash/Daylight Bulbs	5500K
Fluorescent	4000–6000K
Metal Halide	5000K+
Mercury Vapor	6500K+
Twlight	9500K

Figure 4.6
The orange high-pressure sodium vapor light shines on the street, while the blue/green metal halide light is pointed in the opposite direction to illuminate the park.
ISO 3200 · 1/4 sec. · f/8 · 35mm lens

White Balance

How your camera reads color temperature depends on its white balance (WB) setting. This is one of the most important buttons on your camera. The default is Auto White Balance (AWB), which does an OK job during the day. However, a typical AWB range is 3000–7000K, and it is heavily influenced by the strongest light source. AWB struggles at night, especially when you have multiple light sources with varying temperatures.

One of the benefits of digital is that every camera has several source-specific white balances. Each setting applies varying degrees of the opposite color temperature, so any color cast is neutralized. The two most popular settings at night are the Tungsten, or Incandescent, setting and the K (for Kelvin) setting.

The symbol for the Tungsten or Incandescent setting (the name varies depending on the manufacturer) is a light bulb. This is a good setting to start with in most night scenarios. Streetlamps and moonlight tend to warm up the night, so by setting the WB to Tungsten, you can cool the image down and give it a nighttime feel.

The K setting lets you take even more control over the color and mood. You can dial in temperatures from 2500–10000K to suit your needs. This setting is very important when there is a mix of several different colors in the image. The combination of metal halide and high-pressure sodium vapor in **Figure 4.7** made it difficult to choose the correct WB setting. I turned on Live View in my camera and toggled through the WB settings before settling on one that best represented the image. If you are new to WB or the light is tricky, this is an excellent technique to employ. Turn the temperature up or down to see which one looks best to you.

Figure 4.7
I used Live View to balance the colors from the metal halide light (left) and the sodium vapor light (right).
ISO 200 • 2 min. • f/4 • 50mm lens

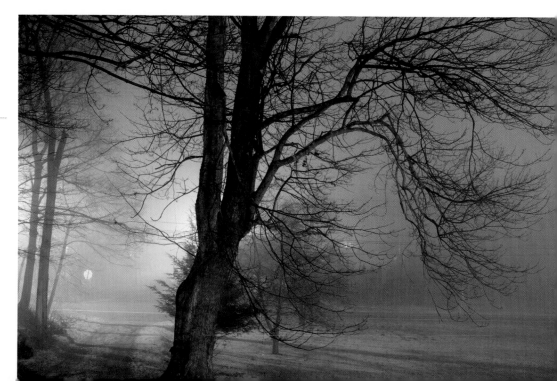

The WB setting influences the overall mood of the image. You want to incorporate, not neutralize, the colors of the night. Sometimes they just need a little adjustment to tone them up or down. If you shoot raw, you'll have more leeway to adjust your WB in post, but I like to get as close to the color I'm trying to achieve in the field. I can "read" the scene better, and it influences the other adjustments I make.

Light Painting

Light painting is one of the most expressive and creative ways to capture the night. When you paint with light, you add a new source of brightness to the picture. You can use it to simply open up uninteresting shadows, or you can add splashes of color to change how the viewer sees the image. Given the long exposures of night photography, you can paint or draw almost anything in your imagination. The instant feedback of digital, combined with the availability of so many light sources, makes this a very exciting time to experiment with painting with light.

Controlling Brightness

- **Ambient light.** Longer (slower) shutter speeds increase the brightness of ambient light; shorter (faster) shutter speeds decrease its brightness.

- **Added light.** Larger apertures (smaller numbers) increase the brightness of added light; smaller apertures (bigger numbers) decrease its brightness.

Light Painting from Start to Finish

Light painting is all about balancing the ambient light with the light that you're painting. Think of it as combining two different layers in the picture. One layer is the ambient, or base, layer; the other layer is the light you add to the darker areas of the image.

The first step is to assess the situation. Before I even set up my composition, I walk around the scene to see how the light and shadows are falling. Then I go back to the camera and figure out my composition and base exposure with several test shots. When you're light painting, it's a good idea to underexpose your base exposure by a half or full stop, especially when the sky is the main source of ambient light. This gives the image a nocturnal feel and enhances the contrast of the light painting. **Figure 4.8** is a high-ISO test shot. The brightest ambient light is the sky, and the foreground is dark and prime for painting. I liked the direction of the light falling on the statue and wanted to highlight it.

Now that you've established a base exposure, you need to figure out how much light painting to add. You can control the brightness of the ambient light by increasing or decreasing your shutter speed. The brightness of light painting is controlled in the camera by the aperture. ISO affects both ambient and additional light the same way; it cannot change the ratio between them. So although a high-ISO test shot is great for figuring out composition and ambient exposure, it does not help you gauge how much light painting to add. If you raise your ISO for a test shot, you will need to lower it accordingly before assessing the light painting. Otherwise, your light painting will be overexposed (**Figure 4.9**). The better light painting test shot is shown in **Figure 4.10**. Remember that this is the second layer; I'm not including the ambient light in my light painting test shots. This cuts down the time needed to take three or four test shots to figure out the power, distance, and angle of the light that I want to add.

Figure 4.8 This high-ISO test shot helped me read the ambient light in the scene and assess where light painting would be needed.

ISO 6400 · 6 sec. · f/4 · 50mm lens

Figure 4.9 Because I didn't change my exposure from the high-ISO test shot, the light painting just adds more light onto the scene and overexposes the statue.

ISO 6400 · 6 sec. · f/4 · 50mm lens

Figure 4.10 I like the placement of the light in this test shot, but it's a little bright, so I dialed the flash down half a stop.

ISO 200 · 3 sec. · f/4 · 50mm lens

The tight beam of light in Figure 4.11 was from a snooted flash raised high on a painter's pole. It took me a couple of tries to get the power and placement of the flash right; you can see one of my first attempts in **Figure 4.11**.

Now it's time to add the ambient light and the light painting together in a single exposure. **Figure 4.12** shows the 2-minute base exposure with the pop of the flash that lit the statue. I used a 40-lumen flashlight low to the ground to subtly open up the grass, which took some practice. Do three or four takes of your final shot—there will be subtle variations each time you paint.

Figure 4.11 **You'll need to practice to get the time, angle, and distance correct.**

ISO 200 • 9 sec. • f/4 • 50mm lens

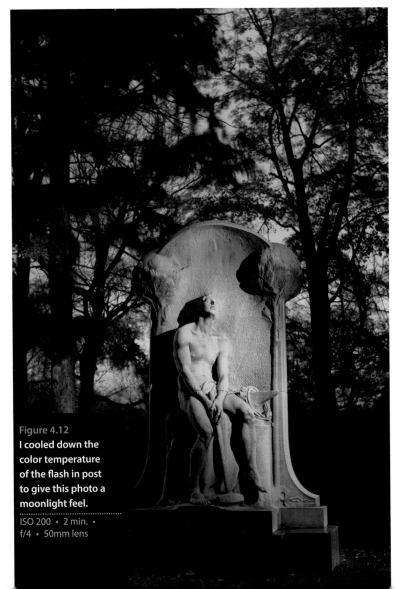

Figure 4.12
I cooled down the color temperature of the flash in post to give this photo a moonlight feel.

ISO 200 • 2 min. •
f/4 • 50mm lens

Flash vs. Flashlight

The two most common sources of light to paint with are the flash and the flashlight. Always have at least one of each in your bag. Flashes add a big burst of light that can illuminate a dark room or freeze action. They can also be measured with a meter, which makes it easy to figure out the proper amount of power to set. You will be operating the flash in manual mode, so be familiar with how to set all of your flash's settings, from full power all the way down to the lowest. The cool thing about flashes is that there are lots of modifiers that sculpt the light and make it bigger (softer) or smaller (harsher). I often put a colorful gel on my flash to add a complementary or contrasting color to the scene **(Figure 4.13)**. But the darker the gel, the less light comes through it—you'll need to either increase the power of the flash or do multiple pops. Some gels have markings that show how many stops of light you are losing so you can compensate properly.

Figure 4.13
It took four pops of the red-gelled flash at full power to light up this beehive rock.
ISO 800 • 15 min. • f/5.6 • 18mm lens

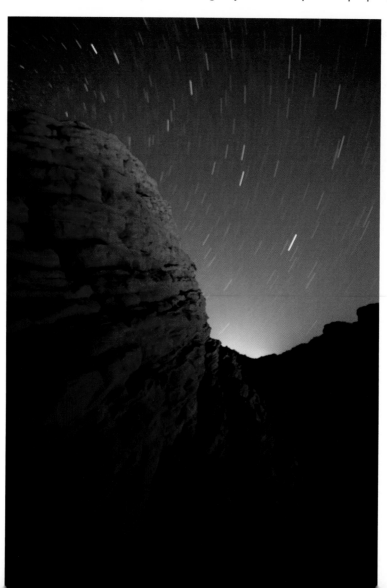

Flashlights are a night photographer's paintbrush. You can gently finesse the light from a flashlight. And because you have to keep the flashlight moving (so you don't get a hot spot in your image), it creates a softer and more diffused light than a flash. A flashlight is perfect for opening up the shadow area in an image (**Figure 4.14**). Keep your lighting as even as possible. It's hard to repeat the same strokes, so sometimes it's better to back up and get a bigger spread of light rather than constantly stroke the flashlight back and forth. Keep track of the amount of time you are painting or the number of passes you make with the flashlight. There is a learning curve to using a flashlight, but once you get it, you'll find it an indispensable tool.

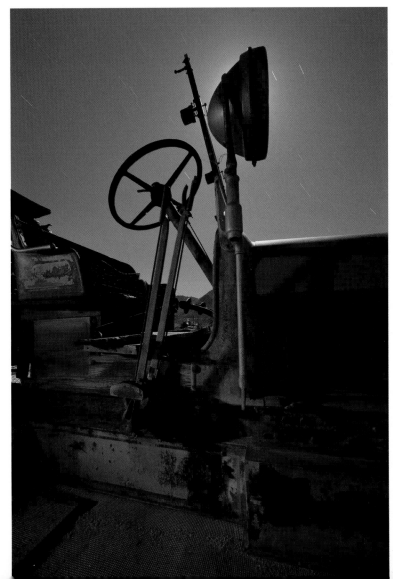

Figure 4.14
This firetruck was completely in shadow. I moved so that the headlamp blocked the moon, and then I used a low-power red flashlight at a 90-degree angle to paint the light.

ISO 320 · 7 min. · f/8 · 14mm lens

A flash's color temperature is 5500K; a flashlight's color temperature varies depending on what type it is (incandescent, LED, xenon, and so on). I prefer warmer flashlights, which add contrast to the cooler night light I like to work under. I always carry several CTO (color temperature orange) filters, which help convert cooler light sources (like a flash) to a warmer light. CTO gels come in a variety of "cuts," or densities: full CTO converts 5500K to 2900K; 3/4 CTO converts 5500K to 3200K; 1/2 CTO converts 5500K to 3800K; 1/4 CTO converts 5500K to 4500K; 1/8 CTO converts 5500K to 4900K.

You can purchase a sheet of these inexpensive gels and use them over flashlights or flashes. They are also available in convenient kits. To figure out what gel to use with a scene, take a test shot to gauge your ambient light and see what in-camera WB setting looks best. Since I typically shoot between 3800K and 2900K, depending on the light source, I always bring three CTO gels: 1/2 cut, 3/4 cut, and full cut.

Figure 4.15 is a shot that I worked on with a student, Albert Bronson, during a workshop that Tim Cooper and I teach. It definitely needed two people to assess and paint the scene. First we worked our composition so that the dark bus was in front of the lighter rock. We knew we wanted to light up the interior of the bus, so we chose a blue light that would contrast with the yellow exterior. I used a blue-gelled flash—three pops at full power—and was careful not to create any hotspots on the reflective interior. Albert used a high-power incandescent flashlight at a 90-degree angle from the left side, out of frame. He also came in at a 45-degree angle to paint some light on the black tires. It took us several attempts before we were happy with the result, and the cool and warm colors really complement each other in this scene.

Figure 4.15
I often use a combination of flash and flashlight to light a night scene. Using gels will help you play warmer and cooler colors off each other.

ISO 400 · 2 min. · f/8 · 21mm lens

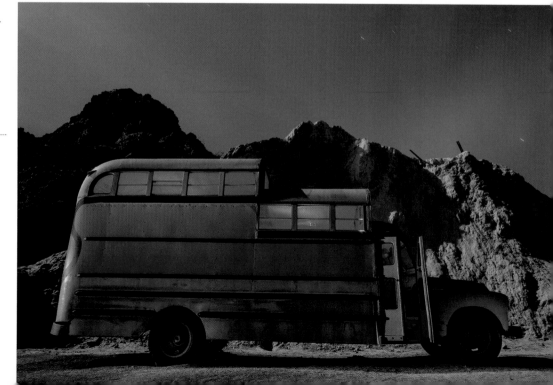

The Power of Light

There are two important factors to consider when figuring out how much light to add to a scene: the power of the light source and the reflectivity of the subject matter.

Every light source can be rated for power. Flashlights are rated in lumens; flashes can be set from full power to 1/128 power. The intensity of a light can be controlled in several ways: dialing the power of the unit up or down, adjusting your aperture, or moving the light source closer to or farther from the subject. We all understand that the closer the light source, the brighter it will be, but there can be a significant decrease in brightness by moving it just a few steps farther away.

Now let's look at the reflectivity of the subject. Is it light or dark? Is it textured or glossy? Lighter colors reflect light better than darker colors. Metallic and glossy surfaces can be highly reflective and create specular highlights. The more light reflects off the subject, the less light you will need to paint.

Figure 4.16 is my light painting collaboration with Troy Paiva. The truck was white, highly reflective, and in the shadow of the moon. There was a lot to light, so we divided the duties. I handled the candy striping of the truck, and Troy worked on pulling out detail in the tires and shadows. I had to stand about 30 feet away in order to make the beam of light the correct size to fill in the lines of the truck. Because the subject was so reflective and my flash was 80 lumens, one pass of light was sufficient. The trick I learned here was to turn my flashlight on out-of-frame and point it to the sky; turning it on where it should be on the truck created a hot spot of light. It was easy to match up the beam of light above the truck and then with one quick motion fill in the reds and then the greens. Meanwhile, Troy worked the lower, darker foreground, which was a black hole of shadow. He made several passes with his flashlight low to the ground. He was careful not to fully open up the shadow, and the low angle created the perfect amount of contrast and texture. He then spent the rest of the time opening up the tires (black tires are notorious for absorbing lots of light). It took a few test shots to figure out all the painting details. Troy is a master light painter—check out his work for inspiration!

Figure 4.16 **This scene had a variety of surfaces to deal with and required many angles and distances to get the most from our flashlights.**

ISO 200 • 2 min. • f/8 • 22mm lens

Direction and Bounce

Want to add dimension to your subject? Then don't light it while you are standing next to the camera— that's where the flattest and least interesting light comes from. The perfect way to see this is to shine a flashlight directly at a white wall (**Figure 4.17**). Now hold the flashlight parallel against the wall and shine the light (**Figure 4.18**). Look at all the detail and texture that you can pull out of a boring white wall.

Figure 4.17 (left)
Frontal lighting from beside the camera does not show the subject's depth or texture.

Figure 4.18 (right)
Side lighting can pull texture out of places you wouldn't expect.

If your subject is textured, light it from the side to call attention to it (**Figure 4.19**). Painting with light is not about obliterating the shadows and revealing all the information—it's about creating interesting light that accentuates the subject matter.

Figure 4.19
If the subject has an interesting texture, emphasize it by lighting it from the side.

ISO 200 · 40 sec. · f/11 · 18mm lens

A light source doesn't have to be direct. You can bounce or diffuse it to create a soft light that still shows texture. This is an excellent technique to use when you don't want to create more contrast in a scene. The light will be a soft, subtle light that, if done correctly, will look like there was no light painting added. I lit the Texaco sign in **Figure 4.20** with a quick hit of my 40-lumen flashlight. The sign was highly reflective (metal and white), which made it difficult to evenly light it with direct light, no matter what angle I used. So I pulled out my trusty 8x10 white card. I pointed the flashlight toward the white card and directed the diffused light toward the sign (**Figure 4.21**). Diffused light requires more time to paint than direct light. The timing depends on distance and reflectivity, but for this sign I bounced the light for more than half the exposure; for the direct shot in Figure 4.20, it was just a flick of the switch.

Figure 4.20 (left)
I like the vibrancy of the sign's colors, but its reflective surface made it tricky to light evenly with direct light.

ISO 400 · 2 min. · f/4 · 35mm lens

Figure 4.21 (right)
With bounced light, it doesn't even look like there was any painting added. Note the illumination where the light bulb is, as well as the texture of the rusty bullet holes.

ISO 400 · 2 min. · f/4 · 35mm lens

If you forget your white card, you can bounce light off the ground. This works best when the subject is close to the ground. (A white card is better when the subject is farther away.) **Figure 4.22** is a high-ISO test shot from Zion National Park. I was drawn to how the moon's side-lighting revealed the crags and crevices of the mountain. I added even more texture by including the foreground shrubbery, which had been hidden in the shadows (**Figure 4.23**). For two minutes, I pointed an 80-lumen flashlight toward the ground about 5 feet from where the shrubs enter the frame. At that distance, an evenly diffused light reflected off the plants.

Figure 4.22 (left)
The test shot for the ambient exposure confirmed the large shadow area, which I would need to either crop or subtly light.

ISO 6400 · 15 sec. · f/5.6 · 21mm lens

Figure 4.23 (right)
The reflected light of a flashlight adds the perfect amount of luminosity to the foreground, leading the eye up to the mountain.

ISO 400 · 4 min. · f/5.6 · 21mm lens

Do you really need to hold the light in your hand and shine it from just off-camera? What if you were to put it in your scene? In **Figure 4.24**, I placed a low-power red flashlight in a defunct furnace; the interior was dark but not very reflective, so I could leave the 10-lumen flashlight on for the entire exposure. The dramatic light effect in **Figure 4.25** was a collaboration with Matt Hill. I placed a large sparkler behind the statue to create a beautiful golden light that separated it from the wall. Matt used a flashlight from the left side to create a nice accent, and then swept the light across the foreground to make sure that the shadows weren't too dark. Look for unusual places to put your light. If you have flashes that can be triggered remotely, think about where you could place them to create cool lighting effects.

Figure 4.24 (left)
As soon as I saw this furnace I knew I wanted to breathe life into it. I just needed to make sure that the camera saw the red light reflecting off the interior.

ISO 200 · 8 min. · f/8 · 21mm lens

Figure 4.25 (right)
I taped a sparkler to the back of my model, and it created a dramatic separation between her and the wall.

ISO 200 · 6 min. · f/8 · 18mm lens

Don't Over-paint

Light painting can be a lot of fun, and in the beginning you'll probably want to paint everything in sight! And you probably should, because by making mistakes you'll learn what works and what doesn't. But not every shadow needs to be revealed. I love the strong lines cutting across the lower part of the frame in **Figure 4.26**. The moon was lighting one side of the structure with a direct and flat light. I went to the "dark side" and composed my shot so that I could highlight the ripples of the corrugated metal. I liked the dramatic shadow on the bottom of the structure but wondered if it was too heavy for the scene. So I took another picture, this time painting underneath (**Figure 4.27**). It revealed the framework underneath, which isn't as interesting and competes with the other lines in the image. Experiment by taking multiple shots of your light painting. That way, you can figure out which one best represents the scene.

Figure 4.26 (left)
Not every shadow needs to be revealed. This one emphasizes the structure cutting across the frame and gives it more weight and presence.

ISO 400 · 4 min. · f/5.6 · 21mm lens

Figure 4.27 (right)
This version opens up the shadow underneath, but it just creates competing highlights and lines that I find distracting.

ISO 400 · 4 min. · f/5.6 · 21mm lens

When you bring a new source of light into an image, you are putting your stamp on it, no matter how subtle or sophisticated it might be. I've given you guidelines, but there is no exact science to most of it. Experience is the key. The more you repeat the techniques, and the more environments you put yourself in, the more comfortable you will become. My best photographic work came when I was just starting to explore a new style or when I became so comfortable with it that I could easily apply my vision to it.

Writing with Light

To write with light, you deliberately place a point light source in the frame and "draw" with it. The image is no longer about what the light is reflecting, but about the light source itself. You can write with flashlights, glowsticks, sparklers, or anything else that emits light. Incredible art and "light graffiti" can be created with this simple concept.

Basics

Once you trip an exposure, any direct light source that is seen by the camera—such as someone walking into your shot with a flashlight, phone, or headlamp—will leave a light streak in the photo. In **Figure 4.28**, an 8-minute exposure, I walked into the frame and bounced a red-gelled flash six times while a friend (visible in the center of the frame) spun some fireworks. You don't see me because I was constantly moving and my body blocked the direct light of the flash from the camera. If you look carefully, you'll see one red pop of my flash in the lower-right side. I was so obsessed with making sure the rocks were lit that I forgot where the camera was in relation to the flash.

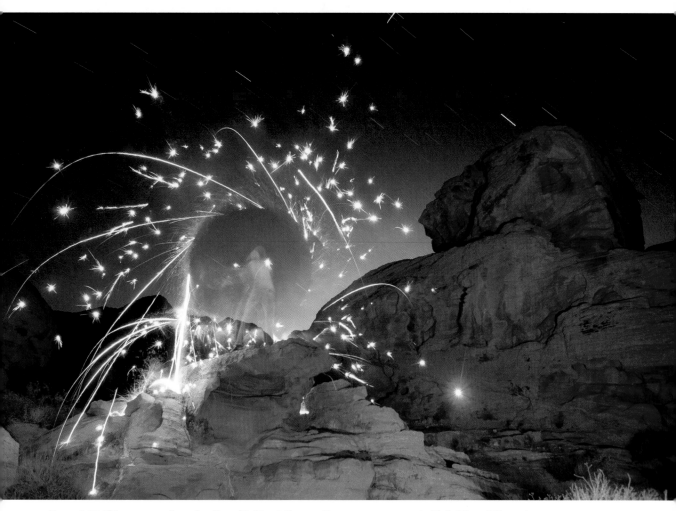

Figure 4.28 This was an early exploration of light painting, and I was more concerned with lighting all the rocks. I popped the flash from almost every angle, creating a very flat light.

ISO 400 • 8 min. • f/7.1 • 24mm lens

Phones and tablets are fun light writing tools, and you always have them on you. In **Figure 4.29**, I walked into the frame with the screen of my phone pointing toward the camera. I shut it off about 15 feet into the picture to create the single blue bolt of light leading you up the path. This also allowed me to walk back to the camera without painting any more light onto the image.

Sparklers are another playful light source to write with. Unlike a phone, which can leave a very clean streak of light, the sparkler burns a jagged light. With any light writing, you need to be careful not to write over previously lit areas; otherwise, you risk the possibility of those areas being overexposed. In **Figure 4.30**, three brave night photographers each held a sparkler at a different level and walked around the mausoleum to create a very dramatic effect.

Figure 4.31 is a wonderful example of combining light writing and a portrait. I took some students from NYC SALT (a photography program for inner-city teens) on a night walk along the Highline. I found a darker area on the pathway and placed the kids in the shot. Andrew drew the stick figures, and then I popped a flash to freeze the students in the shot. Then they got out of the picture—except for Ashley, who wrote *Highline* across the top of the frame. I fired the flash one more time as she finished spelling it out, creating a multiple exposure of her. Donis, all the way on the right, appears ghostly because the brighter background continued to add light where he was sitting and burnt through his portrait.

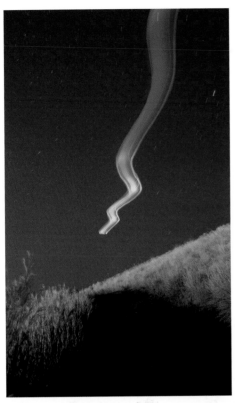

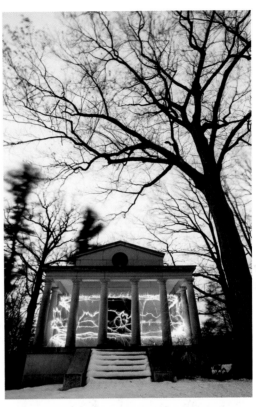

Figure 4.29 (left)
The light writing took 10 seconds, and then I waited 8 minutes for the ambient light to reveal the rest of the picture.

ISO 200 • 8 min. • f/5.6 • 28mm lens

Figure 4.30 (right)
The sparklers give this shot a frenetic vibrancy—you can feel the other-worldly energy.

ISO 200 • 6 min. • f/9 • 21mm lens

Figure 4.31
Ashley did a great job of spelling back-ward. She also had to turn the flashlight off and then back on each time she completed a movement so that the light wouldn't continue to trail in the shot.

ISO 200 • 6 min. • f/9 • 21mm lens

The Night Portrait

It can be a struggle to take a simple night portrait that shows off not only the subject but also the surroundings. When you take a picture of a friend in front of the many city lights, why does the background come out pitch black? In this section, I introduce you to the wonders of slow sync, as well as some creative effects with and without flash.

Slow Sync in Low Light

This is an easy technique, and conquering slow sync will improve your low-light snapshots immeasurably. We've all experienced the limitations of flash at night. In night portraits, often the subject is illuminated but the background is black (**Figure 4.32**). The quick fix is to use a longer shutter speed by switching your flash to slow sync or your camera to Night Portrait mode. This adds more ambient light by keeping the shutter open longer as the flash fires (**Figure 4.33**). Shutter speed controls the amount of ambient light that comes into the picture. No matter how much flash you pop, you can't light up the sky.

Figure 4.32 In Auto mode, the flash fires and the shutter speed remains a safe 1/60 of a second to prevent camera shake. But this quick shutter speed kills the ambient light, and the built-in flash on a point-and-shoot camera has only enough power to go 10–15 feet.

ISO 200 • 1/30 sec. • f/2.8 • 28mm lens

Figure 4.33 A slower shutter speed lets in more ambient light and reveals the skyline.

ISO 200 • 4 sec. • f/2.8 • 28mm lens

Understanding this concept will improve your flash photography in low-light environments like restaurants and clubs, where you want to light the subject but not lose the feel of the surroundings. Keep an eye on your shutter speed—you don't want it to be below 1 second unless you are on a tripod and your subject is still. From 1/2 to 1/15 of a second will usually work (**Figure 4.34**). Be aware that any direct light sources will permanently burn into the picture, but you can work that to your advantage—a cool trick is to spin or move the camera during a slow sync exposure. In **Figure 4.35**, I asked the subject to remain still. The flash fired, and I had half a second to spin the camera around, which created a rainbow effect on the lights.

Figure 4.34
The subject was moving slowly enough for the flash to freeze her in a sea of movement and color.

ISO 200 · 1/8 sec. · f/2.8 · 24mm lens

Figure 4.35
By spinning the camera during the exposure I was able to make the lights trail around the subject.

ISO 200 · 1/2 sec. · f/3.2 · 24mm lens

The Ghost

My early explorations in long exposures proved that objects or people could "disappear" in an image, depending on how long they remained in the frame. This led me to think about how I could control it. Ghost photography has been popular since the beginning of the art form. So how do you do it? The easiest way is to think about mass and time. If something is in the frame for only half the exposure, then only half of it will show up. **Figure 4.36** was an early test of this theory. I sat as still as I could for half of the 6-minute exposure. This shot works because I had two factors going my way. First, my clothing was darker than the white background of the steps. Dark subjects stand out better against light backgrounds, and vice versa. Second, my camera was about 20 feet from the steps, and I shot with a wide lens, so I'm small in the picture. If this had been a tighter shot, my slight movements would have been magnified.

Figure 4.36
One reason this ghost shot works is that I'm wearing clothes that contrast with the background.

ISO 200 • 6 min. • f/8 • 28mm lens

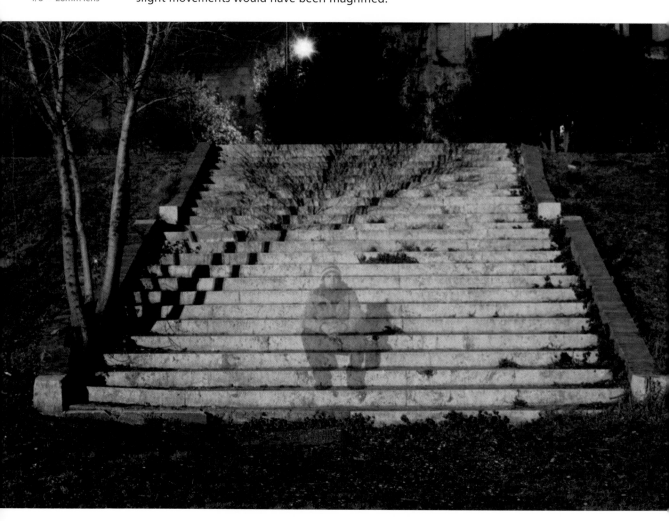

It can be hard for a subject to hold still for longer than a second. An easier way to create ghosts is to incorporate flash. Flashes work better than flashlights because they fire a lot of light for a fraction of a second, freezing the action. You can often light a person with a single pop of a flash, whereas it would take several strokes of a flashlight—running the risk of capturing any slight movement the person makes. **Figure 4.37** is a perfect example of using a flash to create several ghosts. I lit the subject three times with a Vivitar 285 flash at full power. Her head is the only thing that appears because it is more reflective than the black coat that's covering her body. Black absorbs light, so I would have needed to fire the flash two or three more times to make her body stand out against the darker background. But triggering a flash multiple times with the subject staying in the same spot has its own problems: If the subject moves even slightly between flashes, the light will create a blurry overlap.

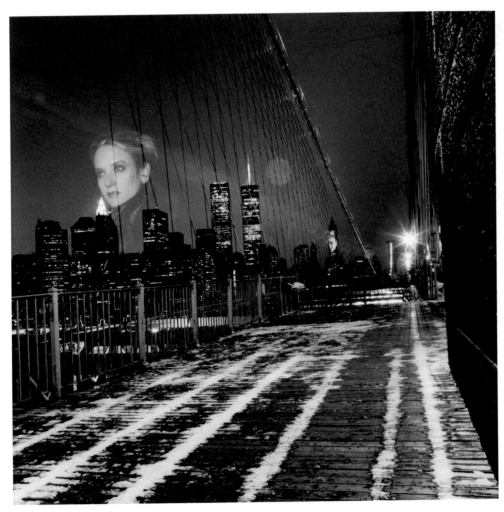

Figure 4.37
I lit the closest figure from a 45-degree angle just off-camera. Then I moved behind the wall to the right. You can barely see the third ghost because the distance of the flash from the subject doubled, lessening the power of the light.

ISO 100 • 4 min. • f/8 • 80mm lens

What if you want your image to be a true night portrait rather than a moody ghost image? Fire the flash once, and have the subject hold their position as you finish the exposure. This builds density in a softer way than illuminating them again with a flash. You may have to reduce the ambient light by using shorter shutter speeds. If your model is in front of a bright light source, like a streetlight, it will burn through your portrait, so be careful where you place them.

For **Figure 4.38**, I fired a flash at one-quarter power each time the subject struck a pose. I tried to keep the flash the same distance from her so the power of the light wouldn't change. The flash was in a grid to keep it a tight beam and limit the light falling on the foreground. The flash was fired from above, so it reflected more off the top half of her body than the bottom.

Figure 4.38

Balance the ambient light with the flash. If I had reduced the shutter speed to 5 seconds, the background would be darker and I would have lost the sense of the environment.

ISO 200 • 10 sec. • f/8 • 28mm lens

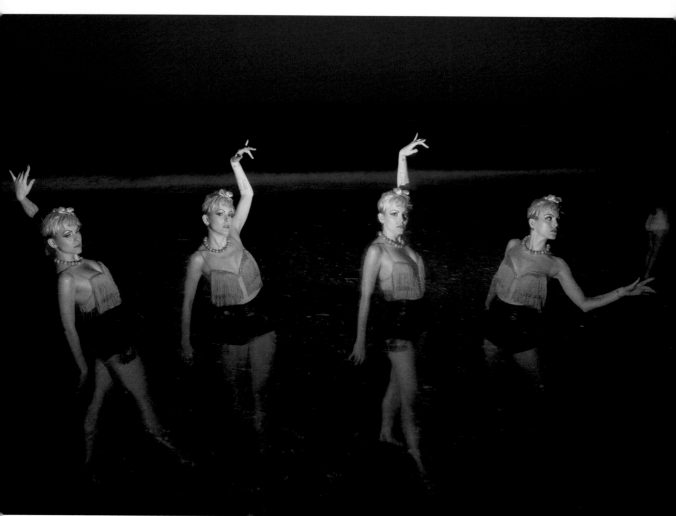

Chapter 4 Assignments

Paint with light

Add light painting to your night photography repertoire. Experiment with a variety of subjects. Try angles that accentuate texture, and try placing the light source inside the frame. Experiment with different colors and color temperatures. But remember to paint in the shadow areas, not in the highlights.

Write with light

Bring your light source into the frame and point it back at the camera. Draw simple shapes and designs. Familiarize yourself with writing words backward, and use different light sources to create patterns. Spin the light around to create a ball of light. When you get comfortable, challenge yourself to make it about more than just the drawing. Try to make the light writing and the environment complement each other.

Create a night portrait

Hone your slow sync capabilities, and be the hit of the next party with shots that show just the right amount of flash and movement. Tell people to hold still after the flash fires, or play with time and have them be ghosts in the shot. Mix in as much ambient light as possible, but be aware of it burning into your portrait.

Share your results with the book's Flickr group!
Join the group here: www.flickr.com/groups/night_fromsnapshotstogreatshots

5
The Night Life

How to Succeed in Nocturnal Scenarios

What symbolizes the night to you? A classic cityscape? An epic star trail?
The night life can offer many creative and challenging opportunities.
As with anything you do, the more you practice the better you will
become. When I committed to shooting every full moon, my portfolio
of night images took a turn for the better. In this chapter, I go over the
wide variety of scenarios you might encounter once the sun goes down,
as well as the best ways to capture them. Put yourself in as many of these
situations as possible to see which ones you enjoy the most. The magic
of the night can bring peaceful tranquility under the stars or a constant
beat beneath the city lights.

These are 40-minute star trails facing south-west.

The water is white in areas where the waves are breaking.

ISO 100 · 40 min. ·
f/11 · 105mm lens

Haystack Rock is one of the most photographed places on the West Coast. During sunset, the beach was littered with photographers. But once the sun went down, everyone disappeared and I had the whole beach to myself! When I got home, I searched online for images of Haystack Rock at night, and I found very few. I quickly posted mine, and it is still one of my most popular shots.

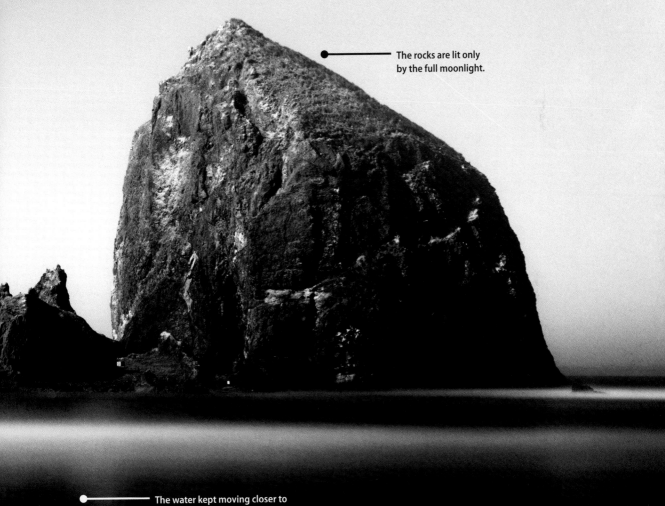

The rocks are lit only by the full moonlight.

The water kept moving closer to me, creating a subtle reflection.

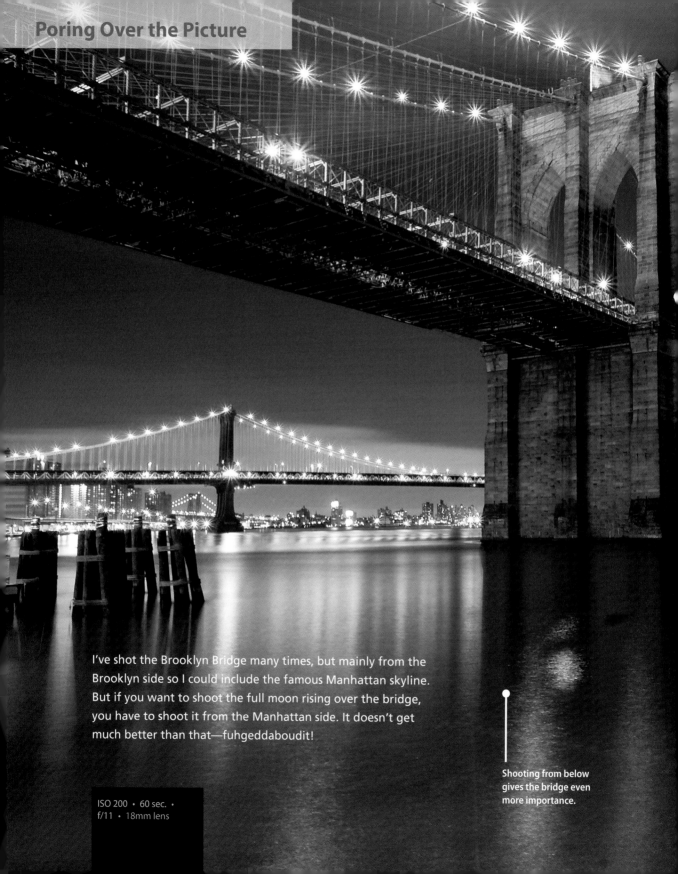

I've shot the Brooklyn Bridge many times, but mainly from the Brooklyn side so I could include the famous Manhattan skyline. But if you want to shoot the full moon rising over the bridge, you have to shoot it from the Manhattan side. It doesn't get much better than that—fuhgeddaboudit!

Shooting from below gives the bridge even more importance.

ISO 200 · 60 sec. · f/11 · 18mm lens

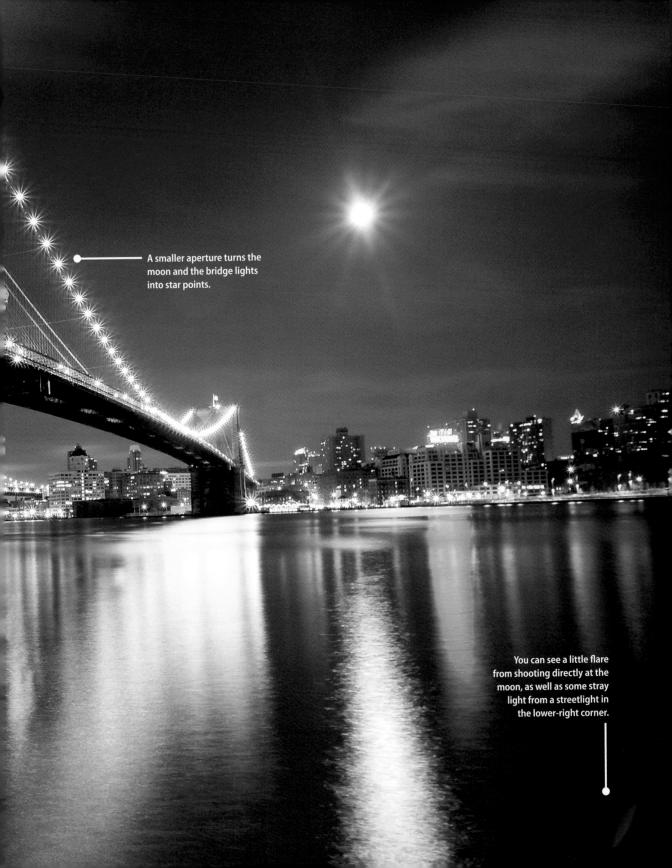

A smaller aperture turns the moon and the bridge lights into star points.

You can see a little flare from shooting directly at the moon, as well as some stray light from a streetlight in the lower-right corner.

Scouting Your Location

Every photographer should be able to summon his or her inner scout and research the location before embarking on a night shoot. It's important to know whether the location is accessible at night (I prefer not to climb fences!). Research the location online, and educate yourself on its history. Scout during the day or when you might find the owner or security there. Showing an honest appreciation and enthusiasm can often help you access a place more quickly. If you do cross the trespassing line, bring samples of your night work so you can show that you are an artist and not a vandal.

Setting up a tripod in cities can bring unwanted attention from security officers. In New York City, as long as you are not impeding traffic, you can set up a tripod on any sidewalk or in any public park. But in Las Vegas, security guards have stopped us from shooting hotels from the public sidewalk. They regard tripods as "professional use," and informed us that we needed to contact their PR department to get permission to photograph any of their properties.

Repeat Visits

A good example of scouting a cool location was my adventure at the Renwick Smallpox Hospital on Roosevelt Island in New York. All that remains of "Manhattan's castle" is its façade. When I visited it during the day, I noticed an imposing gate with barbed wire at the top, and a big sign that said the park (and gate) promptly closed at sunset. Beyond the entrance, a six- to eight-foot tall fence surrounded the ruin. This meant that I would need to bring a camera and lens that were small enough to shoot through the fence.

I returned at night to figure out when the park observed sunset and to see what lights and other factors I would encounter. I arrived an hour before sunset on a brisk, wintry day. The gate was open, and the ruin was about 40 yards away. I brought a point-and-shoot camera that easily fit through the links of the fence and started working on compositions. As dusk approached, the outdoor lights came on and presented several challenges. One was that each light was a completely different color temperature, making a consistent white balance impossible. The lights were also bright spotlights that unevenly lit up the building. I was able to keep shooting until 30 minutes after sunset, when a police officer came by: "Hey, boss man. Better wrap it up, we're closing." I've never had a cop call me "boss man," and I wasn't going to take advantage of it, so I quickly packed up and made my way home. Knowing that I had an hour of dusk to shoot, I planned to return with a friend and more serious equipment.

The bonus of that next night was that it started to snow. As I focused on shooting close-up detail shots through the fence (**Figure 5.1**), my friend Andre Costantini took a wider perspective and froze the snow with a burst of his flash (**Figure 5.2**). An hour later, right on cue, the police officer stopped by again to let us know they were closing up. By this time, there were three or four inches of snow on the ground, and I asked the cop if he could give us a lift to the train station. He laughed and let us jump in the car. This was only the second time I'd been in the back of a police car!

Security and police can go either way. We were very fortunate to encounter a nice guy who understood how cool the location was and that we were not a threat or breaking any laws.

Figure 5.1 I like how the floodlights in front of the tree cause it to silhouette against the ruin.

ISO 80 · 4 sec. · f/8 · 35mm lens

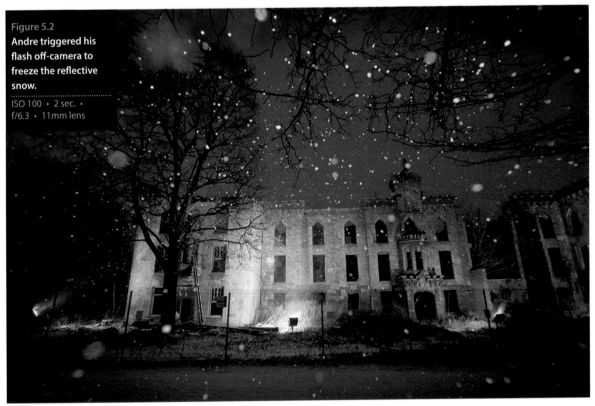

Figure 5.2
Andre triggered his flash off-camera to freeze the reflective snow.

ISO 100 · 2 sec. · f/6.3 · 11mm lens

© Andrew Constantini

Vantage Point

Finding a spectacular vantage point certainly makes taking that ultimate shot easier. Bridges, hills, and observation decks can offer grand views of a city. In New York, most people go to the top of the Empire State Building, but I think the Top of the Rock offers a much better view, because you can include the Empire State Building in your shot.

The Tower Bridge in Sacramento offers many vantage points. I arrived an hour before sunset so I could scout them out. The classic shot for most bridges is from below, along the water (**Figure 5.3**). I used a 10-stop ND filter to extend the exposure to thirty seconds so the water would be silky smooth. The smoother the water, the better the reflections, and all the colorful city lights really enhanced this picture.

Figure 5.3 **The low angle and long exposure make this a powerful shot.**

ISO 100 · 30 sec. · f/11 · 24mm lens

Actually walking on the bridge presented several unique abstract perspectives. Timing was more important than length of time for **Figure 5.4**. This image works because the bright lights blend in well with the waning nautical twilight. You can see the darkness of the astrological twilight creeping into the top of the sky. Five minutes later, the sky would turn black and there would be too much contrast between the bright bridge and the dark sky. Shooting on a bridge with a tripod can be tricky, because they tend to vibrate. You'll often need to limit your exposures to 15 seconds or less. If you can, time your shot for when there isn't as much traffic

Figure 5.4
Don't settle for one interpretation of a picture. This composition is just as powerful.

ISO 125 • 2.5 sec. • f/5.6 • 28mm lens

When you're considering your vantage point, think about how to best interpret the subject matter. Before I set up my tripod, I walk around and assess the situation. I ask myself what would make the most dramatic shot. Many of the water towers in Portland, Oregon, are easily accessible. The typical shot would be to photograph them from the outside, among the houses (**Figure 5.5**). But once I saw that I could walk under the water tower, I knew that would be an image with more impact (**Figure 5.6**).

Figure 5.5
This is how I initially saw the scene, a very realistic documentation.

ISO 200 · 3 min. · f/11 · 32mm lens

Figure 5.6
I moved underneath
and shot up with a
wide-angle lens to
heighten the drama
of the structure.

ISO 200 · 5 min. ·
f/8 · 24mm lens

Don't forget to look for low angles—
a tripod shouldn't always be set up at
six feet above sea level! All roads lead
to Rome, and those cobblestone streets
should not be overlooked. **Figure 5.7** is
one of my favorite interpretations of
this ancient city. When in Rome, you are
on sensory overload, so don't forget to
look low.

Figure 5.7
I set up my tabletop
tripod as low as it
would go and shot
wide open to create
a very shallow depth
of field.

ISO 3200 · 1/15 sec. ·
f/2.8 · 35mm lens

The Night Sky

The quality and quantity of light in the sky plays a major role in how we go about creating our night images. How much light is there? Is it overcast or clear? Is the moon out, or are we operating solely under artificial lights? The light changes drastically during the golden hour from sunset to twilight.

Start Before Sunset

It's imperative to arrive at your location before sunset. You'll be able to set up while it's still light, and you'll have time to improve on your sunset shots. My main tip for shooting the sunset or sunrise is to not shoot the sun. Instead, look around at what is bathing in the light behind you. Look for interesting foreground elements or silhouettes (**Figure 5.8**). If you include the sun, it will often be a bright white spot on your image, but all around it will be a warm color that hopefully turns a thousand shades of magenta when the sun dips below the horizon.

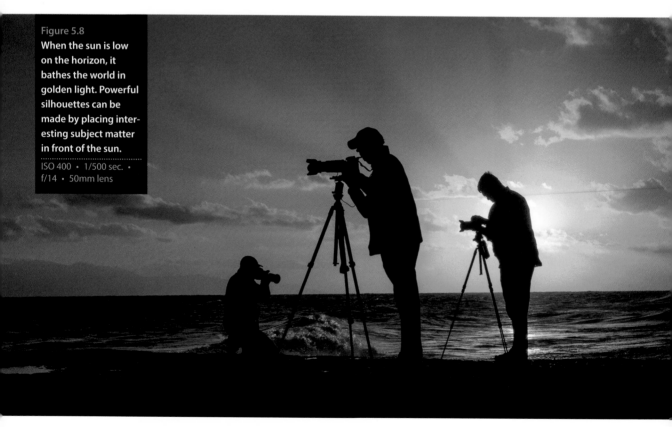

Figure 5.8
When the sun is low on the horizon, it bathes the world in golden light. Powerful silhouettes can be made by placing interesting subject matter in front of the sun.
ISO 400 • 1/500 sec. • f/14 • 50mm lens

The Magic Hour

When I was first getting into photography, I was told that the easiest way to improve your images was to shoot during the magic hours, usually one hour before sunrise and one hour after sunset. For some crazy reason, I chose the early morning hours to shoot. I was impressed by the soft quality of the light, but I realized that early mornings are really not my forte.

The evening magic hour begins with civil twilight, or the blue hour, which has neither full daylight nor complete darkness. During civil twilight, the sun is 6 degrees below the horizon and its light scatters in the upper atmosphere. The quality of light is amazing, as the cobalt-blue sky can quickly change to deeper shades of blue until complete darkness. How long civil twilight lasts depends on your longitude and what time of year it is. Twilight can last 15 to 20 minutes near the equator, or several hours closer to the poles. When I was in Alaska in the summertime, I remember twilight lasting until 2 a.m.! Civil twilight is the perfect time to take bright-city-light shots, because the intensity of the artificial lights matches the ambient light of the sky (**Figure 5.9**). You'll have to move quickly—this time typically lasts only 20 to 30 minutes before we dip into nautical twilight.

The second evening twilight time is called nautical twilight, when the sun dips 12 degrees below the horizon. The light in the sky becomes less blue but not completely dark. This term dates back to the days when sailing ships navigated by the stars. It is during nautical twilight that the horizon line becomes too difficult for sailors to distinguish. To a night photographer, this means that the light is disappearing quickly. There is a two- to three-stop difference between civil twilight and nautical twilight, so keep an eye on your meter and histogram, as the exposures will vary during this time. A second sunset (**Figure 5.10**) can sometimes happen during nautical twilight, depending upon atmospheric conditions, as the last licks of the sun's reflected light reach for the clouds. The brightest stars also become visible during nautical twilight.

Figure 5.9

Twilight is the easiest time to blend the bright lights of the city with the brilliant blue sky. Twenty minutes later, the black sky swallowed up the scene and created too much contrast against the lights.

ISO 200 • 1/10 sec. • f/2.5 • 35mm lens

Figure 5.10

This 10-minute exposure captures the painterly colors of the second sunset.

ISO 200 • 10 min. • f/8 • 35mm lens

The last evening twilight time is called astronomical twilight, when the sun falls to 18 degrees below the horizon. During this time, the sky will go from dark blue to completely black, save for the moonlight. If you are in an area without too much light pollution, you'll be able to observe dimmer stars. If during this time we are shooting solely by moonlight, we can settle into an exposure time that will remain constant for the rest of the night. **Figure 5.11** will help you visualize where the sun is during these twilights, as well as the different colors.

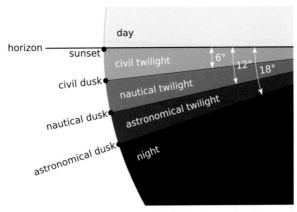

Figure 5.11 **Use this graph to better understand twilight and what type of blue the sky will be.**

The Cloud Factor

Clouds move, and this will factor into how long we can let an exposure go. Clouds can start to lose detail and shape in as quickly as a few seconds. The longest I generally expose a shot with clouds is four minutes. It is at this point that the movement from the earth's rotation affects the clouds and they start to drastically lose their shape. This is definitely subjective to the photographer; sometimes it is nice to see the shape and detail of the cloud, and other times the blurring movement of the clouds can give a heightened sense of motion. In **Figure 5.12**, I have taken the same shot while extending my exposure in one-stop increments from 2 seconds to 4 minutes. This was a fairly windy night, and the grouping of clouds kept their shape from 2 to 4 seconds. After 4 seconds, I don't think it looks interesting again until 30 and 60 seconds, when they have a nice sense of motion. After 60 seconds, they are moving too fast and are starting to smear. Note that in order to get the 2- and 4-minute exposures, I needed to stop down my aperture to f/16 and f/22, respectively. This caused more flare in my image, and the dust and dirt in my sensor became visible. Those smaller apertures create more depth of field in front of the lens but also behind it, where any dirt on the sensor resides. Note that the flare and dirt disappear altogether at f/8.

Try to get the clouds to interact with something of interest in the foreground. In **Figure 5.13**, I positioned the camera so that the clouds were hovering over the cement factory. I took a few test shots, but this 2-minute exposure created the perfect amount of movement in the sky.

Figure 5.12
The same shot, with exposures in one-stop increments from 2 seconds to 4 minutes.
ISO 200–1600 •
2 sec. to 4 min. •
f/5.6–22 • 21mm lens

Figure 5.13
A 2-minute shutter speed was ideal for conveying motion in the clouds.

ISO 400 · 2 min. · f/16 · 24mm lens

Avoid shooting clouds that are hiding the moon. These clouds will become too bright and lose all detail (**Figure 5.14**). Instead, turn away from that cloud and focus on what that diffused light is shining on. If you are shooting under the moonlight and the clouds keep passing over the moon, you will need to adjust your exposure accordingly. Overcast moonlight can be two to three stops dimmer than direct moonlight. Clouds moving through bright stars will break them up and make them look like unconnected star trails. Shorten your exposures so the stars aren't trailing, or wait for the clouds to pass before committing to those star trails.

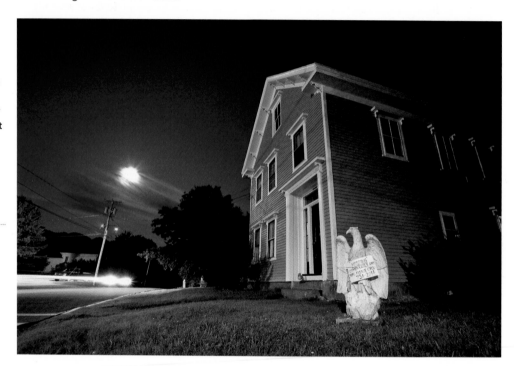

Figure 5.14
I generally avoid shooting the moon when it is behind the clouds, because it just creates a bigger and brighter light source without detail. This shot works because the moon's rays peek over the clouds and play off the car trail below.

ISO 200 · 3 min. · f/11 · 18mm lens

Cityscapes

Every city and town has a unique personality. And when the sun goes down and the bright lights get flipped on, a whole new vibe is revealed. I love the glow of streetlights on the sidewalk. The city moves at many levels and in many ways. These movements can inspire us to explore the essence of the metropolis. There are so many ways to interpret the city that it could keep you busy every day of the year. In this section, we explore the many methods you can use to create the best shots of the spirit of the city.

The Grand View

When we think of a grand view, we often think wide shot. And most of the time you would be right—I never leave home without at least a 21mm lens. But having a zoom lens or a variety of focal lengths allows you to fill the frame with your vision. Make it your mission to find the spot that best represents the city. One of the trickiest aspects of getting the grand view is mixing the night sky with the city lights. In **Figure 5.15**, I shot wide and during twilight, which is the perfect time to blend the bright lights and the ambient light in the sky. I purposely composed the picture to include the warm colors of Seventh Avenue. They complement the blue sky, and the line draws you down to the Tribute of Lights. Thirty minutes later, into nautical twilight, and the sky was too dark. I switched to a more telephoto lens with a heavier emphasis on the 30-second car trails (**Figure 5.16**).

Figure 5.15 I shot wide and included more of the brilliant twilight sky for this 15-second exposure.

ISO 200 · 15 sec. · f/11 · 28mm lens

Figure 5.16 With the color of the sky gone, I switched to a more telephoto lens and focused on a tighter shot. Those white lines in the sky are airplanes headed into LaGuardia Airport.

ISO 200 · 30 sec. · f/11 · 50mm lens

The Detail Shot

Another way to avoid the high contrast of the city lights against the black sky is to look for more detail-oriented shots. Switch to something more telephoto, like a fast 50mm lens, and start hunting for reflections and little abstract moments. I was just walking down the High Line when I noticed the blue chairs bathed in blue light in **Figure 5.17**. I didn't have my tripod, so I opened my aperture all the way to f/1.4 and handheld the shot at 1/60 of a second. Because the depth of field was really shallow, I switched from single shot to continuous and fired off several shots. This is a popular technique to use when you're not using a tripod and your shutter speeds are from 1/8 to 1/30 of a second or when your depth of field is very shallow. This will guarantee that one or two of the shots are sharp.

When you shoot with a lens wide open, you can create beautiful out-of-focus highlights, called bokeh. This can be further emphasized when you focus on something close, like the bridge detail in **Figure 5.18**. The shape of the aperture is reflected in the out-of-focus highlight, turning the streetlights into vibrant circles of light.

Figure 5.17
Not all your night shots should be on a tripod. There is a certain freedom and creativity in walking around with a fast lens in low light.

ISO 400 · 1/60 sec. · f/1.4 · 50mm lens

Figure 5.18
By shooting wide open and focusing on the bridge detail, I turned the distant highlights into ethereal balls of light.

ISO 200 • .5 sec. • f/2.8 • 70mm lens

The City Moves

The city is constantly in motion, and movement is emphasized when there is something solid around it. Car trails are a popular way to tap into the ebb and flow of city streets. Cars will often drive right through the frame, and the only thing the camera records is the light trail of the head- or taillights. Getting to an advantageous point and looking down onto traffic is typically the first order of business. When you can combine the white headlights with the red taillights in the same picture, you get an even more heightened sense of motion. The streets and car lights will be bright, so stop down your aperture (f/8 to f/16) and lower your ISO and see how long an exposure you can get. The amount of traffic that passes is the biggest factor. Las Vegas Boulevard is so bright that I recommend you put an ND filter over your lens so you can get exposures longer than 4 seconds. If you can get farther away from the lights and zoom in, you can get longer trails because

the lights will be less bright. **Figure 5.19** is an example of up-close car trails. The overcast sky was yellow because it was reflecting the city lights, so it wasn't an appealing night for photography. But this vantage point on the Steel Bridge allowed me to shoot the cars from the side, capturing their headlights and taillights in the same shot. My luck increased when a subway trolley passed through the 30-second exposure. This burned in more levels and colors of lights, and it made this one of my favorite car-trail shots. You never know what you'll get, so keep an eye on traffic and keep shooting!

Figure 5.19
The many colors and levels of light make this shot.

ISO 64 • 30 sec. •
f/8 • 28mm lens

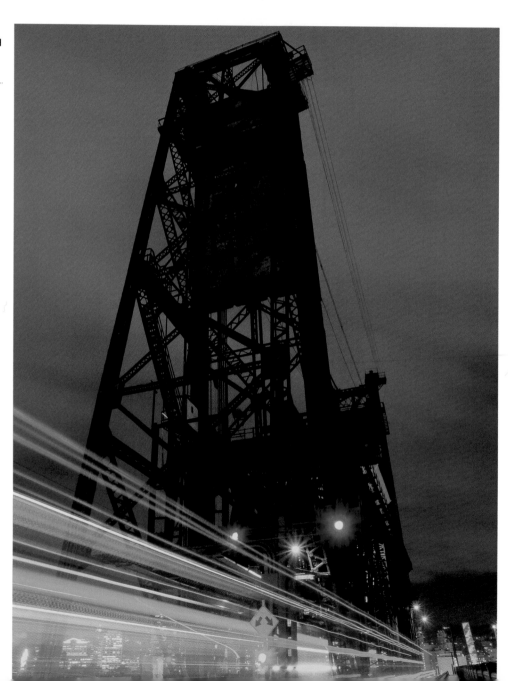

Cars aren't the only things that move in a town. Cities are often built around a water source, and with long exposures we can smooth out the water and capture many different tones and reflections. Sutro Baths in San Francisco is a popular night-photographer hangout, and **Figure 5.20** was taken under a full moon. We can see two different types of water movement here. The foreground is a dark, still pool because there isn't much action in the water. It is slowly and constantly moving, which turns the water into a black mirror that reflects the surrounding structure. Beyond this lies the Pacific Ocean. The constant crashing of the waves against the rocks has turned the foreground water white. The distant water isn't breaking as much and can be seen in darker shades of grey.

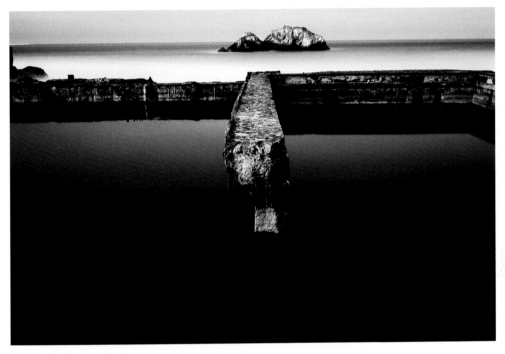

Figure 5.20
Depending on how much water moves during an exposure, it can either reflect or turn silky smooth.

ISO 100 • 8 min. • f/8 • 35mm lens

I keep my eyes peeled for all the types of movements a city might offer. I was shooting the 69th Street Transfer Bridge, and was looking for the best possible composition (**Figure 5.21**). I liked the reflections in the water, but when the wind picked up, the trees started to sway. I immediately thought to combine the movement of the green branches with the smooth water. I framed the bridge through the trees to create an abstract green vignette that moves your eyes toward the bridge. The green and blue colors complement each other and lend a certain calmness to the scene.

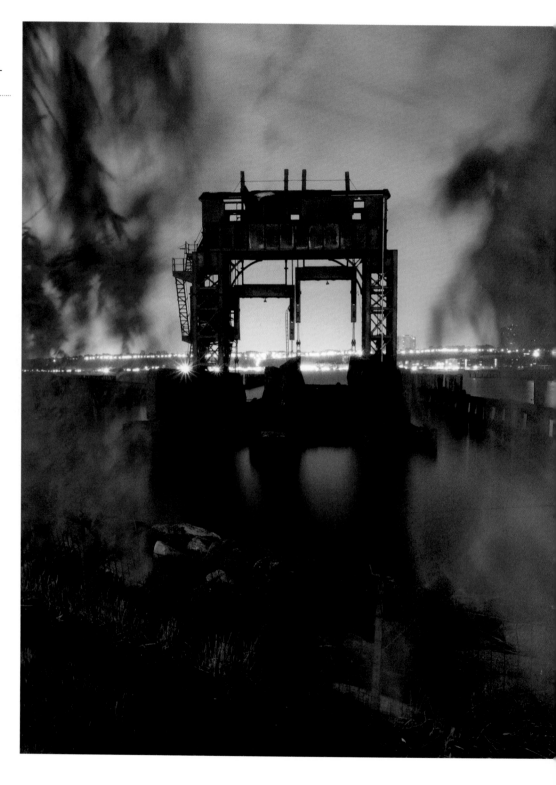

Figure 5.21

Get in close and compose around motion to accentuate the action.

ISO 64 · 3 min. · f/8 · 28mm lens

You can also make your own motion. I'm still fond of the old technique of zooming during exposure. This is a very cool way to depict neon or bright lights in the big city. You'll need a moderate to long zoom lens, like a 28–135mm or a 55–200mm. It is easiest to zoom throughout the entire range rather than stopping at a certain point. Pay careful attention to your composition. Check the wide and tele ends to make sure the composition works at both focal lengths. Make sure your exposure is long enough to zoom throughout the range of the lens as well as to burn in some parts more. **Figure 5.22** is an 8-second zoom exposure. I started wide, tripped the exposure, and waited 2 seconds before starting to zoom. That burned the wide Colony Hotel layer onto the scene. I then tried to time my slow zoom for 4 seconds so that when it got to the end it still had another 2 seconds to expose the close-up shot of the hotel. There is no right or wrong. Zooming is fun to experiment with. Sometimes you'll want to start wide and zoom in tight; other times you will start close and zoom out. Maybe you even stop multiple times. I know that the zoom effect is something you can easily add in Photoshop, but doing it with your camera is really fun, and you can get many different effects.

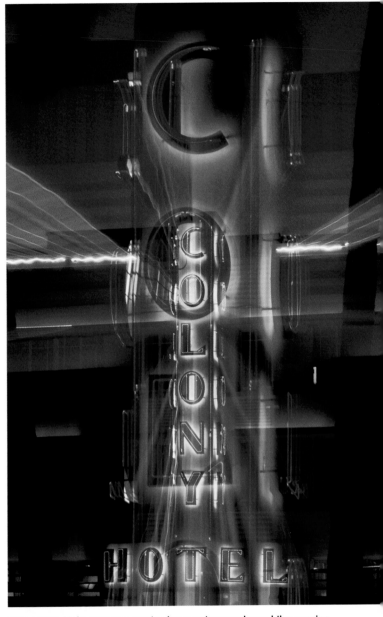

Figure 5.22 Make your own motion by zooming your lens while exposing the image.

ISO 200 • 8 sec. • f/22 • 55-200mm lens

Reinterpret the City

When most people think of Los Angeles, they think of the bright boulevards and hectic highways. The lights are so bright that we don't even notice the sky. But if we take our vantage point to the hills that surround LA, we get an entirely new perspective on the urban landscape. The views from Griffith Observatory are spectacular during the day, but when the city lights come on, we see the true sprawl of glitter and glam.

Your first instinct might be to shoot the scene in **Figure 5.23** with a telephoto lens. But the full moon had recently risen, offering an otherworldly cityscape. To include the moon, I had to shoot with a 21mm lens. Wide-angle lenses make the moon appear smaller, so I made it bigger by turning it into a "moon star." Direct light sources tend to turn into white blobs at big apertures, like f/2.8 or f/5.6. If you stop down your aperture, you can turn those white blobs into star points—the smaller the aperture, the more star points shoot out. I applied this same technique to the moon by shooting at f/11. It made the moon seem larger, like a beacon of light guiding the dreamers to the city of Los Angeles.

Figure 5.23
By shooting wide and vertical, I was able to include the moon over the city.

ISO 200 · 1 min. · f/8 · 21mm lens

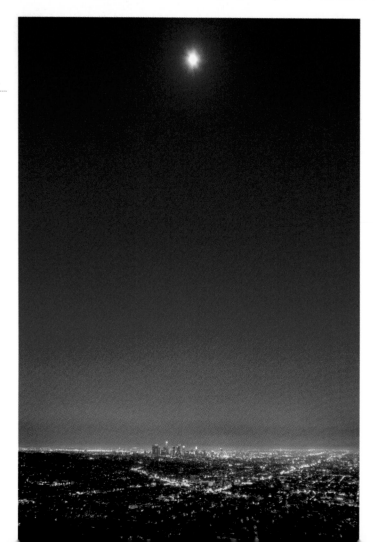

Once you get comfortable capturing images with longer exposures, you start seeing the world with your mind's eye. You'll see and create inspirational pieces wherever you go.

As I walked down South Beach at night, I was curious to see how an extended exposure would capture the tide. My rule of thumb with long exposures is to emphasize movement by placing it next to static objects: rushing water that appears smooth surrounding a wooden pier, big rocks, or trees. But in **Figure 5.24**, I wanted to challenge that rule and create something more abstract. I took a couple of test shots, and I was amazed by the many shades of blue that were revealed in the water. It reminded me of a Rothko painting, and I decided to run with that idea. I increased the exposure to 2 minutes and was careful to compose and click when no lights from boats were on the horizon. I wanted a pure image of these many shades of blue.

Figure 5.24
I used a telephoto lens to zoom to where there were no ships on the horizon and then let the long exposure paint the many shades of blue.

ISO 400 • 2 min. • f/5.6 • 300mm lens

The Moon

The moon's gravitational pull not only controls the ocean's tides but also affects and inspires humankind. One of the best places for a night photographer to shoot is under the moonlight. The quiet stillness and peace that you can find under a full moon is guaranteed to get the creative juices flowing.

Phases and Cycles

There are three considerations when shooting under the moonlight: the phase (brightness), the cycle (angle), and the elevation (how high the moon is in the sky).

Remember that moonlight is reflected sunlight on a gray surface, and the moon's orbit is synchronous with the earth. We are actually always looking at the same half of the moon. Either the moon is passing in front of the sun and being silhouetted (new moon), or it is

being illuminated by the sun. When we observe the moon waxing or waning we are actually seeing the sunlit and shadowed portions of the moon.

How long will the moon travel across the night sky? When the moon is waxing (getting bigger) it is up in the sky before the sun sets. You'll get the biggest and brightest moon for the longest amount of time when there is a full moon. Shooting on the full moon or two to three days before will yield the best results. When the moon is waning (getting smaller) it rises 30 to 50 minutes later each night in the first quarter. This means that three nights after a full moon it might not be visible until after midnight! Winter is a night photographer's favorite season because you get more hours of moonlight.

Another key consideration when relying on moonlight is your horizon and how high the moon is in the sky. If you're surrounded by mountains, you won't get any direct light for two to three hours. Atmospheric conditions also play a part in how bright the moon is. On a clear night, the light from the moon becomes most useful once it is 30 degrees above the horizon. The moon has reached optimal brightness at this height, which means our exposures won't change much for the rest of the night.

Shoot the Moon

The tricky thing about taking a picture of the moon is that most of the time it is much brighter than the rest of the scene. If you expose for the moon, the rest of the picture will be black or severely underexposed (**Figure 5.25**). If you want to get a shot of all the craters, you'll need an exposure more akin to that of daytime. A good starting point is 1/250 of a second at f/11 and ISO 100, with a lens whose focal length can get at least to 300mm. Autofocus is hard to attain on a shot of the moon, so shift to manual focus and set the lens to infinity.

The best times to shoot the moon are when it is at its lowest and during civil twilight. The overall exposure will be more balanced (**Figure 5.26**). The moon can appear bigger when it is rising over the horizon, but this is just an illusion. The moon remains the same size throughout its nightly orbit. We can make it seem bigger by putting it next to something that can put it in perspective, like a building or mountain ridge. When you shoot the moon during twilight, it will often reflect the yellows and oranges of the sunset.

A popular way to incorporate a crater-filled moon into your photos is to take two exposures and combine them in post. One exposure should be zoomed in on the moon. The other exposure can be a medium, not wide, shot of the scene. You can easily cut the moon out of the first shot and layer it over the second. But when you combine a big moon with a wide shot, it can look artificial, so make sure you size the moon accordingly.

Figure 5.25
There was still plenty of blue in the sky when I took this picture, but because the moon is so bright I had to under-expose the sky to get the correct exposure for the moon.

ISO 400 · 1/250 sec. · f/8 · 300mm lens

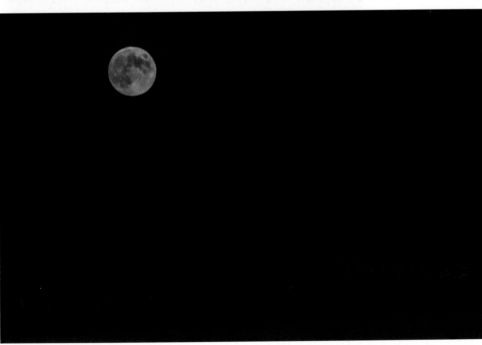

Figure 5.26
One to two days before the moon is full it will be in the sky at the same time as the sun is setting. You'll have 10–20 minutes to capture an exposure with detail in the sky and foreground.

ISO 400 · 1/250 sec. · f/8 · 300mm lens

When I shoot the moon I like to turn it into a symbolic beacon of the night (**Figure 5.27**). The rule of thumb when shooting the moon this way is that you should not let your exposure go much past four minutes. Because the earth is rotating, the moon will start to elongate after two minutes. While this is good for star trails, I have not seen many good moon trails—they tend to be moon blobs.

Figure 5.27
I had to time my exposure for when the moon wasn't behind the clouds, and I used an aperture of f/11 to turn it into a star point.

ISO 640 · 5 min. · f/11 · 21mm lens

The Full-Moon Advantage

There is nothing like being away from it all and shooting under the light of the moon. Try to find a place with little to no ambient light or light pollution. When you use the moonlight as your main source of light, you can attain creative long exposures (**Figure 5.28**). Deep shadows can be created under the moonlight, but their edges seem surreally soft. This is because the moon's light is slowly moving as the world turns.

Figure 5.28
Mono Lake is a very popular full-moon spot. There is very little light pollution, and the landscape looks like a lunarscape.

ISO 400 · 5 min. · f/5.6 · 21mm lens

Light pollution can spread farther in fog and clouds, filling blue night skies with too much magenta. If you are shooting raw files, you can cool down those photos in post. A full moon's white balance is somewhere between 3500 and 4000. If you are battling ambient light and light pollution, you might have to go as low as 2800.

This is where the six-stop rule discussed in Chapter 1 saves the day. A good starting point for an exposure lit only by the full moon is 6 minutes at f/8 and ISO 200. But do a test shot at 6 seconds at f/8 and ISO 12800 to work out the composition and exposure. This baseline exposure will change in a half-stop increment for each day before or after a full moon.

I typically spend 20 to 30 minutes working on one shot. I zoom into the image on my LCD to confirm that everything is in focus and make sure that the histogram isn't bunched up on the left. When shooting by the light of the moon, I want to overexpose my image so that the histogram is in the middle and leaning toward the right. This will make images on the screen look like they were shot during the day; these are called "day for night" shots (**Figure 5.29**).

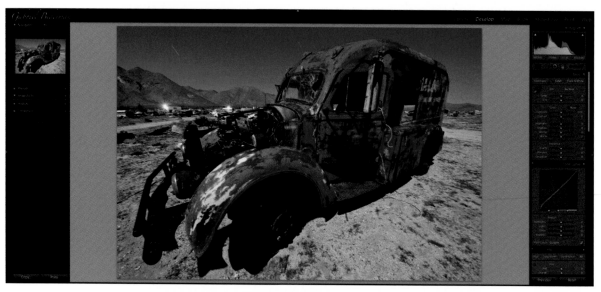

Figure 5.29 A typical "day for night" shot. Note that the histogram goes to the three-quarter mark, yielding lots of information in the image. Use your histogram as a reference for exposure in the field, and avoid crushing the histogram all the way to the left or right.

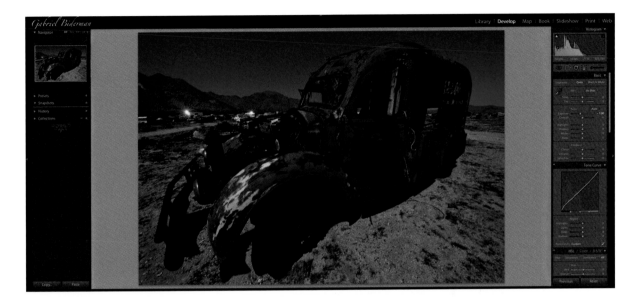

It is better to overexpose and bring in more information than to have too little. I then take these pictures into Lightroom and underexpose them by one-half to one stop to give them a more nighttime look (**Figure 5.30**). This technique gives you a cleaner file with less shadow noise.

Figure 5.30
Taking down my exposure by one stop has given this image a more night-time feel. Because I overexposed and underdeveloped the image, I have a smoother file with richer shadows.

Star Trails

Star trails cannot be seen with the naked eye; they can only be recorded by a camera. The apparent movement is due to the earth's rotation, not the stars' movement. Stars will start to trail at 15 seconds of exposure.

Star Trail Tips

- If you can't see any stars, neither can your camera.
- Your aperture controls how bright the stars will look. I try not to use an aperture smaller than f/8.
- Length of exposure and direction (north, south, east, west) determine how long your star trails will be.
- Star trails come in different colors. Younger stars burn hot and have a bluish color. Older, dying stars are warmer in color.
- The less light pollution and ambient light, the more stars will appear.

Let's take a closer look at the importance of the direction you point the camera. The earth rotates on its own axis, an imaginary line that runs from the North Pole to the South Pole. In the northern hemisphere, we have the bright North Star, Polaris, which is the closest star to the northern polar axis. Because the earth rotates on this axis, the North Star remains a star point throughout the length of the exposure. Stars closest to the North Star will have the shortest trails, whereas stars to the south will be the longest and straightest. There is no star near the southern axis. Stars will bend diagonally up in the east and diagonally down in the west. Bring a compass with you on a star shoot. In **Figure 5.31**, I pointed my camera south and limited my exposure to 7 minutes so I could get the straightest possible star trails.

Figure 5.31
Knowing which way the stars will "bend" helped me create these straight beams of light coming out of a "lighthouse."

ISO 200 • 7 min. • f/8 • 50mm lens

In order to get the incredibly long star trails seen in **Figure 5.32**, you will need an exposure equivalent to at least an hour. There are a couple of ways to do this. The most popular way is to take consecutive shots that will add up to 60 or 90 minutes; for example, 12 5-minute exposures. It is very easy to combine, or stack, those images in Photoshop (see Chapter 6). But when you're capturing those consecutive shots, the time between them can be no longer than 1 second. Use an intervalometer to set the exposure (5 minutes), the number of shots (12), and the duration between shots (1 second).

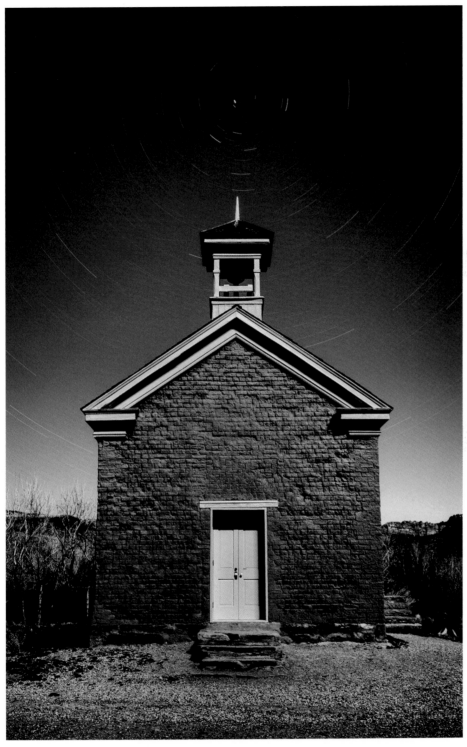

Figure 5.32
This is a single
1-hour exposure
pointing north; the
full moon is illumi-
nating the church
and foreground.

ISO 200 • 60 min. •
f/16 • 35mm lens

Five-minute exposures are easy to stack—unless it is above 75 degrees outside. Heat makes sensors noisier more quickly. At 65 degrees, you can probably get clean 5-minute exposures, but at 85 degrees you could be limited to 1 minute before noise in the image becomes excessive. This could force you to instead stack 60 1-minute exposures. Even with a 1-second interval between exposures, breaks in the trails may be seen when viewed at 100 percent or printed. This has become somewhat accepted, however, there are several plugins that will connect the lines for you.

The other way to capture longer trails is to commit to a single long exposure and turn on Long Exposure Noise Reduction (LENR). This is not the most productive way to capture long star trails, because your camera will lock down, as it takes an equivalent time to apply noise reduction (see Chapter 1). In my tests, Fujifilm X-Series cameras seem to be able to handle longer exposures the best.

Be creative with your placement of the North Star (**Figure 5.33**). The default is often to put the North Star in the middle, but you could also move it around or not include it at all. And you'll have a more diverse night portfolio if you include star trails of different lengths and shapes.

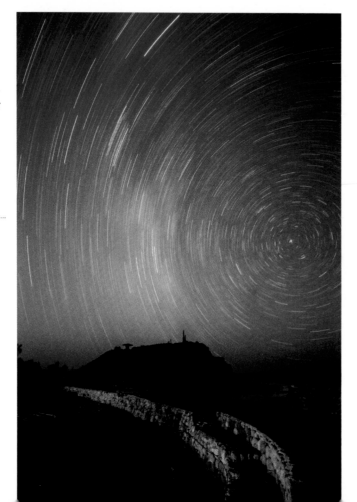

Figure 5.33
I placed the North Star to the right so the long western stars would seem like they were curving into the breaker below to form the letter S. This image suffers from long exposure noise because it was 80 degrees and I did not turn on LENR.

ISO 800 · 45 min. · f/8 · 28mm lens

Star Points

Star trails are great, but lately I've been more fascinated with star points and celestial skies. You'll need to rely on higher ISOs and shorter exposure times, but these images can be just as jaw-dropping as hour-long star trails. **Figures 5.34** and **5.35** are the same shot, one with star points and the other with star trails. Which do you like better?

The first factor you have to figure out is how long the exposure can be before the stars start to trail. This all depends on focal length. The more telephoto the lens, the more zoomed in you are on the stars' "movement," and the shorter times you will have. The best lens to use is a fast wide lens, something that opens up to f/1.4 or f/2.8. A 21mm 2.8 is my preferred star-point lens.

 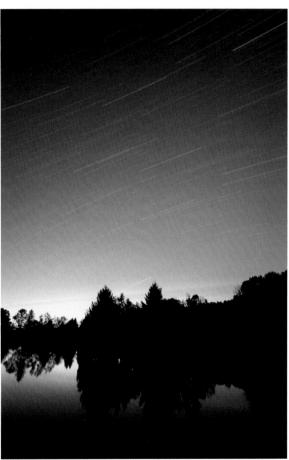

Figure 5.34 The 30-second exposure shows minimal movement in the stars, giving it a more celestial feel. I also light-painted the trees for 10 seconds to open up their shadows.

ISO 1600 · 30 sec. · f/2.0 · 28mm lens

Figure 5.35 A one-hour exposure pointing due south. Note that the stars trails in the middle are straight. They start to bend to the east or west as they move farther away from the south.

ISO 400 · 60 min. · f/16 · 28mm lens

The 500 Rule

The 500 rule is a simple way to figure out the best star-point exposure. For full-frame cameras, you divide 500 by the focal length of your lens to get the number of seconds you can expose before star trails begin to form. For example, 500 ÷ 50mm = 10 seconds. With a 21mm lens, it would be 24 seconds.

If you have a different sensor size, you divide 500 by the crop factor to figure out your new starting point. Nikon DX and Sony NEX are 1.5x and Canon EF-S is 1.6x, so they would be 333 and 312, respectively. For example, a Nikon D7100 with a 21mm lens would be 333 ÷ 21 = 16 seconds.

Now that you know how long your exposure can be, start playing with the aperture and ISO combinations. Celestial skies are better to capture when there is no moon, because more stars can be seen. Without the moon, the sky is dark, which forces you to use high ISOs and large apertures. A typical star-point photo with an exposure time of 24 seconds would use ISO 3200 at f/2.8.

When shooting star points, I try to find something interesting to silhouette against the starry night. The stars have more impact when you put them in perspective with something in the foreground (**Figure 5.36**).

Figure 5.36 I've never seen as many stars as I did this night. I worked the crosses at the top of the hill into my composition.

ISO 3200 • 15 sec. • f/1.4 • 50mm lens

The Milky Way

The stars and clouds of the Milky Way can be very elusive (**Figure 5.37**). You'll need to get to a place with very little light pollution from the months of February to September. If you are in the northern hemisphere, you'll find the Milky Way toward the south. In the southern hemisphere, you'll just need to look overhead. Use the 500 rule, and capture the universe we live in!

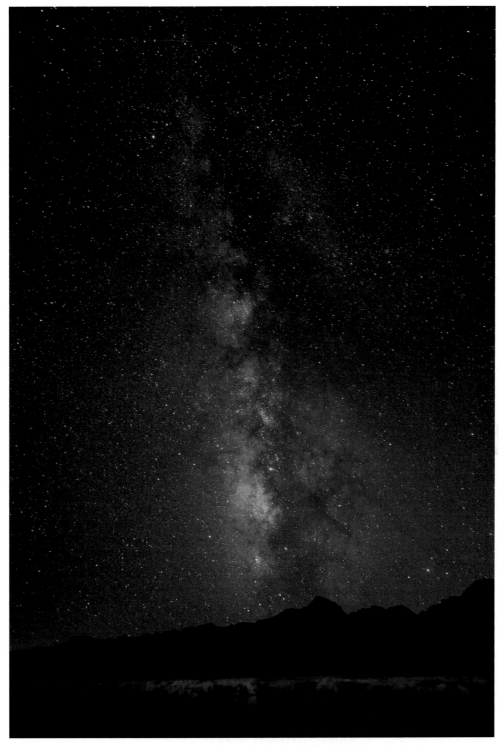

Figure 5.37
The Milky Way is within your reach if you can get somewhere remote before the moon rises.

ISO 6400 • 30 sec. • f/4 • 21mm lens

Fireworks

Everyone shoots fireworks, but many people fail because the lighting and timing can be so extreme. Separate yourself from the pack by bringing a tripod, a DSLR, and a zoom lens. Find the best vantage point from which to incorporate landmarks like bridges and buildings. If it is a popular event, you might have to stake your claim to a spot several hours before the fireworks go off. Make sure your camera is securely attached to the tripod, and watch out for people bumping into you, as they are often paying more attention to the sky than to what's around them.

Bring a black card that will cover your lens. Set your camera to Bulb, and use a remote release to trigger the exposure. Cover your lens with the black card before tripping the exposure, and only remove it when a firework explodes in the air. Once it explodes, cover your lens and keep exposing. Quickly remove and replace the black card for each firework that lights up the sky. This is a great technique for adding more than one ball of light without overexposing the image (**Figure 5.38**). After you have captured three or four fireworks, stop the exposure and start again. You'll have to be careful, because overlapping fireworks can make one area of the photograph too bright. Keep shooting, and you'll be sure to bring home a few bangers!

Fireworks Tips

- Find the ideal vantage point—fireworks are shot over water, and they will make great reflections.

- Be aware of downwind smoke and stray light from lampposts.

- Shoot raw, and turn noise reduction off.

- Use a tripod and a zoom lens; include the silhouettes of people watching.

- Set your ISO to the lowest number, and use an aperture of f/8 or f/11.

- Manual focus to infinity.

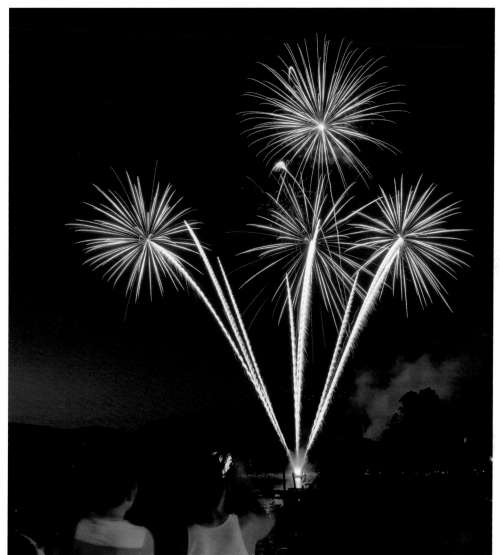

Figure 5.38
I held a black card over my lens and opened it up four times to stack four different fireworks. I included the people in the foreground to add a human element to the picture.

ISO 200 • 8.5 sec. • f/8 • 28mm lens

Fun at the Fair

Summertime rolls around and it is time to have fun at the fair! Most fairgrounds don't have a problem with photographers bringing their tripods, so turn their rides upside down with long exposures! Get to the fair early and scope out the scene. Find strong compositions, and come up with a list of eight to ten shots to hit once the sun starts to set. The magic hour will yield images with the most impact (**Figures 5.39** and **5.40**). The red and yellow lights of the fair blend beautifully with the cobalt sky. Fairs are bright, so two key accessories to bring are ND filters and a flash. During twilight, an ND filter will help you extend beyond 4 seconds. Use your big flash to create a slow sync effect. Experiment with firing your flash at the beginning or end of a long exposure (that is, rear or 2nd curtain sync). The flash will freeze an action, such as people swinging, and the longer exposure will layer the movement and the ambient light to create a very cool effect.

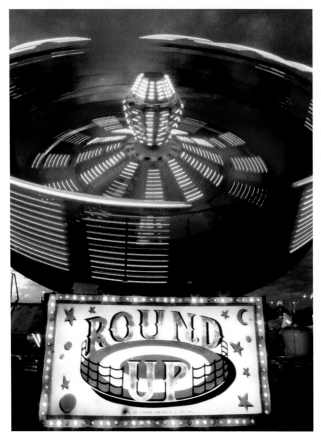

Figure 5.39 **Twilight at the Missoula fairgrounds.**

ISO 200 • 1/8 sec. • f/8 • 28mm lens

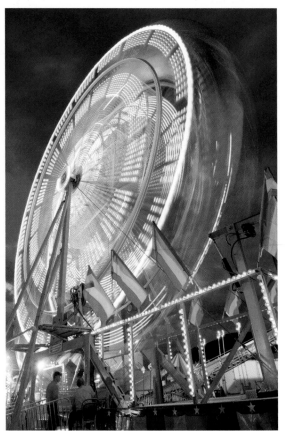

Figure 5.40 **It doesn't take long to capture the movement and lights of these thrilling rides!**

ISO 250 • 2.5 sec. • f/9 • 24mm lens

- Shoot during twilight, the best time to match the blue skies with the colorful rides.
- Emphasize motion. The movement of the rides will have more impact in exposures of 2 to 20 seconds.
- Freeze action with flash.
- Shoot low, and separate your subject from the rest of the scene.

Keep Clicking in Inclement Weather

Amazing photographs are ours for the clicking during bad weather, but use extra caution when bringing your camera into the rain or snow. Several companies make rain covers that you can wrap your camera and lens in to protect them from the elements. At the very least, use a lens hood to protect your lens from getting wet.

Right after a rainstorm is the perfect time to photograph, especially at night when the wet streets get an added boost from the reflections of street lamps and cars. Plus, most photographers will have packed up, so you'll have the streets to yourself!

I took a lot of shots of Boston's Bunker Hill during a light rainstorm. I was playing with exposures between 4 and 15 seconds. This made the moving cars disappear, leaving only the streaks of their red taillights (**Figure 5.41**). The red reflection on the wet street makes this shot and leads your eye to the top of the Bunker Hill Monument.

Shooting in the snow can be even more rewarding at night. Snow is reflective, and if you light it up with a flash it will be forever frozen in the image. Seems easy

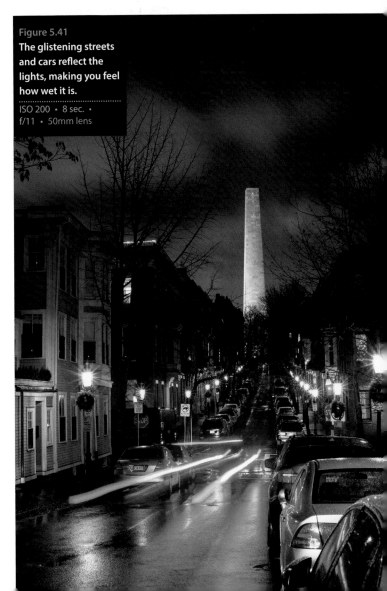

Figure 5.41
The glistening streets and cars reflect the lights, making you feel how wet it is.

ISO 200 · 8 sec. · f/11 · 50mm lens

enough, but here's a tip that will help you get the best snow shots. Make sure you bring a selection of CTO gels to go over your flash. If you don't match the flash's white balance (5500K) with the ambient white balance (3000–4000K), the snow will appear blue (**Figure 5.42**) because it is reflecting the daylight color temperature of the flash. So figure out your ambient white balance reading first, and then use the proper CTO gel. For city scenes with a lot of ambient light, you would typically use a full-cut CTO gel. Take your flash off the camera, and manually fire it at 1/8 or 1/16 power from different angles. Use a lower power so you are not lighting up the rest of the scene; the multiple pops of the flash help you fill the frame with snow (**Figure 5.43**).

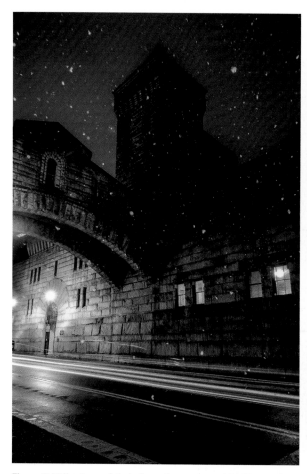

Figure 5.42 I set my white balance in-camera to 3200K to cool down the orange light coming from the street lamps. But a flash's color temperature is set to daylight, or 5500K, which, when mixed with the cooler white balance of the camera, creates blue snow.

ISO 200 • 12 sec. • f/11 • 28mm lens

Figure 5.43 I popped a handheld flash three times and used a full-cut CTO gel to make the snow whiter.

ISO 200 • 10 sec. • f/8 • 28mm lens

Fog

Nothing adds mood and atmosphere to a night scene like fog (**Figure 5.44**). It forms when there is water that is warmer than the surrounding air. It typically appears in the mid to late evening and will last until dawn, when the sun burns it away. Fog acts like a huge softbox, scattering the light around and reducing contrast and color saturation. Because the air is more reflective, your camera meter will think there is too much light. I suggest overexposing by at least a stop to compensate.

Look for concentrated or directional light sources, and see how they are interacting with the fog. Often, light streaks will make themselves more visible if you move just off-center from the light source. Lighthouses are the perfect subject when there is mist or fog in the air (**Figure 5.45**), because their light beams become more visible when reflected.

One final consideration when shooting during misty nights is that there is a lot of condensation in the air. If your camera is cooler than the outside air, water may appear on the surface of your gear, including the front of your lens. There are two solutions. Before bringing your gear outside, put it in a bag and seal it tight. Keep it in there until it has warmed up, which could take 30 or 40 minutes. You can also try warming up the camera with a hairdryer before bringing it outside. I always keep a thick lens cloth on hand to wipe dust and water off the front element.

Figure 5.44 (left)
Fog has a timeless quality. It desaturates colors and can make a scene ethereal.

ISO 1000 · 1/30 sec. · f/2.8 · 50mm lens

Figure 5.45 (right)
There was no way to avoid the flare from shooting directly at this light source. But the reward was getting an angle where the light was reflecting off the mist. You can also see the stars through the beams of light.

ISO 1600 · 15 sec. · f/5.6 · 18mm lens

Lightning

I'm no storm chaser, but shooting lightning is exhilarating. Use common sense when shooting during a lightning storm. The safest time is when it is several miles in the distance and can be shot with a focal length of 50mm or beyond. If you hear thunder, the lightning isn't far behind, and you should get to safety. Photographing lightning during the day is incredibly difficult without a device like the Lightning Trigger, an extremely sensitive optical flash sensor that fires your camera at the exact moment the lighting strikes. For night photography, you can just hold open your shutter until the lightning appears.

The trickiest part is knowing where and when lightning will strike. Patience is probably the most important factor. Track the storm and see what direction it is moving. Use a focal length that will get you close enough but also give you a wide field of view to anticipate the lightning strikes (**Figure 5.46**). Set the focus to manual and infinity.

Figure 5.46
A 50mm lens is great for tracking lightning. It has a wide enough angle of view to ensure that you get something as you follow the storm.

ISO 200 • 1 min. • f/4 • 50mm lens

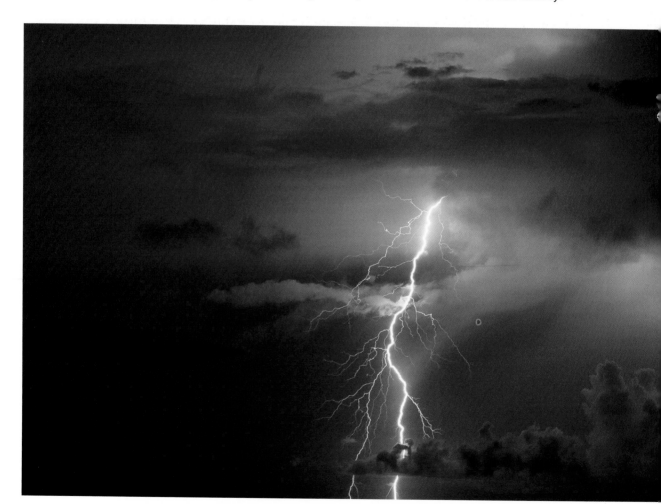

Shutter speed controls the ambient light, and aperture controls the brightness of the lightning. Keep your ISO low and figure out your maximum ambient exposure. If your meter says 30 seconds, take a test shot. If the sky is too bright, the lightning won't stand out. Better to underexpose at least one stop. Start with an aperture of f/5.6 or f/8; if the lightning is too bright, stop it down. Without a Lightning Trigger, it is all but impossible to time your shot for when a bolt strikes. Whether you get lightning in the shot or not, just keep shooting. Keep an eye on your exposures between shots, as they can vary quickly as the storm gets closer or farther away. If a big bolt of lightning lights up the sky, it's best to stop your exposure. This will ensure that your image is not overexposed from the big flash in the sky. **Figure 5.47** shows the two most common types of lightning: cloud to cloud, and cloud to land. Cloud to cloud isn't as bright but can bounce around in the clouds for a longer time.

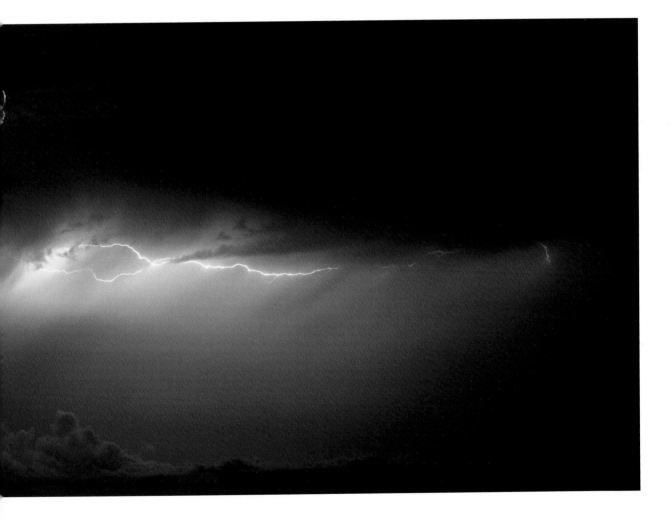

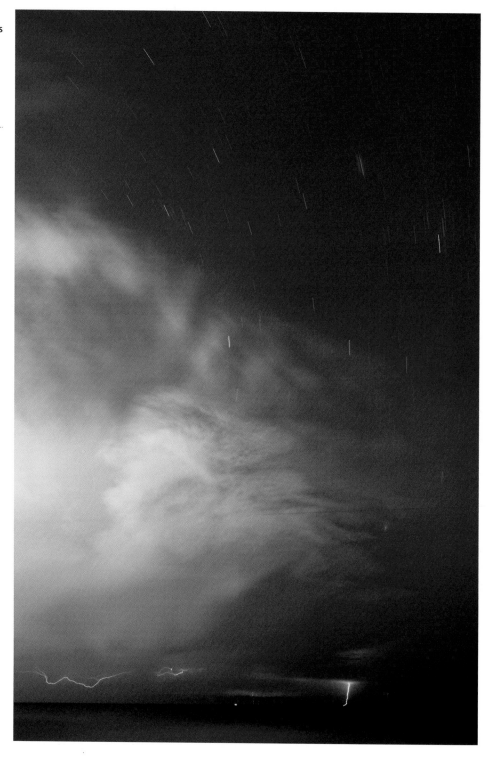

Figure 5.47
Normally lightning is not shot with super-wide lenses, but I wanted to capture the whole storm cloud. Getting the stars was a bonus!

ISO 200 · 8 min. · f/8 · 18mm lens

Pitfalls in the Dark

Strange things happen when the lights go out. Take your time at the beginning of a night shoot, and make sure that everything is secure. Let your eyes adjust to the light. I like to start with a few simple setups to warm myself up. Once I get rolling, I often don't stop until daylight breaks.

You are bound to experience difficulties in the dark, and often there is a simple solution. Let's take a look at some of the most common frustrations.

Extreme Lighting Conditions

Extreme lighting conditions can be a photographer's nightmare. Bright lights and shadows are always hard to mix. We've discussed how light painting can help, but some shadows, such as the dark sky, can't be lit, which means the dynamic range of the image can't be captured in a single shot. You can try bracketing and then blending them together as an HDR shot, but sometimes the range is too extreme and you just have to walk away and look for more ideas.

In **Figure 5.48**, I arrived after twilight, and when I tried to bracket longer exposures with detail in the sky, the image was filled with flare. It would have taken me hours in Photoshop to remove. But Corona Park has plenty of subject matter, so I found a more evenly lit scene and got some good shots.

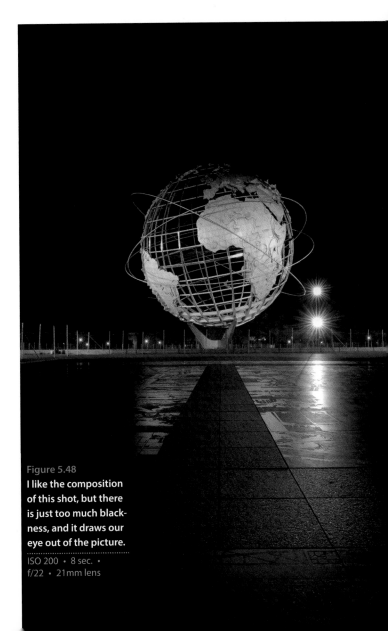

Figure 5.48
I like the composition of this shot, but there is just too much blackness, and it draws our eye out of the picture.

ISO 200 · 8 sec. · f/22 · 21mm lens

Streetlights and Flare

The best way to meter in intense lighting conditions is to pay attention to where the light is falling. Streetlights will remain white; we are not looking for any detail in them. But we certainly don't want the area around them to be overexposed. So set your meter to spot, and then adjust your exposure to make sure the sidewalk and buildings around the light retain detail. In **Figure 5.49**, the streetlights make the surrounding area too bright, so I adjusted my aperture to f/16 (**Figure 5.50**). Smaller apertures beyond f/8 turn streetlights from street blobs to star points. Be careful not to stop down too much, as it will make too many star points around the light and increase flare. To reduce flare, use a lens shade and keep your aperture at f/8 or below. In severe situations, a black card can block extraneous flare. But there will be times when you need to embrace the flare or remove as much as you can in post.

Figure 5.49 (left)
I generally like to shoot at a moderate aperture, like f/5.6, but when I have to deal with streetlights I close down to f/11 or f/16 to make the bulbs less like blobs.

ISO 1600 · 2 sec. · f/5.6 · 21mm lens

Figure 5.50 (right)
Here I used f/16 and created a starburst effect on the streetlight. Smaller apertures create this effect on direct light sources, like streetlights and the moon.

ISO 400 · 1 min. · f/16 · 21mm lens

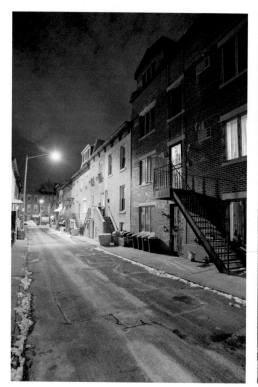

Planes, Boats, and Satellites

The lights from boats on the horizon and planes and satellites in the sky can cause havoc with long exposures. The only solution I can offer is to watch for the flight patterns of planes and try to time your exposure accordingly. Nothing is worse than a plane making its way right through your image at the halfway point of a long exposure. Removing it is tedious, but sometimes you can try to work the planes into the scene, like in **Figures 5.51** and **5.52**.

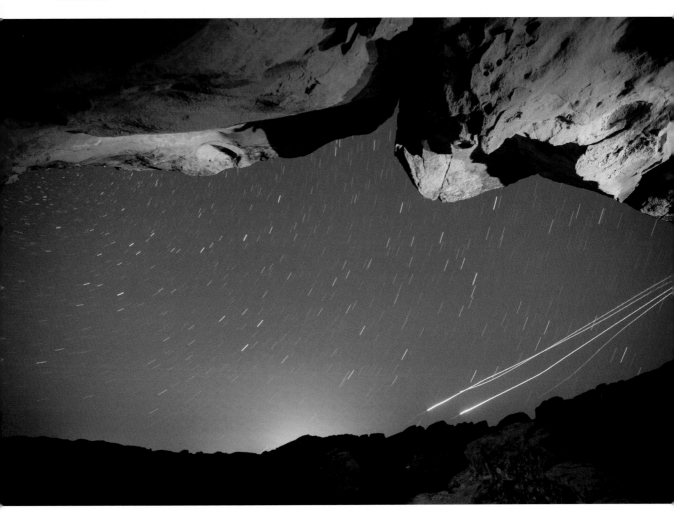

Figure 5.51 I wanted this image to be the Neanderthal's view of a starry night and was bummed when I saw airplanes fly into the frame. But I think the airplane trails make it post-apocalyptic.

ISO 800 • 8 min. • f/5.6 • 18mm lens

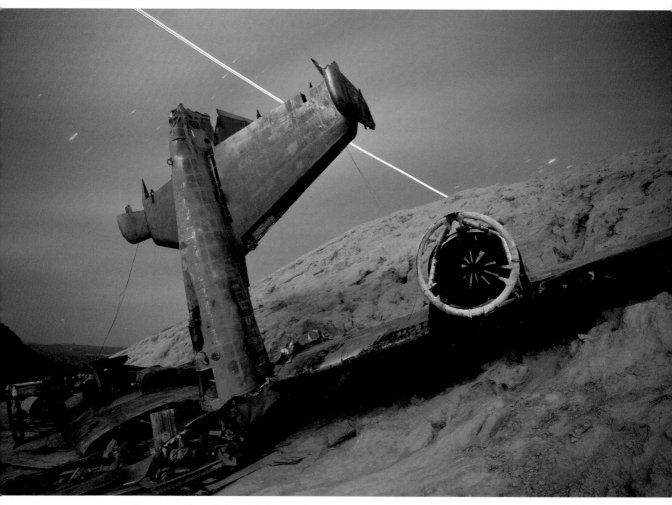

Figure 5.52 If you find an old plane crash from a movie set, then it is certainly OK to incorporate an airplane trail! Note that the clouds break up the star trails.

ISO 800 · 6 min. · f/4 · 21mm lens

Chapter 5 Assignments

Shoot the moon

Get away from it all the next full moon. Join one of the many full-moon workshops, or find a rural location that is away from all the light pollution. Get there before the sun sets, and shoot the moon as it rises with a 70–300mm or longer lens. Shoot it during twilight with something strong in the foreground. Then spend the rest of the night operating by the light of the moon. It is guaranteed to be therapeutic as well as invigorating.

Star points or star trails?

Which do you prefer? Why not try them both and then use whichever one works best in the scene. Use the 500 rule to figure out your optimal shutter speed for star points.

Get a feel for how star trails bend. At the same location, do 4- to 8-minute exposures facing north, south, east, and west. Then commit to an hour-long star trail facing north. You can either use the star stacking method or turn on Long Exposure Noise Reduction for one of your last shots of the night.

Reinterpret the city

Challenge yourself to reinterpret your city or town. It doesn't matter how big or small it is. Find a unique vantage point, shoot while it is snowing, or shoot just after a rainstorm when the streets glow. Look for intriguing motion that will separate your shot from the rest.

Share your results with the book's Flickr group!
Join the group here: www.flickr.com/groups/night_fromsnapshotstogreatshots

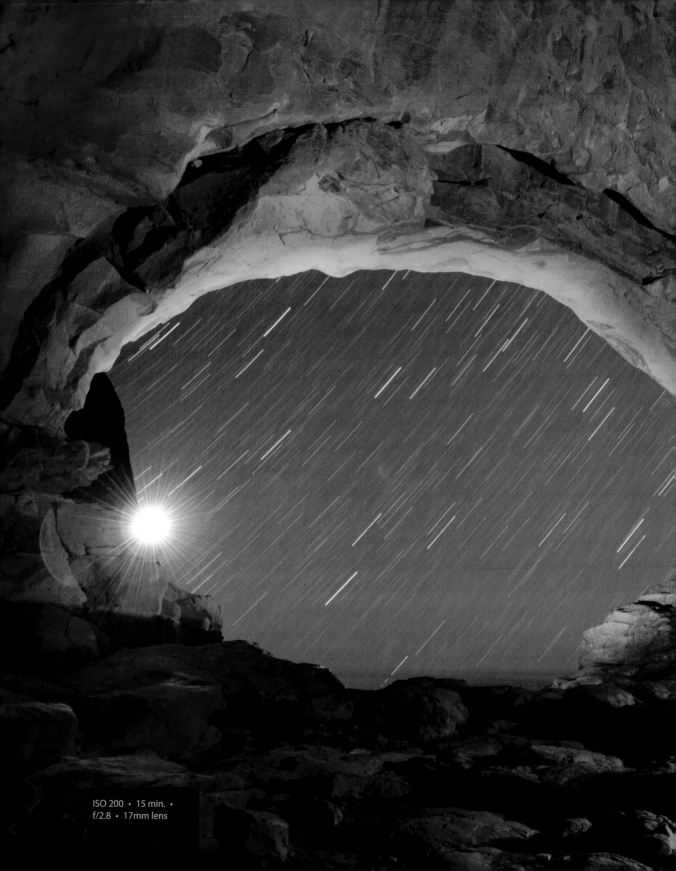

ISO 200 · 15 min. ·
f/2.8 · 17mm lens

6
Processing Your Night Life

Developing That Night Look

The previous chapters have shown us that careful attention to detail while shooting will provide the best possible image files. Having the best possible file is the first step in creating great night photography. The next step is your personal interpretation of the scene.

Ansel Adams said, "The negative is comparable to the composer's score and the print to its performance. Each performance differs in subtle ways." This quote is every bit as important today as it was 50 years ago. Adams used the darkroom to finalize his vision, to create his performance. Today we use our computers to interpret (or reinterpret) our files and bring our ultimate vision to life. Once you begin to see the limitations of the camera, it's time to explore the possibilities of postprocessing.

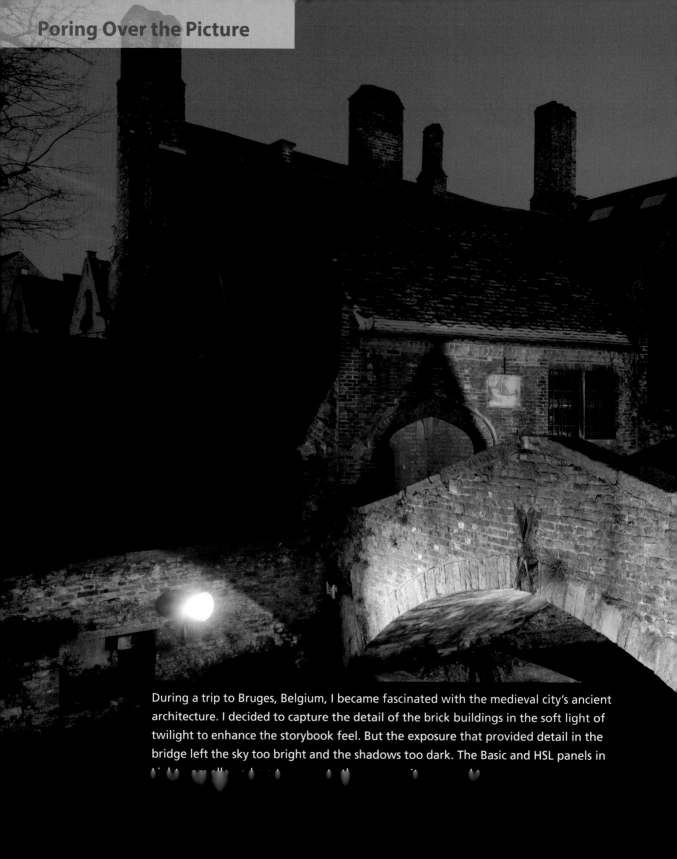

During a trip to Bruges, Belgium, I became fascinated with the medieval city's ancient architecture. I decided to capture the detail of the brick buildings in the soft light of twilight to enhance the storybook feel. But the exposure that provided detail in the bridge left the sky too bright and the shadows too dark. The Basic and HSL panels in

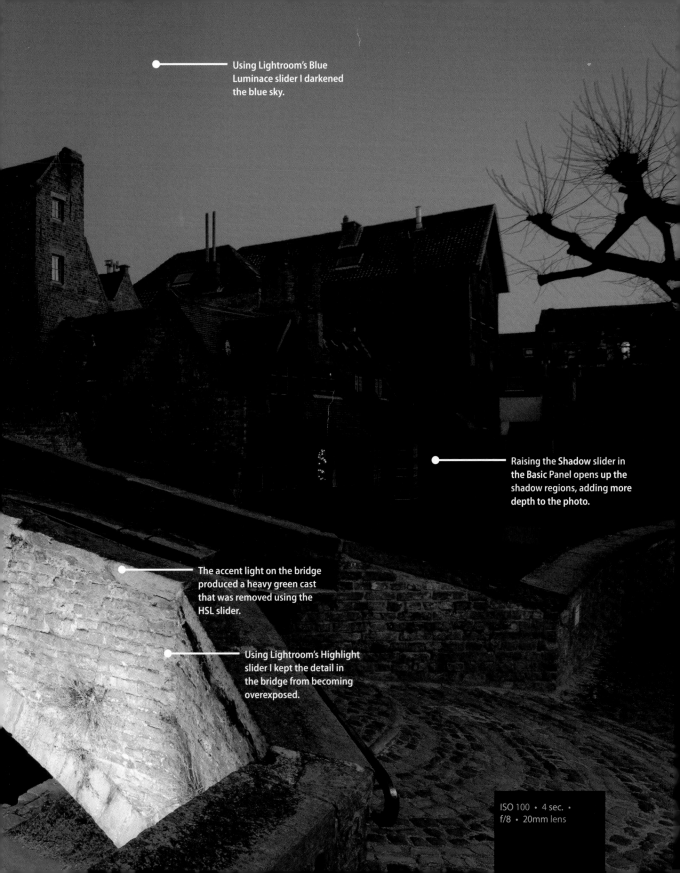

Using Lightroom's Blue Luminace slider I darkened the blue sky.

Raising the Shadow slider in the Basic Panel opens up the shadow regions, adding more depth to the photo.

The accent light on the bridge produced a heavy green cast that was removed using the HSL slider.

Using Lightroom's Highlight slider I kept the detail in the bridge from becoming overexposed.

ISO 100 • 4 sec. • f/8 • 20mm lens

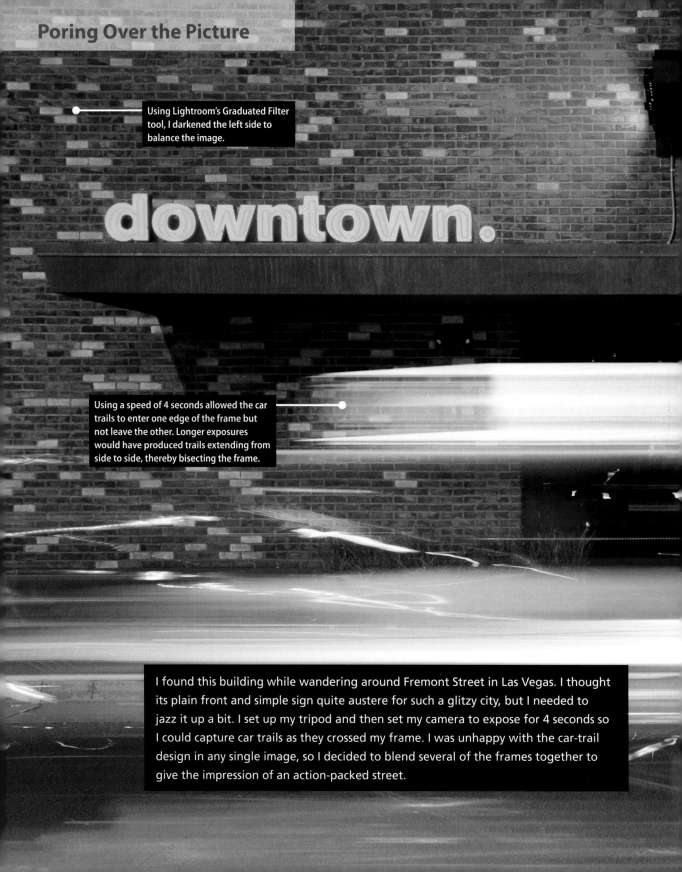

Using Lightroom's Graduated Filter tool, I darkened the left side to balance the image.

Using a speed of 4 seconds allowed the car trails to enter one edge of the frame but not leave the other. Longer exposures would have produced trails extending from side to side, thereby bisecting the frame.

downtown.

I found this building while wandering around Fremont Street in Las Vegas. I thought its plain front and simple sign quite austere for such a glitzy city, but I needed to jazz it up a bit. I set up my tripod and then set my camera to expose for 4 seconds so I could capture car trails as they crossed my frame. I was unhappy with the car-trail design in any single image, so I decided to blend several of the frames together to give the impression of an action-packed street.

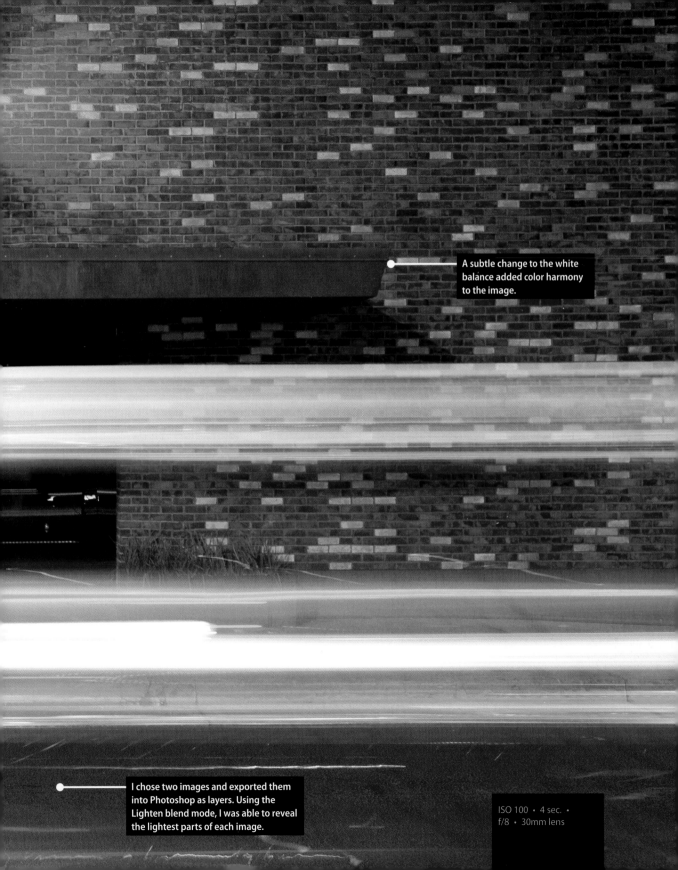

A subtle change to the white balance added color harmony to the image.

I chose two images and exported them into Photoshop as layers. Using the Lighten blend mode, I was able to reveal the lightest parts of each image.

ISO 100 • 4 sec. • f/8 • 30mm lens

Workstation

To capture great images, you need a decent camera, a tripod, and a lens. To edit them, you'll need a decent workstation. A barebones computer setup consists of a moderately powered computer, a reliable monitor, a monitor calibrator, and plenty of hard drive space. Mine consists of an Apple MacBook Pro laptop, an Apple 27-inch monitor, an X-Rite ColorMunki monitor calibrator, several portable hard drives, and a host of handy extras such as the Wacom Intuos5 tablet. While slightly more expensive than my original dark-room, the computer workstation is infinitely more powerful.

Computers

Although you don't need to purchase the most expensive computer, you should steer away from the cheapest models. Macs and Windows machines come in a range of models, and both run the industry-standard image processing software. Although I work on a Mac, I recommend using the platform you are most familiar with.

The bottom line for computers is speed, and for night photography, we need as much speed as we can afford. Almost all computers these days come with very fast processors (2.5 GHz is a good starting point), but not all come with enough RAM. Image processing software is very demanding, and it needs a lot of RAM. I recommend you have at least 8 GB of RAM to keep your system running smoothly. When it comes to choosing between more RAM and a faster processor, you'll get more speed for your money with extra RAM.

Laptop or desktop? Modern laptops pack a lot of power into a very small package, but you pay a premium for this ability to process your images on the road. For less money, you can purchase a more powerful desktop model. Another consideration is that most laptop screens are insufficient for critical image processing. While they may look fine for playing movies and writing an email, they lack the higher quality of a desktop monitor. I recommend factoring in the price of a separate external monitor when pricing a laptop.

Monitors

The computer monitor is the all-important link to your images. Having a dependable monitor allows you to adjust your images with confidence. Less expensive LCD and LED monitors (especially those on laptops) change contrast and brightness as your eyes move off-axis. This makes it hard to know when your adjustments are just right. Monitors have gained in quality while dropping in price over the last several years, so it's no longer nec-essary to spend thousands of dollars to get an accurate monitor. If you are using a Mac, any of the iMacs or desktop displays will suffice. For Windows users, there are plenty of brands that offer high-quality monitors. One of my favorite brands is NEC. They offer a

great 24-inch monitor that's more than adequate. As with computers, you don't need the most expensive monitor, but stay away from those below $500; they typically don't provide the needed quality.

Screen Calibration

Once you've purchased your monitor, it's time to consider a color calibration system to keep it accurate. Over time, your monitor will display color, contrast, and brightness differently. It's the job of the calibration system to keep it displaying accurately. A typical system consists of a disc of software and a piece of hardware called a colorimeter. Install the software, launch the program, and follow the (usually) simple step-by-step instructions to calibrate your screen. Recommendations vary on how often to re-calibrate, but once every several weeks should be fine.

Hard Drives

Modern high-resolution digital cameras produce enormous files that require lots of storage space. Most factory-installed hard drives (especially on laptops) don't provide enough space to store our software, personal files, *and* digital images. I like to store all my photographs on one drive, separate from my personal files. This drive is then backed up to two other drives, one at my office and the other offsite. This system safeguards against drive failure as well as against fire, flood, and so on. As the old saying goes, "the question is not if a drive will fail, but when will it fail." I recommend that you purchase several high-speed portable hard drives, 1 or 2 TB in size, with USB 3 or Thunderbolt connectivity. These will provide fast data transfer and ample storage, and they'll allow for flexibility in a backup plan.

To back up my drive, I use a program called Carbon Copy Cloner (for Mac), which can be found at www.bombich.com. Windows users may like Acronis True Image from www.acronis.com. Backing up your images is a crucial step in digital imaging. Purchase extra drives and backup software to avoid the headache and heartache of image loss!

Lightroom Is the New Darkroom

Once your computer, monitor, and hard drives are set up, it's time to choose some software. Although there are many companies producing image editing software, Adobe remains the industry standard. Their products are stable, powerful, and well designed, and they were built using direct input from photographers.

Like most professional photographers, I use Adobe Photoshop Lightroom for the bulk of my computer work, including importing, organizing, keywording, making primary global adjustments, and exporting. For finishing touches or special techniques, I export my images to Adobe Photoshop. In this chapter, I show you some of the more important operations in Lightroom and Photoshop.

Lightroom Workflow

Most of us enjoy taking pictures and then enhancing them on the computer. What we find less enjoyable is image management: organizing, keywording, rating, and keeping track of our photos. This is mundane but important work. My suggestion is to establish a repeatable workflow so you can power through the boring work and move on to creating your night photography masterpieces.

My basic workflow begins and ends in Lightroom:

1. Import images, using Lightroom's Import dialog.

2. Add metadata to the files: name, location, keywords, and rating.

3. Make global adjustments: brightness, contrast, and color.

4. Make local adjustments: darken or brighten specific areas of the photo.

5. Export to Photoshop for additional techniques.

6. Save, and return to Lightroom for printing or exporting.

Importing Your Images

The easiest way to get your photos from your camera to your computer is by using Lightroom's Import dialog. If the Import dialog does not appear automatically when you insert your memory card into the card reader, it's time to visit Lightroom's Preferences panel. On a Mac, choose Lightroom > Preferences; on Windows, choose Edit > Preferences. Then click the General tab and the Show Import Dialog When a Memory Card is Detected check box.

The Import dialog (**Figure 6.1**) is fairly simple, but there are a few places that you need to pay attention. The red area shows where the images are coming from, which will usually be your camera or memory card. The green area shows your images; any photo with a check mark in its upper-left corner will be imported. When importing from your card or camera, click either Copy or Copy as DNG in the green area.

Figure 6.1

The Import dialog in Lightroom. The red area tells you where your images are coming from. The green area shows you which images will be imported. The blue area tells you where they are going.

The blue area is where people sometimes get into trouble. This area determines what will happen to the images upon import as well as where they will be copied to. Here are the settings to apply:

- In the Render Previews menu, choose Embedded & Sidecar for the fastest imports.

- Under Apply During Import, you can apply a personalized develop setting. You can also apply a personalized metadata template, including your name and copyright. These settings will apply to all imported images, saving you tons of time.

- The Organize menu determines how the images will be organized on your computer: choose either By Date or Into One Folder.

- The lower section of the Destination Panel indicates where your photos will be copied. In Figure 6.1, you can see that the images will be copied into my Pictures folder on my Macintosh HD. Inside this folder, Lightroom has created a 2013 folder, per my choice to organize By Date. The small + next to the 2013 folder indicates that this is a new folder that Lightroom has created.

Take your time when making choices in the blue area. A simple mistake here can make it difficult to locate your photos later on. Always know where you are telling Lightroom to put your images.

I organize my photos by subject matter. The downside to this method is that when I come to the blue section, I must decide exactly where to place my images. Every time. If you decide to organize by date, your choice stays the same each time you import. The downside to the date method is that you have to remember exactly what date you shot the picture or be diligent about adding keywords. Trying to locate images without keywords or the memory of the date will be an exercise in frustration with this method.

Creating a Metadata Preset

Creating a metadata preset is an easy and fast way to put your name, email, copyright notice, and other pertinent information into every photograph you import. In the blue area of the Import dialog, click the Metadata drop-down menu and choose New (**Figure 6.2**). The resulting dialog allows you to create a new preset that can be applied during the import process. Begin by giving it a useful name, such as Copyright. Next, fill out the IPTC Copyright and IPTC Creator sections, keeping the remaining sections blank and unselected, as shown (**Figure 6.3**).

Figure 6.2 **Choose New from the Metadata drop-down menu.**

Figure 6.3 **Fill out the IPTC Copyright and IPTC Creator sections, and leave all other boxes blank.**

Library Module

Once your images begin to import, you'll see them appear in the Library module's Grid view (**Figure 6.4**). Notice that my metadata template was automatically applied to all images. This is a real time-saver.

Notice that you're viewing the images in a place called Previous Import. These images actually live in the 2013 folder, however. Right-click any image, and choose Go To Folder In Library to switch the view so you can see the contents of that folder. It's important to know what folder you're in when you export and import images in Lightroom. If you remain in the Previous Import area, you will not see the new image when you return.

Figure 6.4
The Library module's Previous Import area.

Keywords

As soon as your images are imported, you should keyword them. I know it's a drag, but it's even worse to be unable to locate your images! Get in the habit of adding keywords right away, and you'll save yourself time and grief. On the right side of the Library module, click in the "Click here to add keywords" box and begin to type (**Figure 6.5**). Words can be separated by a comma and a space, just as if you were writing a sentence. You can also have two-word keywords, such as City Lights or Car Trails. Add whatever words remind you of that photo. Anything that you might type in later to find the image will work as a keyword.

Figure 6.5
Adding keywords
is easy. Simply
type them into the
"Click here to add
keywords" box.

Don't use a city or state as a keyword, because there's a place for those in the Metadata template. From the drop-down menu at the top of the Metadata panel, choose EXIF and IPTC (**Figure 6.6**). This makes the most commonly used meta-data fields visible. Scroll down to find the area containing Sublocation, City, State, and Country. If you want to add this information, this is the place to do it. Remember that you can add metadata or keywords to more than one image at a time. Start big and work small. If all the images are from one area, select them all and fill out the City, State, and Sublocation fields. Then select the next largest group of images with common attributes, and enter some common keywords for them. In this way, you'll work your way down to the few images that need individual keywording.

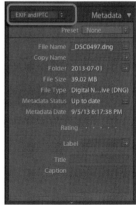

Figure 6.6 Choose EXIF and IPTC to access the most commonly used metadata fields.

Ratings

Once you've added keywords and metadata to your images, it's time to pick your favorites. Don't immediately delete images. After further consideration, you may find a pleasant surprise in images you initially overlooked. I use the rating system (stars) to separate the good from the bad. Click an image to make it active (highlighted), and then press a number key (1–5) on your keyboard to give it a star rating. If I decide an image is worth working on, I give it a one-star rating. Once I have begun to work on an image, it becomes a two-star image. When an image is finished, it becomes a three-star image.

Organization

As mentioned, there are two basic ways to organize your images: by date or by subject. Some people use a mixture of the two. Whichever method you use, it's imperative that you can locate your images. Finding recent images is easy. It's finding the images from four years ago that can be problematic. If you have keyworded your images and rated them with stars, locating them is easy.

1. Click All Photographs in the Catalog panel (**Figure 6.7**).

Figure 6.7
Click the Text tab in the Library Filter bar to reveal the search field.

2. Choose View > Show Filter Bar, or tap the \ key to make the Library filter visible.

3. Click the Text tab, and from the Text menus, choose Any Searchable Field and Contains All. Then type in your keyword.

 In an instant, Lightroom displays the images in your catalog that contain that keyword.

4. To winnow the results down further, click the Attribute tab and another panel will drop down. Click the third star if you want to see only three-star images that contain that keyword. Clicking the third star again will reset.

5. Click the None tab in the Library Filter bar to disable the filter.

Stay Inside Lightroom

Once you begin organizing your images using Lightroom, it's imperative that you don't try to work with them outside Lightroom. For example, if you move a file from within a Finder window, Lightroom will be unaware of this move. The next time you launch the program, you will see a question mark next to your image. This is Lightroom's way of telling you that it doesn't know where the image is located. Click the question mark to show Lightroom the photo's new location. Lightroom is a database program, so it likes to keep track of all changes made to an image. You can move, delete, edit, and export from within Lightroom; take advantage of this one-stop shopping.

Developing for the Night

When you're finished with the keywords and ratings, it's time for the fun. Click the Develop button in the upper-right corner of Lightroom to go to the Develop module. This is where the real magic happens.

Develop Module

Adobe has done a great job designing Lightroom's interface (**Figure 6.8**). Everything is easy to see and within easy reach. The image in the main window is the active file from the Library module, and it remains the active file once you're in the Develop module. This is the image that will be altered once you start making adjustments. The filmstrip across the bottom of the screen shows you the contents of the active folder or collection. To edit another image within that folder, simply click the image in the filmstrip. The panels on the right side of the screen contain the adjustments that you'll apply to the active image. Click a left-facing arrow to expand a panel and reveal its sliders; click again to collapse the panel.

Figure 6.8
Lightroom's
Develop module.

Basic Panel

The Basic panel is the area where you'll do most of your heavy lifting. From within this panel, you can control the brightness, color, and contrast of the image.

White Balance

The WB (white balance) menu (**Figure 6.9**) allows you to choose from several presets. These presets are Adobe's version of the white balance settings on your camera. The Temp and Tint sliders allow you to manually adjust color. By default, when you open an image in the Develop module, the WB menu is set to As Shot, and the Temp and Tint sliders reflect the color temperature setting. Choosing a different WB setting simply moves the sliders to a predetermined location. Notice that the Temp and Tint sliders display color ramps—move the Temp slider to the right, and the selected image will become more yellow as the slider moves over the yellow part of the color ramp.

Figure 6.9 **Control the colorcast of an image here.**

As-Shot White Balance Numbers

The official Kelvin temperature of daylight is 5500K. This means that an image from a camera set to Daylight white balance and imported into Lightroom should read 5500 on the Temp slider and 0 on the Tint slider. The reason it may not is because of Adobe's interpretation of the raw file. Let's just say that Adobe doesn't always agree with the camera manufacturers. This is not a problem, however, because it's just a simple disagreement of numbers. The colors will still look the same even though the numbers may appear off. For example, an image shot on my Nikon set to Daylight reads 4900 on the Temp slider and 0 on the Tint slider when imported into Lightroom, but it looks the same as it did on the back of the camera. For this reason, you should pay more attention to the look of the image than to the numbers on the Temp and Tint sliders.

It's best to set your white balance to the desired setting while you're shooting, rather than adjusting it in Lightroom. It's far better for the health of the file to make small changes that subtly tweak the image as opposed to large changes that shift it dramatically. This is especially important with exposure but also applies to white balance. I try not to change the Temp slider more than a couple of thousand points.

Figure 6.10 was shot using Daylight white balance. Notice that Lightroom interprets this file as 4900 temperature and 0 tint. Due to the heavy influence of sodium vapor (common in city light sources), the image appears overly pink/orange.

Figure 6.10
This scene was photographed using the Daylight white balance setting.
ISO 400 • 30 sec. •
f/11 • 35mm lens

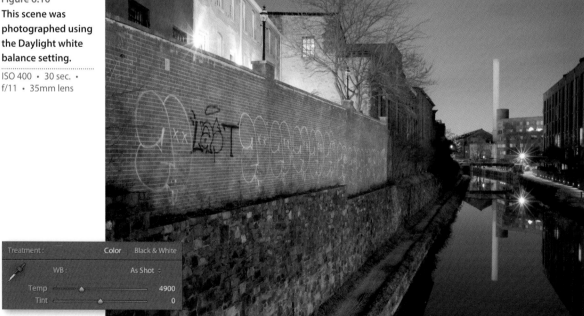

By moving the Temp slider to 3250 and the Tint slider to +10, I was able to remove the colorcast caused by the city lights (**Figure 6.11**).

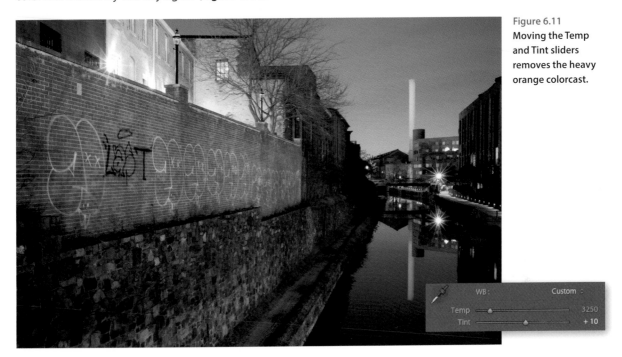

Figure 6.11
Moving the Temp and Tint sliders removes the heavy orange colorcast.

The dominant light source in a scene influences the colorcast of the resulting image. In **Figure 6.12**, also shot with the Daylight white balance setting, there was not as much sodium vapor lighting, so the color is more natural.

Long exposures can also affect your colorcast. It seems that most digital camera sensors produce overly warm images during exposures that last into the minutes. The five-minute exposure in **Figure 6.13** was captured using Daylight white balance, and it's a little warm for my taste. Moving the Temp slider from 4900 to 4200 cools the image down and better provides that nighttime feel (**Figure 6.14**).

Figure 6.12
Daylight white balance is acceptable in some cases. Here, the scene is dominated by halogen, rather than sodium vapor, lighting.

ISO 100 • 4 sec. • f/11 • 16mm lens

Figure 6.13 (left)
The long exposure imparts a warm colorcast.

ISO 640 • 5 min. • f/8 • 24mm lens

Figure 6.14 (right)
Moving the Temp slider from 4900 to 4200 gives the image a nighttime feel.

ISO 640 • 5 min. • f/8 • 24mm lens

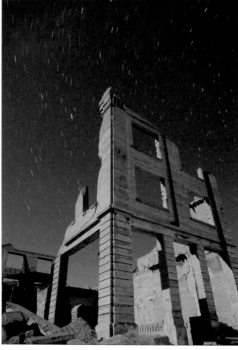

Tone

The Tone section of the Basic panel is where you will enhance the overall brightness and contrast of the image. Each slider affects a certain portion of the histogram (**Figure 6.15**).

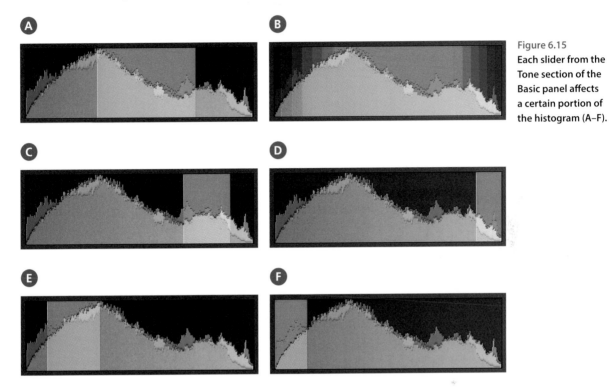

Figure 6.15
Each slider from the Tone section of the Basic panel affects a certain portion of the histogram (A–F).

The Exposure slider controls the overall brightness, or luminance, of the image. It's similar to giving the image more exposure in the camera. The red area indicates the part of the histogram on which the exposure slider has the most effect (**A**). Because it affects mainly the midtones, a slight increase in exposure generally does not overexpose the highlights.

The Contrast slider adjusts the overall contrast of the image. As you can see from the red overlay (**B**), it has the most effect in the midtones. As it nears the highlights and shadows, the effect decreases.

By moving the Highlights slider, you can brighten or darken the lighter portions of the image without affecting the brightest whites (**C**). There is some overlap, however.

The Whites slider affects mainly the brightest portion of your image (**D**). You can occasionally bring back some detail in the whites by moving this slider to the left to darken. Don't count on this slider, however. You should always check your histogram in-camera to ensure that you are not losing detail in important highlight areas.

The Shadows slider can darken or lighten the darker areas of your images. This slider will try to leave the deepest blacks in your image untouched, but again, there is a little spillover (**E**).

The Blacks slider mainly affects the deepest blacks in your image. Move the slider to the right to lighten and to the left to darken (**F**).

Tone Panel Workflow

This first step in assessing your image is to look at its overall brightness. Does the image feel too light or too dark? Adjusting the Exposure slider will correct the global luminance of the image. If you continually find yourself going past +1 on the Exposure slider, give your images more exposure out in the field.

The next thing to look for is the overall contrast of the image. Overall contrast describes the deepest blacks to the brightest whites. When you have good overall contrast, your image glows. Most images made at night should exhibit good overall contrast. **Figure 6.16** shows a histogram with low overall contrast (notice the weak shadows and highlights) and that same histogram after it has been adjusted for better overall contrast. The best way to adjust overall contrast is to use the Blacks and Whites sliders.

Figure 6.16 In the histogram showing low overall contrast (left), notice that the image information does not reach the corners of the box. Moving the Blacks slider to the left and the Whites slider to the right increases the overall contrast, and the edges of the image information now touch both corners (right).

The Shadows and Highlights sliders tweak those areas of your photograph. It's amazing what a small adjustment to the shadow and highlight regions of an image can reveal. A common adjustment for a night image is to raise the Shadows slider to brighten the shadows but then move the Blacks slider back down until the histogram touches the edge, thereby giving it the pure black that's necessary for this type of imagery.

The Contrast slider adds overall contrast to an image. It does this by spreading out your midtones. If you first adjust your Blacks and Whites sliders, you'll notice that only a modest adjustment to the Contrast slider is necessary. Use caution when using the Contrast slider—too much of an adjustment can rob the image of the subtle gradients between tones. With most Lightroom adjustments, less is more. Always err on the side of too little rather than too much.

Figure 6.17 shows an unadjusted image. Notice that the shadows seem somewhat muddy, with no real separation in value. The two triangles in the upper corners of its histogram are white rather than gray. These are called clipping warnings. If they're white, it means that clipping is occurring in that area. It's not uncommon to have some shadow clipping in night images. The moon in this image is the culprit for clipping the highlights.

Figure 6.18 shows the same image after adjustments were made. A slight increase to +20 on the Exposure slider brightened the image. A heavy increase to +78 on the Shadows slider, as well as a decrease to –4 on the Blacks slider, lightened and separated the tones in the shadows.

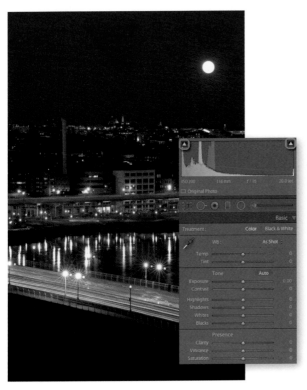

Figure 6.17 The unadjusted image.

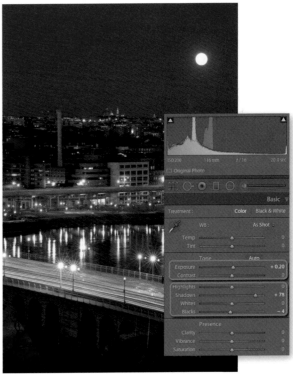

Figure 6.18 Now that the image has been adjusted, it has more life. The values in the shadows have been separated, and the brightness is more luminous.

Shadow and Highlight Clipping

Clipping is the term for lost detail. If your shadows are clipped, they are pure black without any detail. If your highlights are clipped, the whites are pure white without any detail. In general, images can withstand a little clipping in the blacks (especially nightscapes). Highlight clipping can be somewhat off-putting, however, depending on the image. In scenes that include city lights, you can expect to have some clipping in the highlights.

The histogram in the Develop module displays clipping in several different ways. When the histogram touches both corners (**Figure 6.19**), it means there is detail in both the highlights and the shadows. Because the edges are so close, it also means that this image has good overall contrast. You can also click the clipping warning triangles to reveal the clipping in the image. A red overlay indicates highlight clipping; a blue overlay indicates shadow clipping (**Figure 6.20**). Click the arrows again to disable this feature. For a quick look at which areas are clipping, hover your cursor over the triangles: While your cursor is there, the colored clipping will show on your image. When you remove your cursor, it disappears from view.

Figure 6.19 **This histogram shows good overall contrast, with no clipping of shadows or highlights.**

Presence

In the Presence section of the Basic panel, you'll see the Clarity, Vibrance, and Saturation sliders. The Clarity slider controls contrast between very close tones and colors, and increases contrast around the edges of near tones. This slider is similar to sharpening but has a broader effect. A little clarity gives your images more punch. My starting point is +10 for night photography. Magnify your image to 1:1 when making this adjustment so you can avoid creating an overly "crunchy" look.

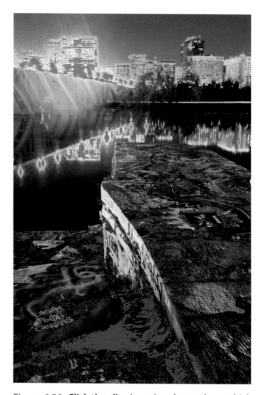

Figure 6.20 **Click the clipping triangles to show which tones are being clipped.**

Saturation and vibrance are similar to one another in that they both boost color intensity. Saturation increases the intensity of all colors equally. Vibrance increases the less saturated colors more and has less effect on the already saturated colors. Vibrance also has a bias toward blues and greens and tends to boost those colors more than reds and yellows. A soft touch is required with all of these sliders. Less is more! It's easy to go too far with this set of sliders and end up with crunchy, overly saturated images.

HSL Panel

The HSL Panel is a powerful and important stop for the night photographer. This panel allows you to adjust the hue, saturation, and luminance of individual colors in your image. By looking at the color ramps on the sliders, you'll get a good idea of what's going to happen when you make an adjustment (**Figure 6.21**).

Hue is the color itself. Moving the Red slider to the right makes reds anywhere in the image turn more orange. Move it the left, and the reds become more magenta.

Saturation is the intensity of the color. Moving the Red slider to the right intensifies the reds; moving it to the left desaturates the reds.

Luminance is the brightness of the color. Again, look to the color ramp. Moving the Red slider to the right brightens the reds; moving it to the left darkens the reds.

The easiest and most accurate way to alter colors in the HSL panel is to use the target button that appears to the left of each adjustment (**Figure 6.22**). By using this button, you are choosing the exact color you want to alter, rather than guessing at the color. Many times, what we think is a green is actually a combination of yellow and green, or green and cyan. The target button doesn't overlook these subtleties and will move two sliders in proportion to exactly reflect that color.

Figure 6.21 **The color ramps on the sliders show what will happen as you move the slider in that direction.**

Figure 6.22 **Clicking the target button allows you to adjust exactly the color you choose.**

Using these buttons is easy. Simply click the button associated with the change you want to make. Let's say you want to change the hue of the blue sky but don't want to change the other colors in the image. Here are the steps:

1. Click the target button next to Hue.

2. Move your cursor over the blue sky.

3. Click and hold on the blue sky.

4. Drag your cursor up or down to adjust the hue.

5. Release the mouse button to apply the adjustment.

When shooting **Figure 6.23**, an 18-minute exposure of the southern sky over Sedona, I accidentally left my camera set on Daylight white balance. You can see that the entire image appears orange. I won't get much help from the HSL panel until I adjust the white balance to separate the colors. **Figure 6.24** shows the image after I adjusted the Temp slider from 4900 to 2900. Better, but the sky is still too cyan and the mountains too green. Moving to the HSL panel, I clicked the Hue target button, clicked in the sky, and moved my cursor up to adjust the sky toward blue. I then clicked the mountain and moved my cursor down to alter the greens and yellows toward orange/red (**Figure 6.25**).

Figure 6.23
Daylight white balance produced a heavy orange cast during the 18-minute exposure.

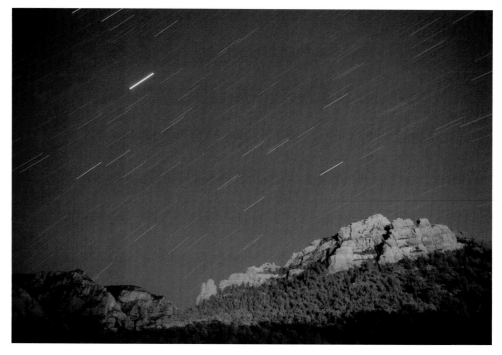

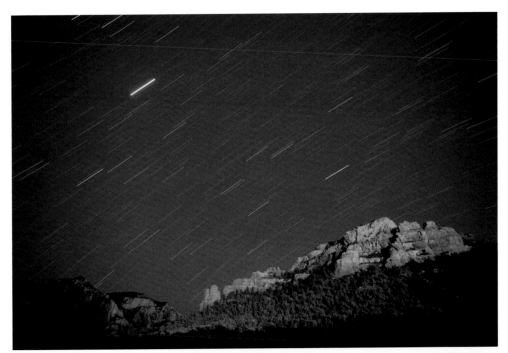

Figure 6.24
After adjusting the white balance, the image looks better, but the sky is still too cyan and the mountain too green.

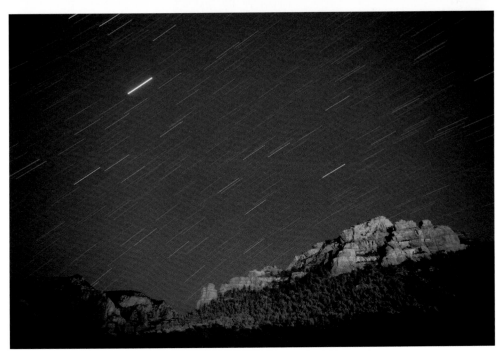

Figure 6.25
By using a target button in the HSL panel, I was able to push the sky toward blue and the green mountains toward orange.

Detail Panel

The Basic and HSL panels are where you'll do the bulk of your work, but there are several other panels that are important to your workflow. The Detail panel is where you'll apply sharpening. While JPEGs are pre-sharpened in-camera, our raw files are just that: raw. Because no sharpening is applied to raw files in-camera, Adobe adds a little when the image is imported. The standard amount is a good starting point, but there are two presets that I use for all my sharpening: Sharpen Faces and Sharpen Scenic. These can be found in the Presets panel on the left of the Lightroom workspace (**Figure 6.26**).

Simply click the preset to apply it to the image. Clicking this preset will not change any other settings that you have applied to your image, only the sharpening. In **Figure 6.27**, you can see the settings applied by the Sharpen Scenic preset. This preset works well with all my imagery but portraits. For those, I use the Sharpen Faces preset.

Figure 6.26
Use the Sharpen Faces preset for portraits and the Sharpen Scenic preset for all other images.

Figure 6.27 **Detail panel settings after clicking the Sharpen Scenic preset.**

Go to the Noise Reduction area of the Detail panel to reduce the grainy sandpaper look that appears when shooting at high ISOs (**Figure 6.28**). There are two types of noise: luminance noise and color noise. Luminance noise is grayscale and looks like grains of sand (seen in the sky in Figure 6.28). Color noise looks like splotches of color (the red groupings in the wall in Figure 6.28).

Lightroom has a default setting for color noise that works quite well for most images. Luminance noise can be fixed by increasing the Luminance slider. Moving the slider to the right removes the noise by blurring it. But move it too far, and the entire image takes on a plastic look. Again, less is more. Better to have a little noise in the image and have it look realistic. The Detail slider brings back detail that has been lost due to the blurring, and the Contrast slider returns lost contrast to the image. A slight increase in the

Amount slider in Sharpening helps return sharpness to the image as well. No two images are alike, so experiment with these sliders. **Figure 6.29** shows the before and after of the ISO 6400 file from Figure 6.28, as well as the settings I used. To reduce the noise, I raised the Luminance slider to 39, left the Detail slider at its default setting of 50, and raised the Contrast slider to 57. Raising the Amount slider under Sharpening from 40 to 66 brought back the lost sharpness.

 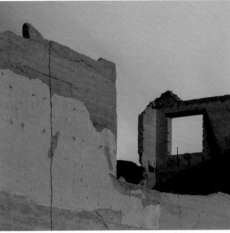

Figure 6.28
The ISO 6400 file (left) shows the grainy look of noise, while the file shot at ISO 200 (right) is clean and noise free.

 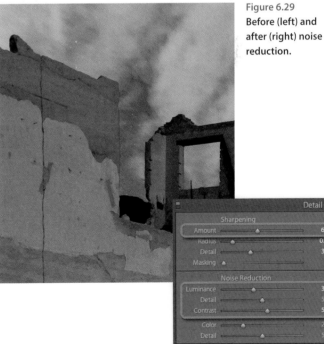

Figure 6.29
Before (left) and after (right) noise reduction.

Lens Corrections Panel

The Lens Corrections panel allows to you fix lens aberrations and perspective distortions. This panel contains more than we can cover in this chapter, but there is one critical adjustment that needs addressing: chromatic aberration. Chromatic aberration is the misalignment of colors on the final image. This is usually found along the edges of a subject in images taken with a wide-angle lens. When your image is magnified (**Figure 6.30**), you may notice color fringe. While this won't be a problem if you are only showing the image on the web, any good-sized print will reveal it.

Navigate to the Lens Corrections panel to fix the problem. Click Basic, and then click the Remove Chromatic Aberration check box (**Figure 6.31**). The color fringe is gone!

Figure 6.30 **This enlargement shows the red color fringe along the edges of the branches.**

Figure 6.31 **Simply clicking the Remove Chromatic Aberration check box fixes most files.**

Camera Calibration Panel

The Camera Calibration panel is often overlooked, but it can be a great starting point for creating the overall look of your image. Unlike JPEGs, raw images have no styles applied to them in-camera. For example, you could set your camera's picture style to Landscape to give your JPEGs higher contrast and better color saturation; set it to Portrait to lower the contrast and color saturation. But Lightroom does not recognize these styles in a raw file. Adobe has its own translation of your raw file, called Adobe Standard (**Figure 6.32**).

By clicking the double arrows to the right of the words Adobe Standard, you can choose from a list of Adobe's interpretations of the camera's styles. Lightroom displays the list according to the type of camera you're

Figure 6.32 **Adobe Standard is the default interpretation given to newly imported raw files. JPEGs will read "Embedded" in this section.**

using, but most cameras will have Landscape, Portrait, Neutral, and Standard. With high-contrast images, you may find that Adobe Standard shows more shadow detail, while a flat image will benefit from the added color and contrast of Landscape.

I highly recommend experimenting with these options, as they can have a dramatic effect on your photos. The Camera Calibration panel is geared toward raw images. A JPEG here will read "Embedded" and have no profile options. **Figure 6.33** shows an image using the Adobe Standard profile. **Figure 6.34** shows the same image with the Landscape profile.

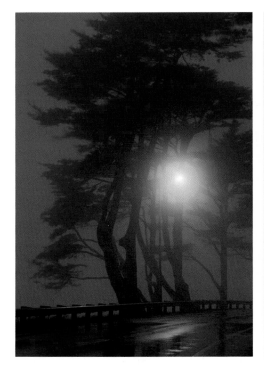 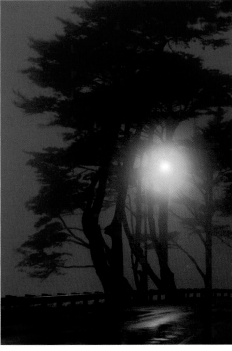

Figure 6.33 (**left**)
The Adobe Standard profile provides average contrast and saturation.

Figure 6.34 (**right**)
The Landscape profile increases contrast and boosts saturation.

Creating a Develop preset for importing images

I enjoy working in Lightroom, but I'd rather be out in the field shooting! I want to streamline my workflow as much as possible. Creating Develop presets is an easy way to reduce computer time.

1. In the Basic panel, set the Clarity slider to +10.
2. Go to the Preset panel, and click Sharpen Scenic.
3. In the Lens Correction panel, click the Remove Chromatic Aberrations check box.
4. Choose Adobe Standard in the Camera Calibration panel.
5. Return to the Presets panel, and click the + in the upper-right corner.

6. In the New Develop Preset dialog, give your new preset a name (**Figure 6.35**). Click the Check None button at the bottom, and then select the boxes next to Clarity, Sharpening, Chromatic Aberration, Process Version, and Calibration. Click Create.

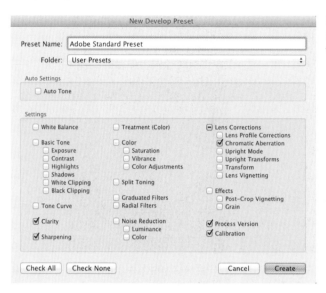

Figure 6.35 **Only check the boxes of the settings you want to apply with the preset.**

You've just created your first Develop preset, and you're on your way to saving time! You can repeat the process with the Landscape profile and again for Camera Standard. This will allow you to apply a range of looks with the click of a button. To apply a preset, navigate to the Presets panel and find User Presets at the bottom. Simply click the desired preset to apply it to the active image. Your presets also appear in the Develop Presets menu in the Import dialog. I use my Adobe Standard preset during import for most of my night photography. If I later find that an individual image needs a boost in contrast or saturation, I click the Landscape preset before I begin work on it.

Local Adjustments

The adjustments we've seen so far are called global adjustments because they're applied throughout an entire image. Local adjustments are edits that are applied to only a portion of an image. There are three tools you can use to apply local adjustments in Lightroom 5: the Graduated Filter, the Radial Filter, and the Adjustment Brush (**Figure 6.36**).

The tools are very similar to each other in operation. When you click the tool, the adjustments associated with it are revealed. **Figure 6.37** shows the Graduated Filter tool's controls.

Radial Filter

Graduated Filter Adjustment Brush

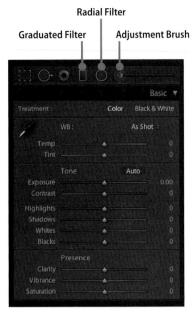

Figure 6.36 **The buttons for the Graduated Filter, Radial Filter, and Adjustment Brush are located just above the Basic panel.**

Figure 6.37 **Clicking the tool reveals a host of sliders.**

Moving the Graduated Filter tool's sliders at this point, however, will not alter the image—first you have to draw the gradient. Click an image and then drag inward. This will draw the gradient overlay, which is the area that the adjustments will appear in. Then move the sliders to adjust the image. When you are finished adjusting an image, click the Graduated Filter button again to close the adjustment box and apply the adjustments.

In **Figure 6.38**, I want to darken the wall on the right to keep your eyes in the center of the picture. I clicked the wall, dragged the cursor toward the center, and stopped just before the opening. The overlay defines the gradient. Everything to the right of the start point receives 100 percent of my adjustments. From the start to the end line, the adjustments gradually fade off. The end line marks the end of the adjusted area. Everything to the left remains unadjusted. **Figure 6.39** shows the adjustments I made to darken the wall. The adjustments of –1.60 to exposure and –91 to contrast darken the wall and keep the contrast of the area similar to the rest of the image. The +30 on tint keeps the colors matching. When you are finished adjusting the image, click on the Graduated Filter button again to close the adjustment box and apply the adjustment.

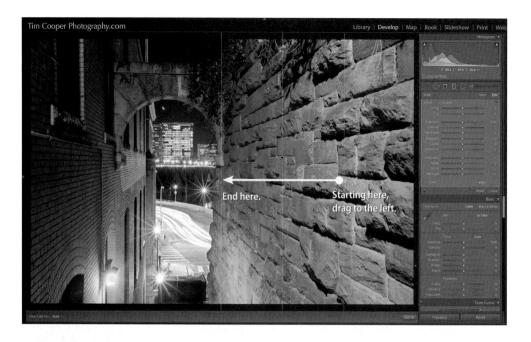

Figure 6.38
A Graduated Filter
tool adjustment.

End here.

Starting here,
drag to the left.

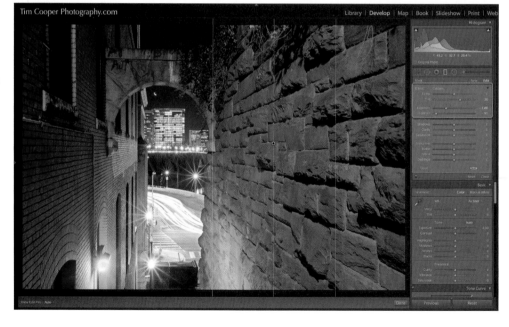

Figure 6.39
Darkening the
exposure, lower-
ing the contrast,
and adding some
magenta downplays
the bright wall.

The Radial tool works much the same way: Click an area and drag outward to draw an ellipse. The adjustments will apply to areas outside the ellipse unless you click the Invert Mask check box (**Figure 6.40**).

In **Figure 6.41**, I lowered the Exposure slider and then clicked the bell and dragged outward. By making an adjustment first, you may find it easier to see the ellipse you're creating. Once the ellipse is drawn, you can adjust its size and shape by clicking the boxes at its edges. Use the sliders to fine-tune the look.

Figure 6.40
The Radial Filter tool provides the same adjustments as the Graduated Filter tool, as well as a Feather slider and the option to invert the ellipse.

Figure 6.41
Drag outward to draw the radial overlay. Making an adjustment first may help you see the ellipse you are drawing.

Figure 6.42

Using the Feather
slider to smooth out
the adjustments.

Here, I've moved the Feather slider to 100% to smooth out the effect (**Figure 6.42**).

The Adjustment Brush tool is the most versatile, because it's not constricted to a certain shape. It allows you to paint the overlay with your mouse or a Wacom tablet.

In **Figure 6.43**, a nearby streetlamp caused the foreground to become too bright. I begin by clicking the Adjustment Brush button and moving the exposure to –2.00. This is just a guess and can be readjusted later. Overdoing the adjustment helps you see where you are painting.

The lower portion of this box contains the Feather slider and the Auto Mask check box. Using a large feather (100) helps blend the adjustment into the surrounding area. Clicking the Auto Mask check box constrains your painting within edges. Continue painting until your area is completely covered, using the Erase brush if you go outside the lines. Then, return to the sliders and adjust them accordingly (**Figure 6.44**).

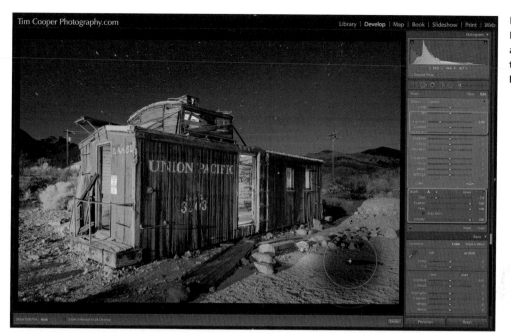

Figure 6.43
Painting in the adjustment with the Adjustment Brush tool.

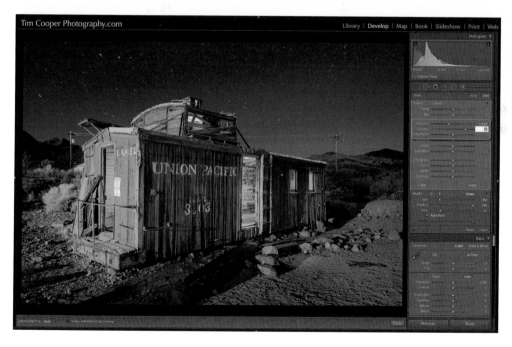

Figure 6.44
Adjusting the exposure to -0.83 and the contrast to +59 darkens the foreground but keeps it believable.

Extend Your Possibilities with Photoshop

Lightroom is an amazing and exceedingly powerful program, but sometimes you need to take your images into Photoshop to get the job done. Here are a few of my favorite Photoshop techniques for night photography.

HDR

Many times when shooting at night you'll find that no single exposure will reveal detail in both the highlights and the shadows. Shadow detail can sometimes be revealed using the Shadows slider in the Basic panel, but once the highlights are gone it's very difficult to get them back. These types of scenes are very high in dynamic range, meaning the highlights and shadows are separated by too many stops of exposure for the camera to capture. The best solution is to make several separate exposures at different shutter speeds to span this high dynamic range (HDR) (**Figure 6.45**) and then export them into Photoshop to be blended together. Here are the steps:

1. In Lightroom's Library module, select all the images you wish to blend together.

Figure 6.45
The three exposures, selected and ready to send to Photoshop.

2. Choose Photo > Edit In > Merge to HDR Pro in Photoshop.

3. When greeted with the HDR dialog in Photoshop, ensure that 32 Bit is selected in the Mode menu, and move the White Point Preview slider until all of the highlight detail is revealed (**Figure 6.46**). Don't worry if the photo looks too dark, you'll fix that back in Lightroom. Click OK.

4. Your 32-bit image appears in Photoshop's main window. Choose File > Save, and then File > Close. This saves your new 32-bit HDR image back into Lightroom.

 Lightroom 5 has the ability to adjust 32-bit images, so you are now free to use all of Lightroom's sliders to fine-tune your blended image (**Figure 6.47**).

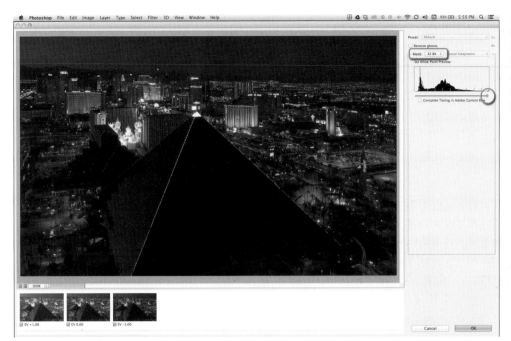

Figure 6.46
Set the mode to 32 Bit, and slide the White Point Preview slider to the right until it reveals all highlight detail.

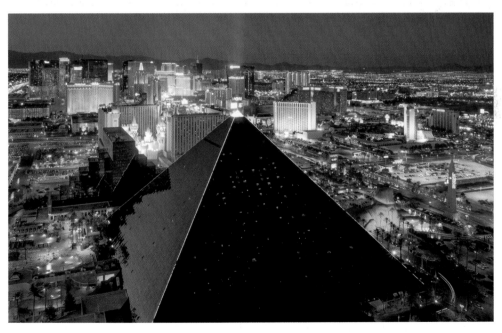

Figure 6.47
I adjusted the image in Lightroom, and it now shows good shadow and highlight detail.

Stacking Star Trails

A great way to capture long star trails without a long exposure is to shoot many shorter exposures and blend them together in Photoshop. Here's how:

1. In Lightroom's Library module, select all the images you want to blend together (**Figure 6.48**).

2. Choose Photo > Edit In > Open as Layers in Photoshop.

3. To select all the layers, click the bottom layer and then Shift-click the top layer.

4. Choose the Lighten blend mode (**Figure 6.49**). (With older versions of Photoshop, you may have to change the blend mode to Lighten one layer at a time.)

5. Your star trails have come to life (**Figure 6.50**)! Choose Layer > latten to reduce the file size. Choose File > Save, then File > Close to return to Lightroom.

Figure 6.49 **Once you select all the layers, choose the Lighten Blend mode from the drop-down menu.**

Stacking Car Trails

Half an hour after sunset is a great time to shoot cityscapes. If you use a small aperture, your exposure time can elongate into the seconds, leaving a busy street lined with car trails. But even a 5- or 10-second exposure may not be long enough to fill the scene with car trails. The trick is to wait for the traffic lights to change and then press the shutter. Then do this again. And again. Soon you'll have several frames that display car trails throughout (**Figure 6.51**). Blending these images together is easy:

1. In Lightroom's Library module, select all the images you want to blend together.

2. Choose Photo > Edit In > Open as Layers in Photoshop.

3. To select all the layers, click the bottom layer and then Shift-click the top layer.

4. If you suspect that your tripod may have moved when you were shooting, choose Edit > Auto Align. From the resulting menu, choose Auto. Photoshop analyzes the layers, then automatically aligns them so they are properly registered.

5. With all of the layers still selected choose Lighten from the Blend Mode.

6. Your streets are now filled with car trails (**Figure 6.52**)! Choose Layer > Flatten to reduce the file size. Choose File > Save, then File > Close to return to Lightroom.

Figure 6.51
The images in Lightroom.

Figure 6.52
The 17 images blended together to fill the streets with car trails.

What you see is what you get

Investigate the various screen calibration solutions on the market. You don't need to spend a lot of money—the middle-of-the-road price range will do. You'll work with confidence knowing that what you're seeing is what you'll get!

Check out your profile

After importing your raw images into Lightroom, experiment with the camera profiles in the Camera Calibration panel. When you find one you consistently like, use it to create a Develop preset for importing.

Study the HSL Panel

The HSL panel allows you to make simple yet powerful edits to your image. Choose one color in an image and alter its hue, saturation, and luminance to study the difference between the three adjustments. Choose another color and repeat. Try maxing out the sliders and magnifying your image to 100%. Notice the halos that can appear at the edges of your color. Learn not to overdo the sliders. Spending time with this adjustment will pay big dividends in the end.

Practice stacking

Stacking images is an easy way to obtain results otherwise impossible with one exposure. Set up a tripod and shoot multiple frames of a busy street scene at dusk. Use a long exposure (5 seconds or more) to capture the cars' head- or taillights as they streak by. An ISO of 100 and a small aperture, such as f/16, will help increase your exposure time.

Share your results with the book's Flickr group!
Join the group here: www.flickr.com/groups/night_fromsnapshotstogreatshots

Index